paint the sea in oils
using special effects

by

e. john robinson

International Artist Publishing, Inc
2775 Old Highway 40
P.O. Box 1450
Verdi, Nevada 89439

Edited by Terri Dodd
Design by Vincent Miller
Photography and illustrations by E. John Robinson
Typeset by Cara Miller

Printed in Hong Kong
First printing in hardcover 1999
Second printing in softcover 2000

ISBN NO: 1-929834-04-7

Distributed to the trade and art markets in North America by
North Light Books,
an imprint of F&W Publications, Inc.
1507 Dana Avenue
Cincinnati, OH 45207
(800) 289-0963

To all who would love and desire to paint the sea.

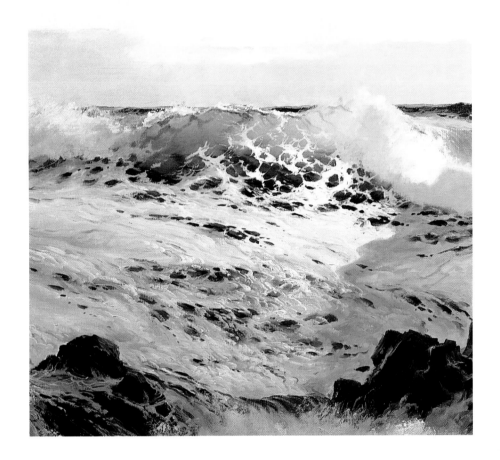

acknowledgments

Over the past few years there have been many students who have urged me to write another book on painting the sea.
These people were the reason for my writing and teaching in the first place and I have put it off for too long.
It took Vincent Miller, Publisher of AUSTRALIAN ARTIST and INTERNATIONAL ARTIST magazines, to finally convince me that there was no better time than now so, at last, I have put my ideas together for this book. My sincere thanks to the students, to Vincent, and my wife June, who has encouraged me at every turn.

contents

introduction

At an early age I knew I wanted to be an artist and learned as best I could to draw, then later to paint. As I matured I painted many subjects but eventually realized that if I were to really improve I needed to concentrate on just one subject and study it in depth.

I had grown up along the rugged Oregon Coast of the United States and considered the sea to be my favorite subject matter. At first I thought that I would specialize, just for a while, until I had some mastery but that specialization lasted 20 years. Eventually I added landscapes but the sea has remained my forte even though I cannot truthfully say I have mastered it.

When I began painting seascapes there were no books on the subject and very little in the way of artists' works that might be seen. I did, however, live near the sea and could make frequent visits to study, sketch, and take notes. Photographs were of some help but usually disappointing. They always seemed to miss the "right" moment and they never captured the atmosphere or spirit I felt. There were also no video cameras in those days either but there were movie cameras and I bought one. At least that allowed me to capture the movement and study it frame by frame.

I knew from art school that one could paint the figure far better if one understood the human anatomy so I concluded that knowing the anatomy of the sea would help me to paint a better wave. I turned to some books and articles on oceanography and gained an understanding that indeed helped answer many questions. Now, after nearly 40 years of study and insights, it is my pleasure to pass along what I can to those who find themselves with more questions than answers.

In **SECTION ONE** of this book you will learn about equipment and supplies for both indoor and outdoor painting and sketching. You will also see how a quick outdoor sketch can develop through a few steps into a finished painting in the studio.

In **SECTION TWO** comes the understanding of the ingredients necessary for a successful seascape: the anatomy of the wave, how to paint translucent water, how to use sunlight, shadow, and atmosphere to influence the components of a seascape, as well as the waves, the rocks, and the beaches and headlands. Finally, we move on to lessons about what are the best colors and how a composition of line, value and color can create a mood and show movement and harmony.

SECTION THREE is made up of step-by-step demonstrations that help you put together all the ingredients in finished paintings. Each demonstration shows a variation of what you have learned in this book and each has a different location as well as mood. This is where you learn to put your own feelings to work and create paintings unique to yourself.

Finally, in **SECTION FOUR**, there is a gallery of paintings that shows other variations of waves, compositions, colors and moods. It is important to say here that the purpose of this book is to help you paint unique seascapes, paintings that are a reflection of yourself. Unless you are very advanced it is important to practice the lessons over and over again until they are can be painted more easily. If you do this before you try to paint a complete painting you will have much less frustration trying to learn and paint masterpieces at the same time. It is perfectly alright to copy in order to learn.

Eventually though, you will want to create your own compositions and use your favorite colors and be recognized for your own technique. In the meantime, painting the sea can be difficult but if you learn the ingredients and follow the steps, you can achieve far more. It is a richly rewarding experience to paint the sea and your daily improvement will be reflected in your efforts.

PAINT, PAINT!

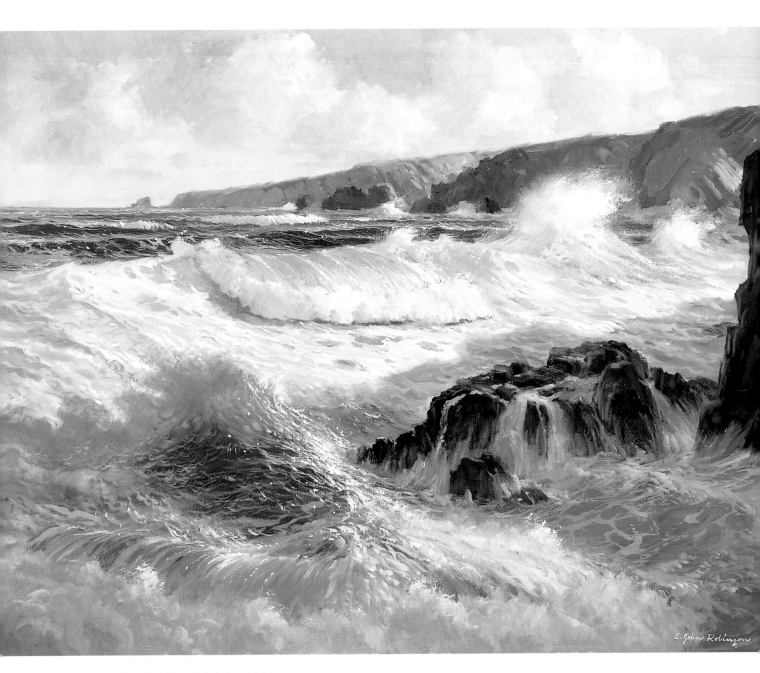

"Power of the Sea", 30 x 40'' (76 x 102cm)

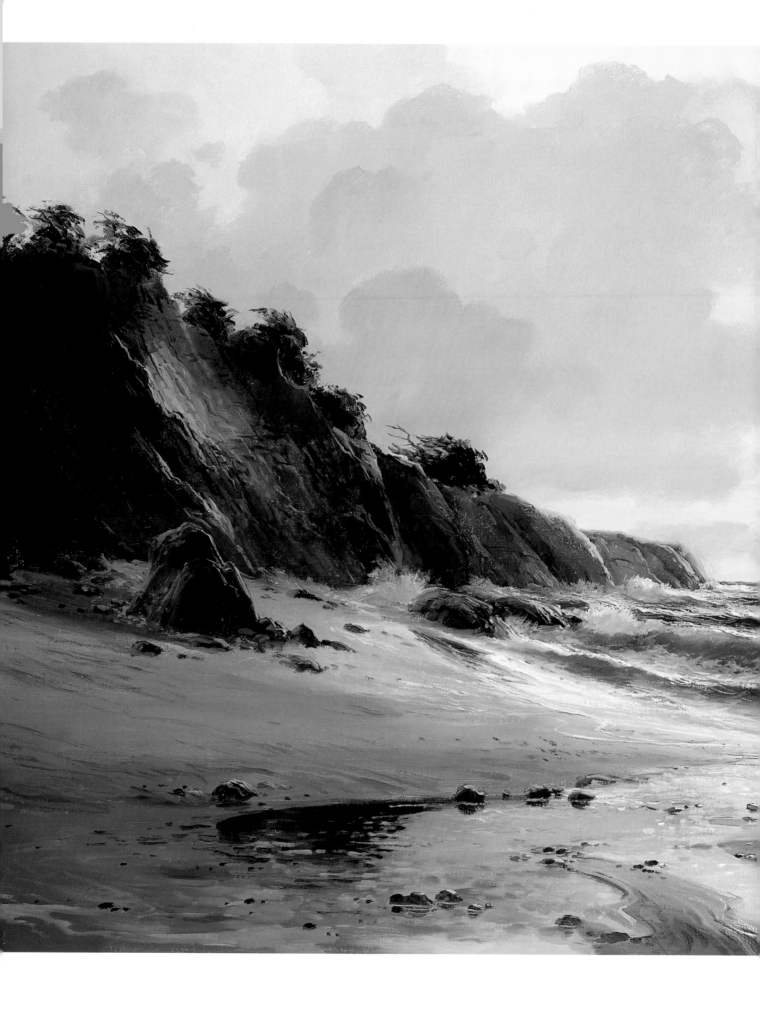

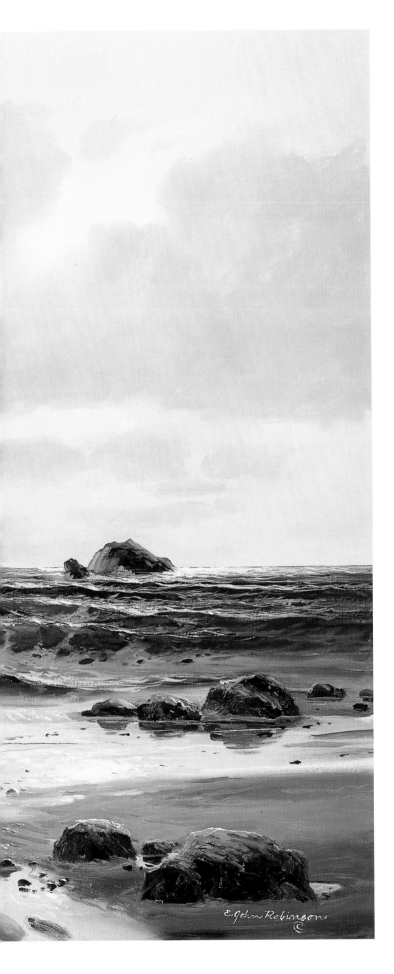

section 1

beginnings

"Van Damme Beach", 30 x 40'' (76 x 102cm)

sketching on site

If you learn to regard outdoor painting purely as an
information gathering exercise for studio painting,
I promise you, you'll have much more fun.

Some people prefer sketching with watercolors
and some with oils. I use either one depending
upon accessibility, how much time I have, or
whether or not I'm driving a vehicle that can
be ruined with wet oil paint.

A preliminary watercolour sketch
Both these sketches are loaded with information

A small oil sketch

I can think of few pleasures so rewarding as being outside painting or sketching. While I have an inspiring scene in front of me others less fortunate than me are hard at work or simply can't be there. Perhaps this is what makes us creative artists. First, we have learned to see what others miss, and second, we just have to put it down in some way and share it. It seems to be our destiny to capture that special moment and share it with those less fortunate.

When I go outside in search of a scene I know there are few ready to paint compositions so I don't look for them. Instead I look for that special feeling, that moment in time that grabs me and makes me want to capture it. I don't want postcard scenes that my snapshot camera can record, I want what it *doesn't* see. I want the spirit of the place; the flickering light, the cast shadows, the atmosphere, and the mood that sends tingles up my spine. Needless to say, I'm not always successful in capturing these moods but I have something very special to take back to the studio. My sketch will have captured something my camera can't. Of course there are professional photographers who can do with a camera what I want to do with paints, but I am not a photographer.

I also don't go outside with the intention of painting a masterpiece. I consider outdoor painting mostly to be information gathering. If I was bound up with the need to make a quality, finished painting out of doors I'm afraid the pressure would cause me to lose interest or try too hard. Outdoor painting should be fun and carefree. Of course we all want to do the best we can so, I have a little plan I follow that gives me a better chance of starting out right, and we'll go through it a little further on.

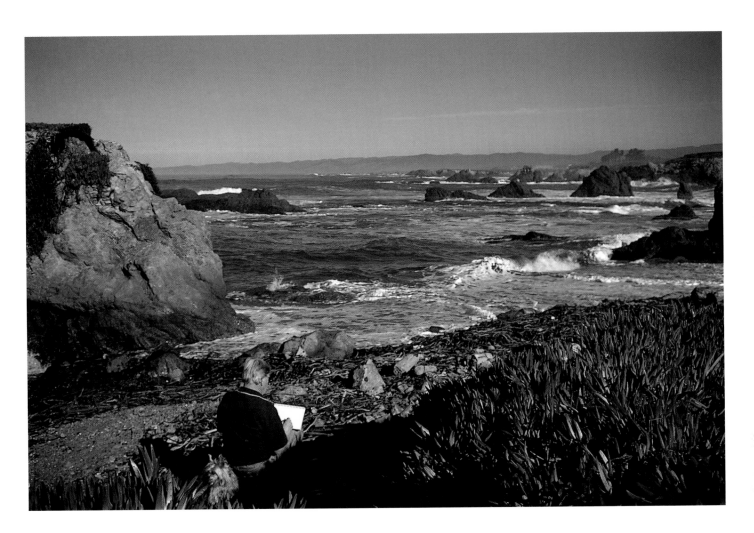

the site

Sometimes it is hard to find the right place to set up and paint. The rocks I want are in one place and the best view of the water is in another, or the light and shadows are better from a different angle than where I can find room to set up. The answer is to walk around, get to know your subject and make a few thumbnail sketches. It is perfectly acceptable to move things around to where you want them. Remember, you want something your snapshot camera doesn't see. There is nothing wrong with moving a rock or importing a wave you saw ten minutes ago to the spot you want in your painting. After all, they keep moving and changing so why not turn your mind into a camera and click one into your memory banks. You could also make a quick pencil sketch with color notes for future reference. It is best to be as accurate as you can with colors and the atmosphere and the actual shapes of rocks and waves, but go ahead and move them around. Think of yourself as a director of a stage play; you want something to be the star and command attention while other objects and things can be in subordinate roles and placed where they will best support the star. We'll refer more to this concept throughout the book

"If you start out painting details it is like trying to board up a house without putting up the framing first"

outdoor sketching with watercolor

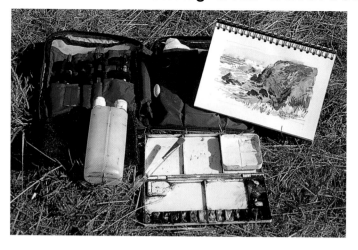

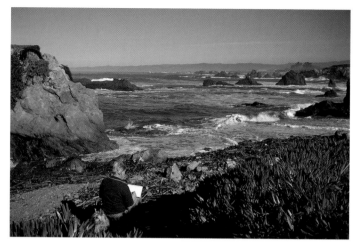

outdoor watercolor equipment

Watercolor is an excellent medium for painting outdoors. When scrambling over rocks and driftwood I like to travel light. This is one of my lighter watercolor kits and probably doesn't weigh more than four pounds. It contains a tin of tube colors that can be closed and also has a mixing tray. (The hard little tins of dry color just don't meet my requirements.) There is also a small bottle of water, a few good sable brushes, a pencil and sketch pad, and either a watercolor block or pad. For more serious watercolor painting I use a larger kit with a full sized palette and large sheets of watercolor paper on a board.

at the site

I have found a beautiful day, gentle breakers, and good lighting to make my efforts a pleasurable experience. Hopefully, not too many of the curious will come around to talk about a cousin who can copy from the funnies, or an aunt who paints cherubs on driftwood.

outdoor sketching with oils

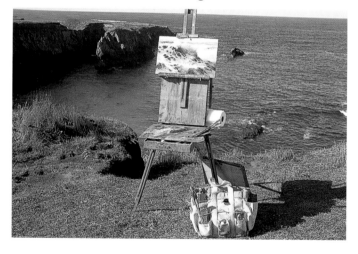

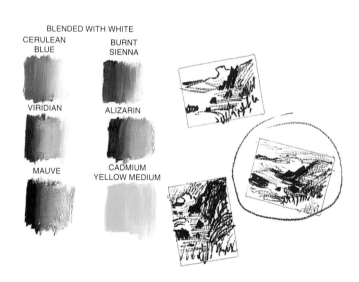

oil equipment

I use a wooden French easel for painting oils outdoors. It holds a selection of colors, brushes, and a palette. I carry a tote bag with extra colors, paint thinner, paper towels, and a good sized jar for the thinner. I use this mainly for keeping my brushes clean. The brushes and colors are the same as those listed on page 17.

oil preliminaries

I don't work out a color theme when painting outdoors because I'm not sure of each color until I study the objects I am painting. I show the six colors here so you can see just how little I use at a time. I also show what my preliminary thinking was with the thumbnail sketches. These sketches are extremely important and will help to avoid problems. This is the time I work in my mind the scene I wish to paint, the values, the location of the light, and where to place the center of interest.

thumbnail sketches

Just as I suggest you do, I walked around and made a few sketches. There was a set of rocks with good lighting that I wanted to include so I decided they would give me contrast to a light wave which I would find later. I first sketched the set of rocks in different positions and values, then chose one I preferred. In a little while I saw just the right wave and committed it to my memory. Now I am ready to start and I have only spent ten minutes preparing.

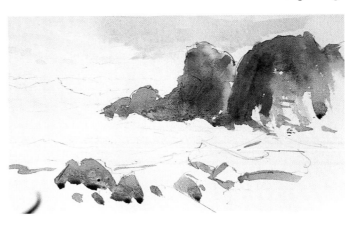

I. establish the underpaint first

I wet the paper with a small sponge. Then, while it was still wet, I applied cerulean blue with more water in the brush. I only made two or three sweeping strokes with my 1'' flat brush then held the paper vertical for a moment to let the color flow. In a few moments the sky area was dry and I mixed alizarin crimson and sap green in the mixing tray with the same 1'' brush, then laid in the shape of the rocks. Where there would be sunlight I used less paint and more water and added a touch of yellow ochre. The reason I painted the rocks at this time was to establish the under paint first. If I had made them too dark the shadow side that will come later would not show up. ▶

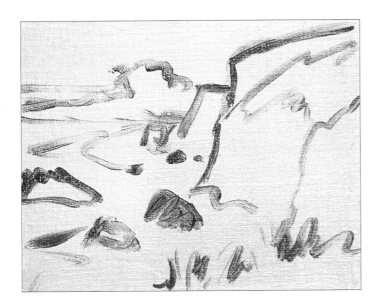

I. a simple outline

When I paint with oils outdoors I usually paint the smaller sketches on panels I prepare myself. I glue scraps of canvas to ¼'' plywood with a good, strong carpenter's glue, then press out any lumps, and put a weight on the panel overnight. The panels are rigid and easy to carry and I enjoy the texture of canvas, even for sketching. I had set up my easel near my truck to be protected from the wind but had a good view of the scene. My first step was to make a simple outline on the canvas, using a small bristle brush and ultramarine blue thinned with paint thinner. This is the time to be sure of the placement of the objects. It is easy to erase a few lines with a paper towel and some thinner at this stage, but it won't be later on.

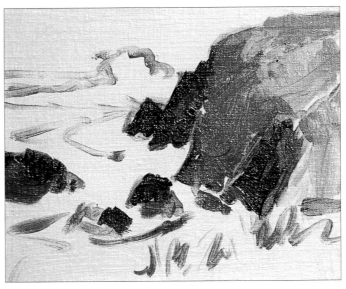

2. darks first

I always like to get the dark values in first. The reason is because I have a tendency to see everything "too dark" when painting outside, and if I started with the sky darker than it should be then it would be very difficult to get the darker objects dark enough to relate. In this second step I scrubbed in the dark side of the rocks first. I used a #6 flat bristle brush and mixed cerulean blue darkened with mauve and viridian. For the lighter top of the rocks I mixed cadmium yellow medium and burnt sienna, scrubbed that in, then laid in a few patches of green mixed from viridian and the yellow. When I say "scrubbed", I mean I used a scrubbing motion when applying the paint. I worked quickly because everything at this stage was under paint. The detailing must wait until there is a foundation of color. I was careful to thoroughly clean my brush after each step. ▶

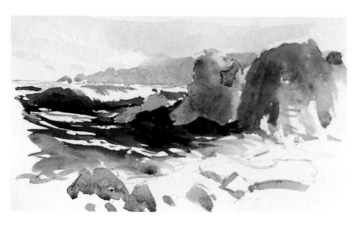

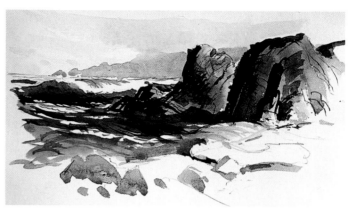

2. headlands first
The paper had dried enough so I painted in the back headlands with cerulean blue and a touch of alizarin to warm it up. I was careful not to paint into areas that would remain white because I don't use white paint with my watercolors. I used a #8 round sable and applied viridian mixed with ultramarine blue for the major wave and the water just under the rocks. I added cerulean to the viridian for the nearer area of water. Finally, I deepened the shadow side of the rocks with mauve.

3. cracks and texturing
The base color and the shadows on the rocks had dried so I used my #2 rigger brush and painted in cracks and texturing. I suggest you mix the same color you are going over but make it a shade darker. In other words, use ochre over ochre and so on, but don't change the underlying color of any texturing.

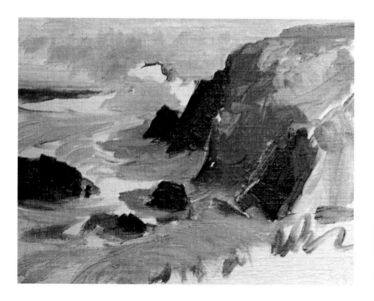

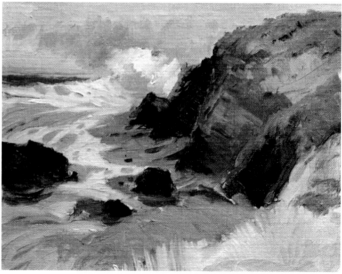

3. light and medium next
Once my dark values were established I quickly scrubbed in my light and medium values. For the sky, I toned down cerulean blue with a touch of mauve and lightened it with white. The breakers and some of the foreground water were next and were just viridian lightened with white. I left clean canvas where I wanted clean, unmuddied whites later. I was still using a #6 flat, or filbert brush and scrubbed in the cast shadows from the rocks and the distant horizon with cerulean and mauve with a touch of viridian. I do not use these colors for every painting. Remember, I was trying to capture what I saw at this particular place at that particular time.

4. adding foreground
I changed to a #2 filbert and began to add some details. First I brushed in the white for the foam burst and some touches on the wave. This stayed clean because there wasn't another color beneath it. Next, I scrubbed in the foreground grass with cadmium yellow medium and burnt sienna. I used vertical strokes in a scrubbing motion. Finally, I picked out some dark lines on the rock and a few in the surf. I also reflected some of the cerulean-viridian color back on to the rocks.

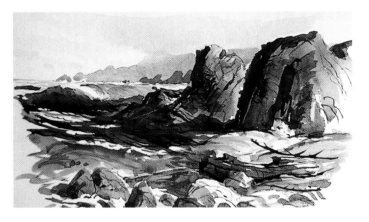

4. detailing

The last step was to refine the sketch. I added some distant rocks to the background, laid more shadow over the breaker, then concentrated on the foreground rocks. I used a #6 round sable and painted in the shadow sides with mauve and a touch of ultramarine blue but using mostly water as I didn't want them to get much darker. I painted the driftwood with yellow ochre and a touch of mauve and when they were dry I textured them with slightly darker versions of the same colors using my rigger brush.

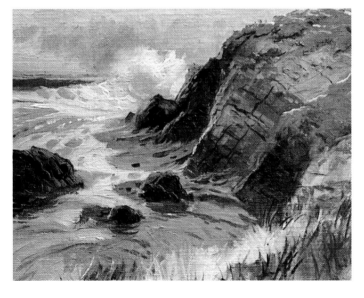

5. detailing

At last I look for details. If I had started out painting details it would have been like trying to board up a house without putting up the framing first. You must have something under the detailing. For detailing I first softened the edges of the foam and the top of the breaker. I used a 1'' dry varnish brush and used a light touch so as not to blend the clean whites with other colors. I used a #2 rigger for thin lines such as the cracks on the rocks and the thinner blades of grass. In each case I used a darker version of the same color I was painting over. The final touch was to add a few details to the surf area, just little reflections of light. Then it was time to look around and see if there was something useful that I had missed. The main thing was not to overwork the sketch. It would be much fresher if left alone.

chapter 2

from sketch
to painting

Instead of rushing in to do the painting,
make some evaluations of the situation
and you will have more chance of
success.

There is nothing nicer than going to the studio knowing you have an exciting composition to paint. I could look through photographs all morning and not feel the urge to paint, but an outdoor sketch, along with my memories of being there, gives me the inspiration and mood I need. However, before we begin to paint, let's look at my studio equipment.

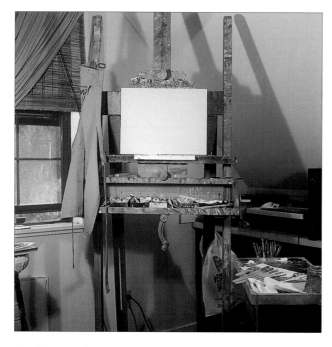

studio easel

I use a large, sturdy, easel that will crank up or down and hold a good sized painting when necessary. I don't want a flimsy easel that will dance around when I'm painting and spoil something, especially my good humor. You can't see the lighting in this photo. I have an overhead bank of five lights. I have always used simple 150 watt floodlights and have never tried the color corrected or daylight types. I figure the painting will be lit in someone's home with the same color of lighting I am using, so there should be no surprises, unless the gallery lights it with something quite different.

Because I am right-handed, my lights are over my left shoulder.

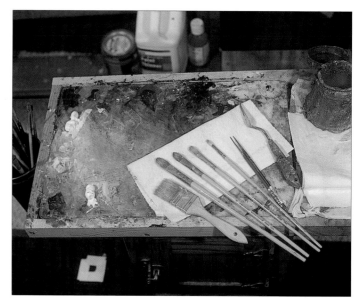

brushes and thinner

I like the flat bristled filbert brushes because they have a flat side and a thin edge for painting. Also, they have a round shouldered tip rather than the sharp corners of other brushes. I use #'s 2,4,6,8, and sometimes 10 and 12 for larger paintings. In addition I use a 1'' or 2'' varnish brush for hazing and softening edges, and a #2 rigger brush for fine lines. My mixing knife is just a size that I am comfortable with. I don't care for the smell of turpentine and the odorless types are more expensive. Therefore, I use plain paint thinner which is much cheaper and does the job without any more toxicity than turpentine. Whatever you may use as a solvent can be bad for your health, so keep a window or two open for cross ventilation. I use thinner mainly for washing my brushes and occasional thinning of paints. I never add anything else to my paints. Other than that, I have a roll of paper towel for drying my brushes and a smock to keep my wife from complaining about paint on my clothes.

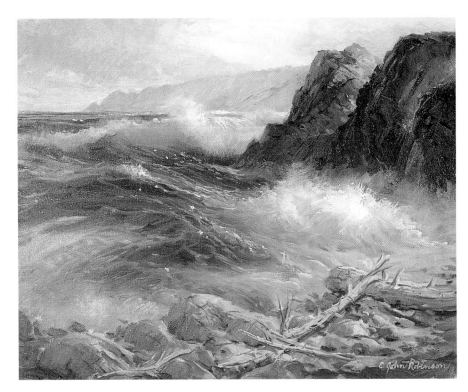

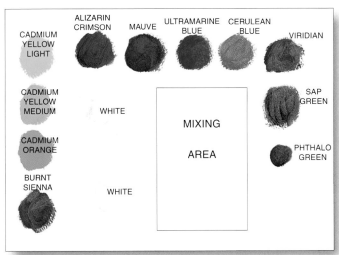

"I keep two piles of white: one for mixing light colors and one for mixing dark colors."

color arrangement

Everyone has their own personal way to lay out their colors on the palette. I don't think it matters much as long as you are consistent. My arrangement somewhat follows the color wheel and as you can see, runs from warm to cool colors with two spots for white paint and a good sized mixing area. I keep two piles of white: one for mixing light colors and one for mixing dark colors. By keeping my brushes clean after each use of a color there is little chance of getting muddy colors.

painting surface

I paint on linen canvas that I stretch myself for any size over 14''x18''. For anything under that size I use the panels described in chapter 1. There is nothing wrong with using a cheaper cotton canvas or boards you have primed with gesso or paint. Choose what you like in textures and stay with it. For practice work, buy a pad of canvas textured paper or anything that will not wrinkle or absorb all the oils.

from sketch to painting

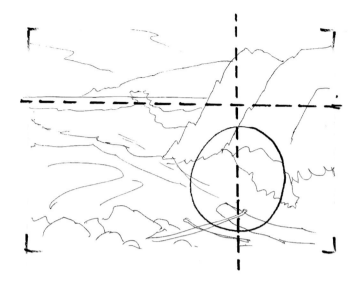

layout

Sometimes I want to rush right into the painting but I have learned from experience that it is best to stop and make some evaluations. I first prop up my outdoor sketch, in this case the little watercolor from chapter one, and see what might be improved. The first thing I notice is that the horizon line divides the space equally, which is not good composition, so I make a new layout and outline. I decided to raise the horizon line to give more emphasis to the foreground. The spacing of the rocks is important too. Notice in here that the vertical line and the horizontal line divide the space into four different sized shapes. This is much more pleasing than equal divisions. Following my sketch I kept the center of interest in the lower, right area where there would be good contrast.

values

The values in my sketch were acceptable but I went ahead and worked them out as well.

This is an overall middle value painting with a large area of dark values with a smaller area of light value reserved for the center of interest. I am not concerned with other values at this time. They will come about as the painting progresses. Also notice I do not think of detail when I work up a value scheme. I just want the spacing of the values to be interesting and not repetitive.

"If you try to practice and paint masterpieces at the same time it will take much longer than if you took the time to practice each segment and then created a painting."

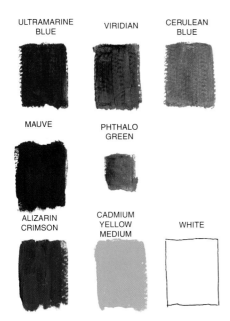

ULTRAMARINE BLUE

VIRIDIAN

CERULEAN BLUE

MAUVE

PHTHALO GREEN

ALIZARIN CRIMSON

CADMIUM YELLOW MEDIUM

WHITE

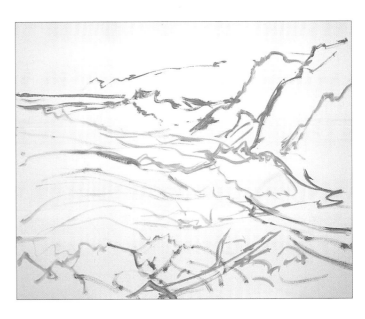

colors

Oil colors are sometimes quite different from the same colors in watercolors. I was determined to stick pretty close to the colors I saw at the scene so I chose oil colors that were comparable. Besides white, I chose ultramarine blue, cerulean blue, viridian, sap green, mauve, alizarin crimson, cadmium yellow medium, and a very small amount of phthalo green.

1. outline

I begin each painting with a brief outline. I often use thinned down ultramarine blue for seascapes if they will be an over all blue or green. A warmer color such as red, or any color that has a lot of tinting power, may show through where I don't want it. If I intend painting a warmer scene, such as a sunset, then it might be best to use a warmer color for the outline. Another exception would be when I tone the entire canvas before painting. Then I would draw the outline with a comparable color to the toning. (See chapter 10). As you can see here, I kept the drawing to a minimum. Any detail painted now would be lost in the next steps.

"You cannot ice a cake until the cake is complete."

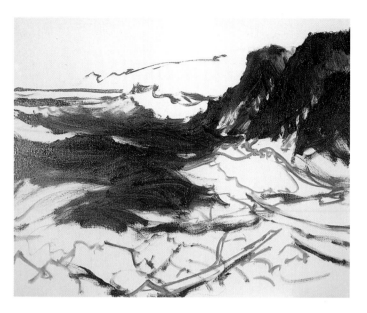

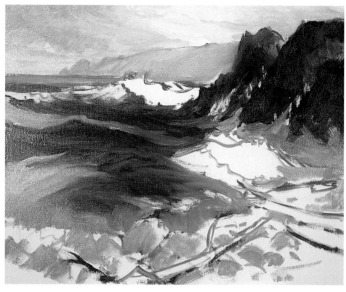

2. establish dark values

I put my dark values in first to be certain all other values would correspond to them. For the rocks I scrubbed in a mixture of alizarin crimson and sap green using a #8 filbert. I indicated a light side by using a bit of thinner with the mixture but used no white paint. For the clear water I used viridian and ultramarine blue. I also used the #8 filbert but I cleaned it thoroughly before dipping into the new mixture. I painted in only the areas that would be clear water, that is, I left unpainted the area of the wave that would get a translucent look and also the areas of white foam , and the areas that would be a reflection of the sky. If you want a clear water effect, you must never mix white into the under paint. Later, when you lay over foam and sky reflection that have white in them, the clear water will show through and not blend in or become muddied.

3. atmosphere and background

Atmosphere is a combination of sunlight and sky colors and will reflect upon the water. I started the sky with a bit of cerulean blue into white and scrubbed it quickly into all of the sky except the section of pale yellow. I then cleaned my brush, a #8 filbert again, and painted in a mixture of cadmium yellow light into white with a very small touch of cerulean. For the underside and shadows of the cloud bank I mixed a bit of mauve into the cerulean white sky color. Using that same color but with less white, I then painted the distant headlands. They appear to be hazy with the color of the atmosphere. The background sea is ultramarine blue lightened with the sky color. I also used the sky color of cerulean, mauve, and white to paint in the foreground foam and water that would be reflecting the sky. The shadow side of the foreground rocks got the same but with a touch of the rock color as well.

"If you want a clear water effect, you must never mix white into the underpaint"

learning point

I had completed what I call the cake. In other words, the foundation. You cannot ice a cake until the cake is complete. What I had painted so far was the form, or foundation. I could then add details, the icing. If I had attempted to add details first they would have become muddied. It takes patience and some working forethought but you should always make your cake before you ice it.

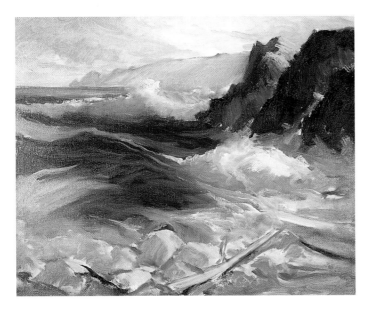

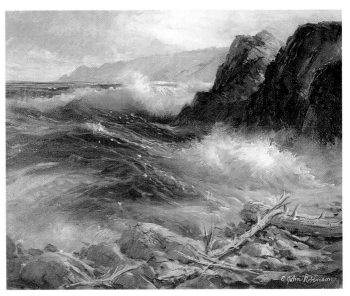

4. sunlight

Just as atmosphere reflects upon water, wet sand, and rocks, sunlight effects everything as well. The first thing I did was to mix a pile of sunlight. That is, I decided the color I wanted, a blend of white and a touch of cadmium yellow light, and mixed enough with my palette knife for the rest of the painting. I then blended some of my sunlight into viridian and painted in the translucent section of the background wave. For this I used a #4 filbert brush. For the foreground translucent water I wanted a brighter green so used a very tiny touch of phthalocyanine green into the sunshine color. I then cleaned the same brush and painted the foam in sunlight with the sunlight color from the pile. I shadowed the foam of both the foreground and background waves with cerulean blue, a touch of mauve, and white; in other words, the atmosphere color Finally, I added sunlight to the top of the rocks and painted the beach sand with a blend of the rock color and more of the sunlight color.

5. final touches

I started the last step by softening edges in the background. I used a #2 dry varnish brush and gently whipped across anything that had too sharp an edge. Background objects would not be in clear focus compared to those in the foreground. I softened the wave foam in the foreground because it is moving and should be blurred. Next, I worked on dark rocks, adding details with my #2 rigger brush, reflecting some of the water back on to the shadow side, and some of the shadows with ultramarine blue and mauve.
The foreground rocks and driftwood needed refining so I used a #2 filbert and a #2 rigger to add sunlight and shadow lines, simply darker versions of their base colors or pure sunlight from the sunlight pile.

The clear water also needed some refining so I used a clean #2 filbert and added sky reflections over it. I was careful not to add too many reflections or the clearness would become opaque. The last touch was to dot in a few sparkles. I used the tip of my rigger brush and pure white and made a small pattern over the clear water. This was the time to stop. Anything more and the painting would quickly become overworked.

a last word

Section one has shown a method of painting that will help you avoid many mistakes. You have first seen the importance of gathering information on the scene and how to record it with watercolor or oils. You have then seen the importance of having good equipment and lighting and the importance of working out some kind of a game plan before rushing into the painting. Then, you have seen a studio painting develop with a few steps in an order that avoids confusion. Details must have a foundation and there are steps to follow that will ensure your success. The next section will go into great detail about the basics needed to paint the sea. Unless you have painted for a long time it is important to study these lessons carefully and do a lot of practice. If you try to practice and paint masterpieces at the same time it will take much longer to learn than if you took the time to practice each segment and then created a painting. Be patient and remember that practice prevents frustration and poor results. Remember, a piano student must practice five fingered exercises before playing Chopin. It is no different for an artist.

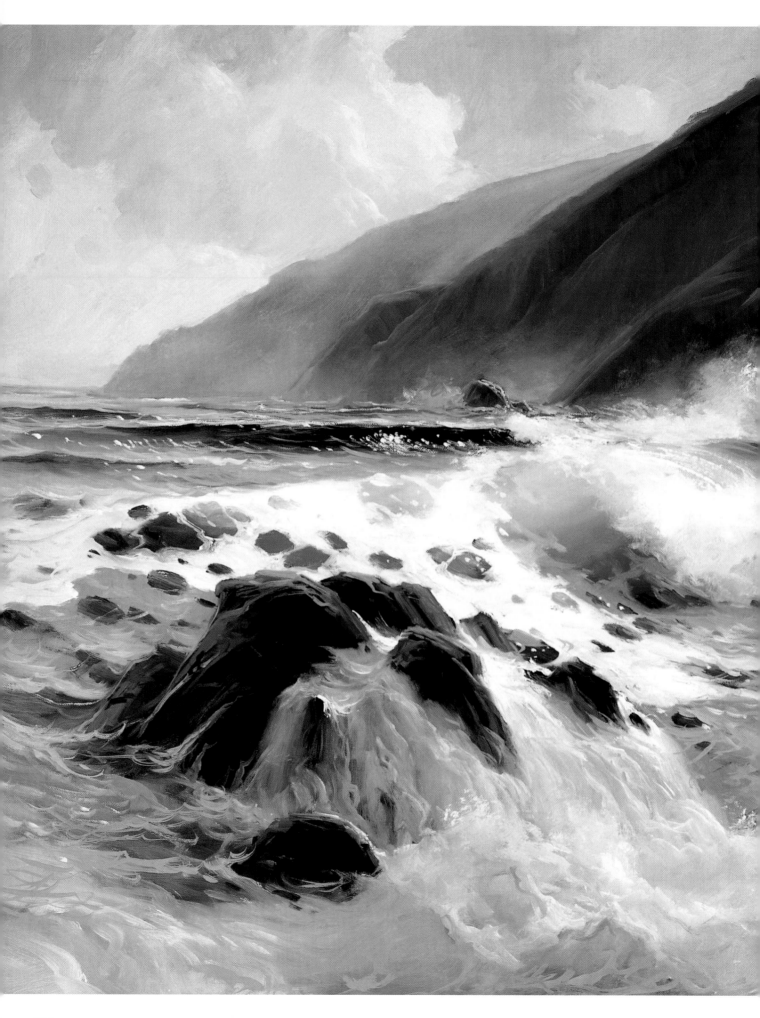

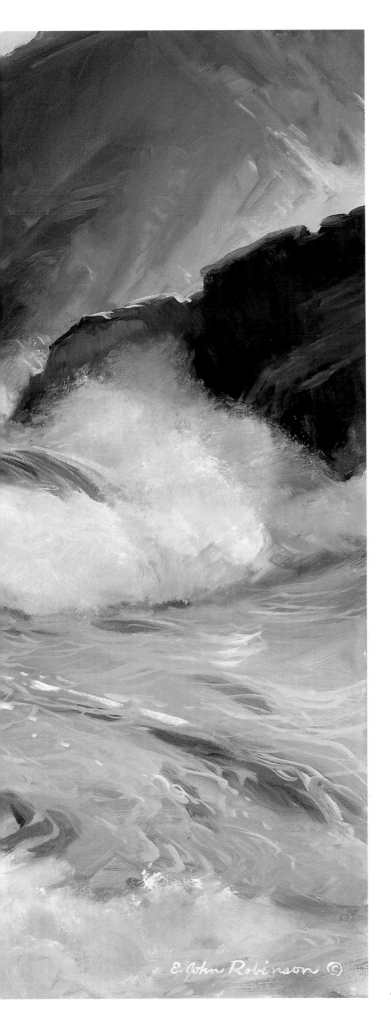

ingredients

"Under the Cape", 24 x 30'' (61 x 76cm)

the anatomy of waves

To paint the sea it's important to understand what's going on out there, that way you won't make the mistake of giving waves shapes that are impossible.

When I began painting the sea I met a lot of frustration because I didn't understand what was going on. I would stand for hours watching the waves break upon the rocks or sweep ashore but they moved so quickly I couldn't figure out what was really happening. Photographs would stop the action but couldn't explain what brought the action to that point.

I had attended art school a few years earlier and knew the importance of understanding human anatomy in order to better paint the figure. I realized that I needed more information about the sea, so I turned to some articles on oceanography and a book or two about waves.

There I found not only the wave structure, but what caused it. This information gave me a basic explanation and understanding of waves at any point of their action.

The first and most important fact was that energy creates waves and their structure. Have you ever picked up a pebble and dropped it into a puddle? If you did, you will have noticed that when the pebble hit the water it made a splash and created concentric circles like tiny waves that moved out from the impact point. Although no one is dropping large rocks into the ocean, energy is being transferred. You transferred your energy to the pebble when you lifted it, and it transferred its energy when it struck. The transference of energy at sea comes from different sources, as you will see below.

storms
When you watch a wave crash upon the shore, it is the end of a journey that may have started a thousand miles away. The heavy winds of storms whipped up the surface and sent its energy on much like the pebble falling into the puddle. The sea is also made up of currents which move like rivers, and at different levels, temperatures, and directions. When these currents converge they also transfer their energy and create new waves.

passing ships
Even ships at sea pass on energy as they plow through the water. I am told that the energy in our universe is neither created nor destroyed but takes on different shapes and is always constantly moving. Keep this in mind — the shape of an object or thing is due to the type of energy it contains. Therefore, a wave takes on a special shape unique to waves, just as a human has a shape unique to humans or a tree a shape peculiar to trees. It follows that, in order to paint a wave, you must understand its energy-created shape.

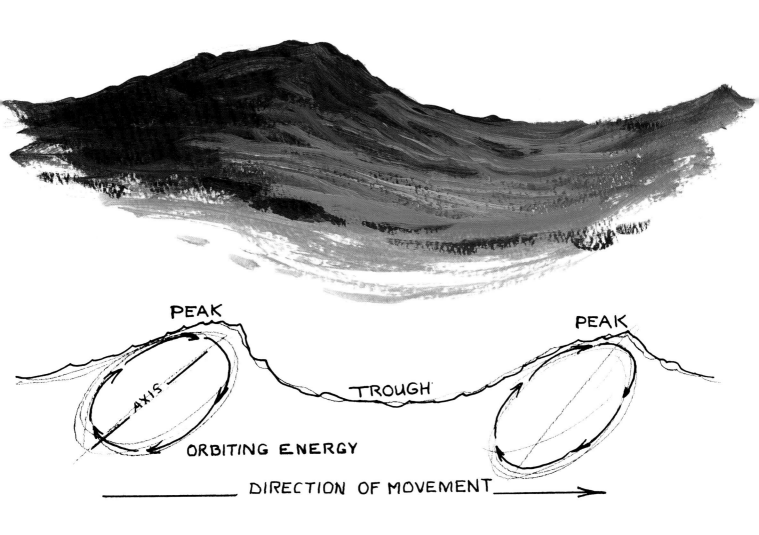

PEAK

PEAK

AXIS

TROUGH

ORBITING ENERGY

DIRECTION OF MOVEMENT

anatomy of swells

Once energy has been transferred to the sea it creates a unique shape that we call a swell. Here you can see a side view of what a swell may look like out at sea. Notice it has a peak with a trough on each side. The shape of the energy is elliptical and leans toward the direction of movement. It is much like an elongated barrel but tapering off on each end. The barrel rolls forward and pushes the surface water upward. It should be pointed out here that the water is not rolling and moving other than with the natural drift of the currents. The rolling movement is just the energy similar to when you ripple a piece of material by moving your arm beneath the surface. In fact, you could stand on a boat and drop a piece of wood overboard and watch as swell after swell moved by while the wood stayed in one place and merely bobbed up and down. Eventually, mostly because of winds and currents, it would reach a shore.

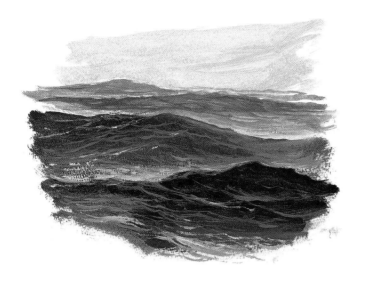

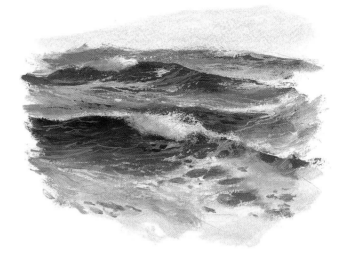

ripples on swells

This illustration shows several swells out at sea. Notice the trough between each one, and how each has a slightly different profile. The swells have similar shapes due to the energy form, but like humans, and trees, and everything else, each one is unique. With swells, this is due to the ripples that cover the surface and the amount of energy that has built it. Ripples are just tiny versions of swells and show up because they reflect the sky and sunlight. Notice that the trough is the lightest because it reflects the light and sky colors better than the more vertical face of the swell. There should be a gradual change from light to dark when painting the ripples with reflections.

swells with foam

When the wind comes up, swells often have their thin, leading edge whipped into foam. If it is heavy enough the foam may look like a breaker, but is not, and the swell will ripple right out from under the froth leaving a trail. Here, you can see both effects. The first swell has the foam of a preceding one riding up the face on the right. Notice there is more distance between these swells than the ones in the previous illustration. The distance between swells is directly related to the storm that created them — the swells are closer together near the storm and farther apart as they travel away from it.

learning point

Knowing the anatomy of a wave will help you in several ways: First, you won't make the mistake of giving swells and waves shapes that are impossible for the energy to create, Second, the anatomy dictates the action and, determines how the wave breaks from the top and aerates as it falls. It shows that the translucent area can only be in thin water and how the wave face is distinct from the roll because of the movement of the energy.

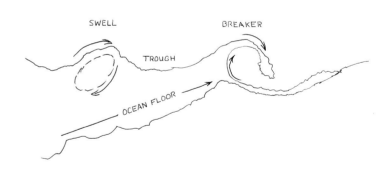

swell to breaker

Eventually the orbiting energy moves near shore and touches shallow water. When this happens the orb of energy is pushed higher than the surface water can support and it breaks. This is the creation of the breaker, the crashing wave we all love to paint. You will notice here that the movement of the energy tries to continue and draws water up from the surf while the top breaks forward. There may be a tunnel of air from the break, an area surfers call the "pipeline". By surfing on water that is moving upward, they can stay in one spot for some time. In any case, the breaker is no longer a swell and is finally moving water with more special qualities which we can easily understand.

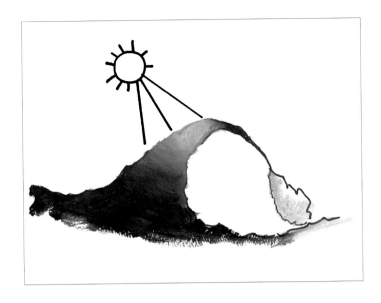

translucent water

This illustration is exaggerated to make an important point. The side view shows that the water can only allow sunlight through where it is "thin". The base of the wave is much too dense for light to pass through but you can see that the dark water *gradually* becomes lighter as the thickness diminishes. Keep this in mind and avoid making the entire wave face translucent.

the breaker

This illustration shows a typical breaker just before it collapses into froth. The face of the wave on the left is water being drawn upward from the movement of the energy. The highest point of the swell breaks first and is falling forward. As the water peels over it mixes with air, or aerates, and when it crashes to the trough it is mostly white foam. Notice that the wave is quite level at its base but the upper edge has tapered off to near nothing on the side. This would be true of the other side of the roll as well. Remember I said the orbiting energy was like a rolling barrel but with tapered points on each side.

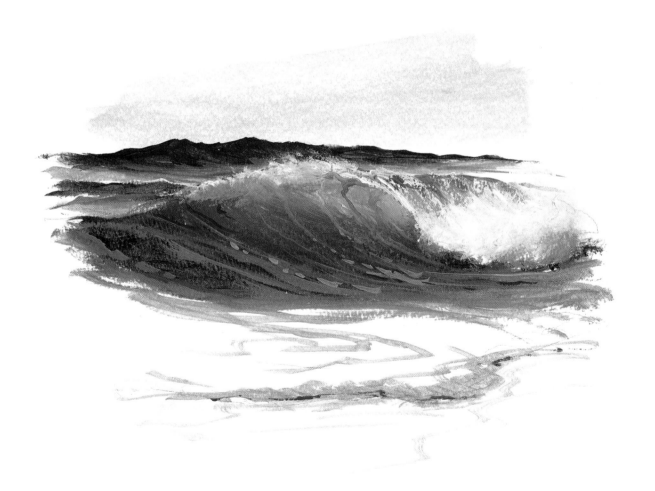

painting a translucent wave

Now that you understand what creates the shape of a swell and breaker, you will find it a lot easier to paint. The following steps should make it even easier.

a rough outline
We are showing only one side of a wave and the breaking foam. Start with a rough outline as shown. Don't make it too humped up and keep the base fairly level. Make a mixture of viridian and ultramarine blue and scrub it into the lower one third of the wave face. By scrubbing, I mean using a scrubbing action of quick, short, strokes rather than the careful back and forth strokes used for painting walls. Please note: white is not used at this stage.

the next third
Now you may mix a little white paint into the blue-green you mixed for the base of the wave. Again, use a scrubbing motion and painting upward create the next third of the wave. You may also show a few strokes of this color at the top of the roll. If there seems to be a line or contrast between the dark base and the middle area, blend it by brushing back and forth over the line where they touch. Be careful not to blend too far or you will either lose the clear water at the base or make the middle area too dark.

"I had attended art school a few years earlier and knew the importance of understanding human anatomy in order to better paint the figure. I realized that I needed more information about the sea"

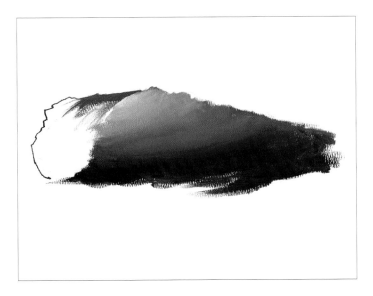

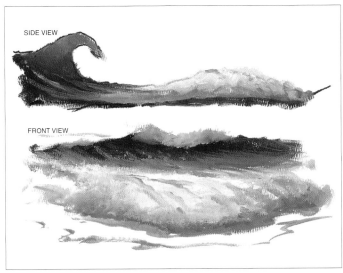

the upper wave

For this final step make sure your brush is clean then add more white to the blue-green mixture and paint it into the upper clean area. Again, you will have to blend where the areas meet so there isn't an abrupt edge or different value. Blend carefully but don't keep on blending or the effect of the translucent water will be lost.

Translucent water is best shown and most effective if the base color has no white in it. The gradual change from dark to light is due to the change of thickness as you saw previously in the translucent water illustration on page 27. There will be more studies and variations of painting a wave in other chapters but this should get you started.

wave scud

Once the wave collapses it forms a moving blanket of foam and froth I call "scud". This illustrations show both the side and front views of an incoming wave with a collapsed wave out in front. Pushed by the remaining energy, the scud moves onto the beach as far as it can, then recedes back into the surf to be met by the next breaker. This is the end of a long journey; a journey of energy that finally resulted in a change of action from a swell to a breaker. There will be more lessons to learn about the water but if you are just getting started with seascape painting the best thing you can do at this point is practice the three steps for painting a translucent wave. Keep at it until you feel you can paint it without referring to the book and are sure the water looks translucent and not muddy from overworking. You will be amazed at how quickly you will be able to accomplish this.

"Translucent water is best shown and most effective if the base color has no white in it. The gradual change from dark to light is due to the change of thickness"

sunlight, shadows, and atmosphere

Certain elements create harmony and unity in a painting — direction of light, shadows and atmosphere. You must learn how to recognize them and how they effect everything in the work.

Too often I see paintings that are well executed in technique and detail but are flat and lack warmth. In most cases they could be much improved with knowledge of sunlight and the shadows it creates, and by understanding atmosphere, which is usually influenced by the sky.

All subjects, whether they are waves, rocks, bluffs, or beaches are incomplete without the influence of the surrounding elements. Water in itself has no color — it is a reflecting surface and all other subjects reflect as well. It is this exchange of elements that creates harmony and a feeling of unity in a painting. In the following pages you will learn how to recognize these elements and how they effect everything in your paintings.

the direction of sunlight

Before you begin a sketch or a painting one of the first things to determine is where the sun is located. Without this you will have no idea where to put shadows or what colors to use. In fact, the position of the sun will also determine the values of your composition. (We will go into depth of color and composition in chapters 7 and 8.) There are five choices for position of the sun and the lighting condition it creates:

five light conditions

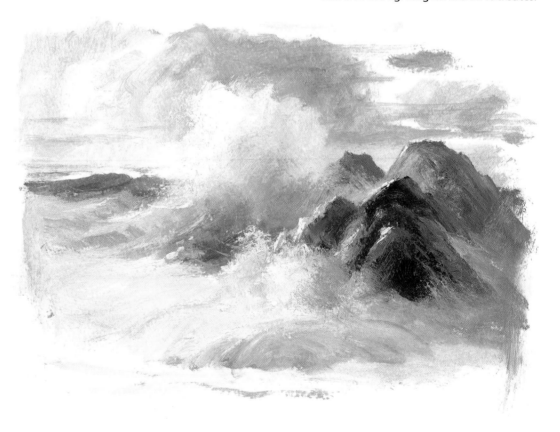

1. side lighting

Side lighting means the sun is off to one side as you look out to sea. It can be from either side and may be low or high depending on the time of day or the time of year. In this example the light is from the left and the shadow cast by the sun is on the right. Notice this effect applies to the clouds and rocks as well as the wave and foam burst.

2. front lighting

Front lighting happens when the sun is behind you as you look out to sea. This tends to create a flat, washed out look unless you break it up in some way. In this example I have avoided flat lighting by placing a dark rock in front of a portion of the wave. This not only changes the color and value but the rock casts a shadow which further changes the wave. The clear water would be a flat green were it not broken by some glitter and a foam trail.

3. back lighting

This is one of the most popular lighting effects in seascape painting and happens when the sun is directly in front of the viewer. It creates drama with light in the background against a shadowed wave. It is also the one time when the water is truly translucent. The sunlight can pass through the thinner portion of the wave and directly into your eyes. While there may be some translucent effect with other lighting, it won't be as strong. Notice in this example how the light barely touches the tops of the waves and foam, and not at all on the shadowed wave face.

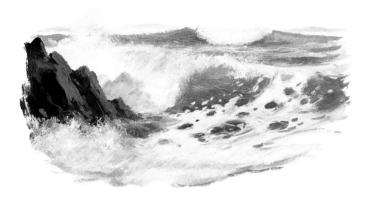

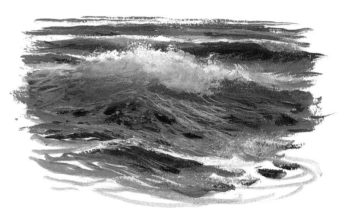

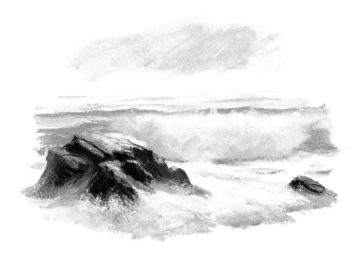

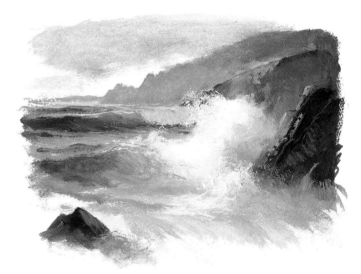

4. down lighting

This is another example of lighting that may wash everything and create a flatness. The sun is directly overhead and touches everything equally. However, there are times when that effect is desirable. As long as something, such as a rock, or bluff, or a cloud shadow breaks the monotony, the overall effect can be hazy or sunny. In this example I placed a rock for contrast and it too, is a reflection of the overhead light.

5. spot lighting

Spot lighting isn't my invention; Rembrandt beat me to it, but I love the effect and use it frequently. All that is required is a cloudy sky, whether it shows in the painting or not. Rembrandt would cast light on only one of several faces from a window high overhead that may or not be seen. You can always justify spot lighting in the same way; a hole in the clouds allows sunlight to pass through. You are the master here, you decide where it will strike. In this sketch I could have highlighted any of several places for a center of interest but chose to let the light strike the foam and a portion of the bluff.

creating shadows

Shadows may be thought of as the opposite of sunlight for two reasons: one, they fall on the opposite side of the object struck by sunlight, and two, they are opposite in color. (We'll discuss the colors of sunlight in chapter 7.) Shadows are essential to a painting because they create contrast, they break up flat-lighted areas, diminish interest where it is not wanted, and add harmony to the colors used throughout the painting. It is important to remember to locate the position of the sun first because that determines where the shadows are cast. Notice here how the angle of the light changes the length of the shadow. Keep in mind that shadows are transparent. That means they are neither black nor very dark. Also bear in mind that details can be seen in a transparent shadow.

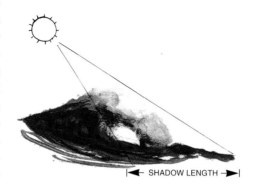

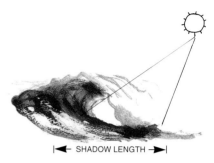

|◄— SHADOW LENGTH —►|

|◄— SHADOW LENGTH —►|

atmosphere

Atmosphere can be two things: It can mean the overall feeling or mood of a scene, or it can mean the amount of visibility shown due to the density of the air. We will touch on mood later in chapter 8. For now, let's look at atmosphere in terms of the sky.

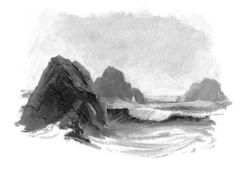

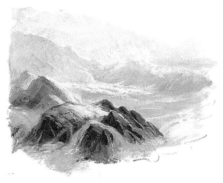

moisture in the air

The amount of visibility in any scene is determined by the amount of moisture and other particles in the air we breathe. When there is a lot of moisture in the air the sun's rays are diminished and objects appear lighter as they recede in the distance. This is also called aerial perspective. The amount of density determines just how much you can see. In this example there is not a lot of density but notice how the rocks fade into the distance nevertheless. All three rocks are the same color but the second rock has some of the sky color mixed into it and the third rock has even more. Don't use white alone to lighten objects, use the color of your sky and everything will harmonize much better.

foggy weather

Fog is the maximum moisture content and it will vary from very dense to not so dense according to what mood you may wish to show. There is mystery in fog simply because it doesn't let you see everything in detail. Again, you are the master and you are the one to decide just how much of a scene to depict. There is very little contrast with a fog painting. The darkest value is up close and everything else fades into a void. As with any atmospheric effect, you must decide the color of the atmosphere *first* because that is the color you will use to diminish or tint all other colors that must fade away. Again, don't use just white to lighten the colors.

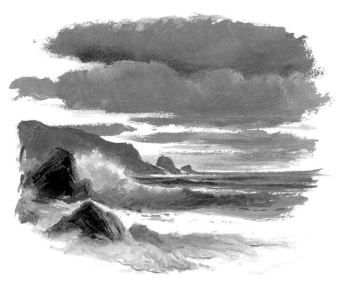

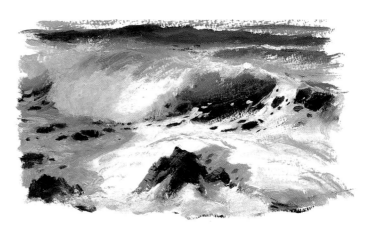

cloud shadows

There are endless formations of clouds and they may be wispy and thin, or heavy and dark with rain. In any case, as mentioned before, they give you reason to cast shadows wherever you need them. In this example I chose some dark, rainy-looking clouds. They cast shadows over nearly all the background. I did this because I wanted all the interest to be in the foreground. Even the first rock and foam are in shadow, with sunlit foam behind. This is also an example of spot lighting.

rock and bluff shadows

Rocks come in all sizes and shapes so you may choose exactly what you need to cast a shadow where it will do the most good. Bluffs are just as important to your plan. If you need a large foreground shadow that could not be created by a cloud then a bluff can to the job. Whether it shows in the composition or not is your choice. In this sketch I chose to have a rock that cast a shadow on the foamy surf. It helps to break up the otherwise flat sunlight. However, I chose to hide the bluff from the viewer because I didn't want another dark object on the left. The shadow from the bluff works well to diminish the detail and interest where I didn't want it. Notice both shadows are transparent. You can see a slight variation of color, as well as the holes of clear water that show through.

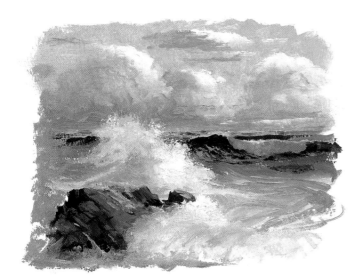

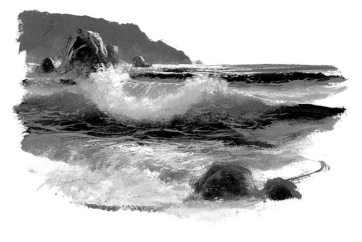

cloudy weather

Clouds that are influenced by sunlight and shadow will have a direct effect upon the sea. Their own colors will reflect off the water if they obscure the sky from doing the same thing. If there are enough clouds then they, instead of the sky, will be the atmosphere. In this example notice how the colors of the clouds and the sky are both used for the rest of the painting. By reflecting sky colors on the sea and rocks you automatically have color harmony.

clear weather

When there is little or no moisture in the air we see everything much clearer, even at a distance. Even then there is some aerial perspective and some fading. This is usually a clear sky day and all objects stand out sharply. In my sketch, I haven't shown a sky color but notice how sharp the edges are in the distance and how clear and detailed are those in the foreground. There are times when this is the atmosphere you may wish to show but remember that less detail may be better. It is not necessary to show photographic detail beyond your center of interest unless this is your chosen method of painting.

reflecting light and atmosphere

Water is generally a clear substance and acts like a mirror unless disturbed or covered in some way. It therefore reflects the sky above, bluffs, rocks, headlands, and even the white foam and spray of a wave may be reflected in the trough. Let's look at just which areas will reflect and which will not.

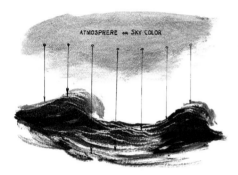

waves and troughs

The sky overhead reflects off the horizontal surfaces rather than off vertical ones. When a swell or breaker rises there is a gradual change. The reflection is strong in the trough but fades gradually into none at all as it climbs the face of the wave. Most reflections therefore, will be in the troughs but the top or the roll of a wave will also face the sky and will reflect its light and color.

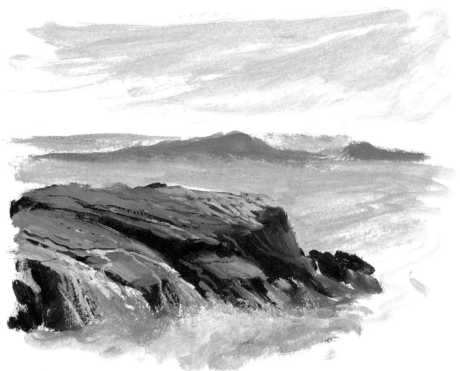

wet rocks

When rocks are wet they will also reflect what is above. In most cases it is the sky but sometimes they may reflect the white foam of a breaker or even another rock. This is usually more the case with foreground rocks. Distant rocks don't show as much of their tops and they show less detail as well. First, the base color of the rock is determined and painted in. Then, the sky color is determined and added to the rock color thus changing it. Keep in mind that if the sky overhead is blue, it will be darker than out toward the horizon line. In this sketch notice that the outer end of the rock is dry and doesn't reflect the sky. The wet portion of the rock is nearer and a bit lower and therefore reflects more fully.

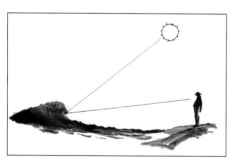

the mirror effect

The mirror effect is not the same as reflecting atmosphere. I refer to the mirror effect as a reflection of the sun itself. In order for this to occur the sun must be behind the viewer who is facing the sea. And the sun bounces off clear water directly into the viewer's eyes. Of course the angle of the water must be in relationship with the viewer in order to be seen. Nevertheless, it can give an added point of interest to any seascape.

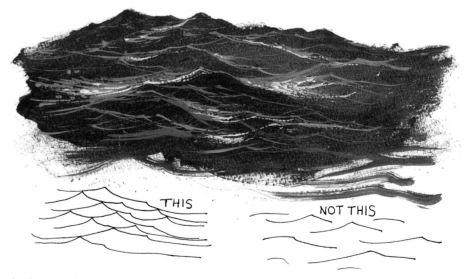

ripples on clear water

Water is rarely a smooth glass-like surface. Its surface is nearly always rippled in one way or another. Ripples can also reflect what is above. However, there is a trick to doing them. Too often I've seen attempts that just looked like a bunch of lines in different directions, or, worse, like white worms crawling in the wave! Here's how to avoid that: first, make sure that each line is a thin scallop that rises and falls; second, each little series of scallops must touch, if not, they are disconnected, and you know what that means. In this illustration I have used the color of the atmosphere but have also varied the reflections by glinting sunlight off some ripples.

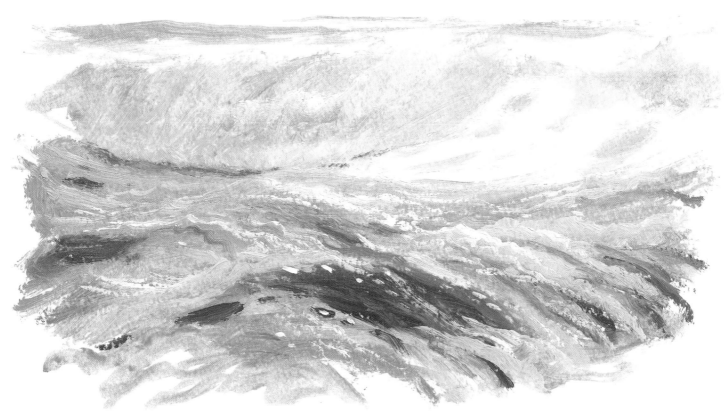

reflections on a foamy surf

Foam doesn't reflect as much as clear water but is still influenced by sunlight and atmosphere. It is important to study foam because it has several characteristics; It may ripple, fold, swirl, bubble, or boil. If you understand these, then it is a simple matter of showing them with reflected light. I generally paint the foam, even the lightest foam, a bit darker than pure white. That way, I can paint in lighter strokes that show the different contours. As with any area of interest, it is important to break it up between sunlight and shadows. In this example I have used down lighting and have shown some ripples as well as the contours of minor swells.

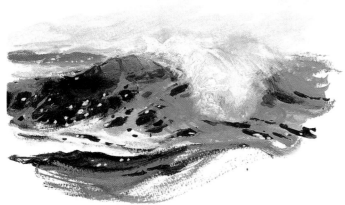

sparkle

One aspect of the mirror effect is sparkle. The light of the sun glints from a rippled or uneven surface creating dots of lights. Some call these "spectral highlights". In this illustration I have used them to sparkle up some dark water. Notice that they do not occur in shadowed areas or in anything but clear water. Caution: use sparkles sparingly or they lose their effectiveness and look like a case of white measles.

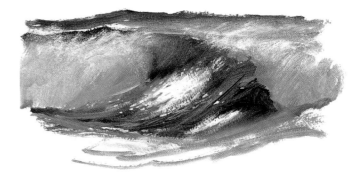

glare

The other mirror effect is glare and it can only be seen on quite smooth water. The trick to painting a spot of glare is to have a very white area against a dark, clear wave. The center of the glare is the lightest and smoothest with the outer edges breaking up into a scattering of tiny sparkle. One or two little ripples, as long as they are not too dark, can be in the glare but mostly it should be undisturbed. Some artists use a painting knife to apply the paint because a smoother application reflects better. Again, caution is the word! One, and maybe one smaller touch of glare will be enough, otherwise the effect will be lost.

chapter 5

rocks, headlands and beaches

These elements are important but make sure they don't steal the scene.

I have often been asked why I don't paint seagulls in my seascapes. I have a ready answer: I think of my seascapes as *portraits* because I usually focus on a wave with its unique shape, form and detail. It is like painting a portrait of a person — you wouldn't place a butterfly on the nose of the subject because it would attract all the attention. Of course, a panoramic scene with a wide vista is different where an individual wave would probably not have as much attention.

Focusing on a wave as the "star" in the scene puts the other "actors": rocks, headlands, beaches, skies and other objects, in supportive roles. However, each role is important and must do a credible job and be in harmony with the star. Some objects may point to the center of interest, some may give the contrast needed for it to show up well, the sun and atmosphere control the lighting and the temperature of the scene. Foam patterns and textures help to individualize the wave and make it important. Now let's study the "supporting actors".

rocks

Rocks are often the most important support to the wave because they provide contrast. They also balance the movement of the wave by being solid and unmoving — the edges of the wave are soft and wispy, whereas the rock provides hard edges. Rocks also allow a choice of colors to balance those found in water. In chapter 8 we will explore their use as lead-ins as well.

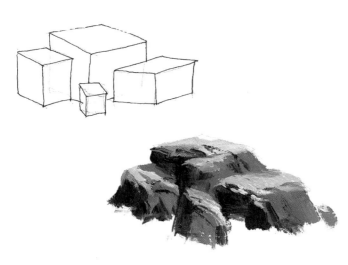

block to rock
The shape and colors of rocks will vary from place to place but they all have something in common: they have distinct tops and sides. Too often I have seen students painting rocks that looked more like potatoes or biscuits because their shape was too rounded and they had no sharp edges. Of course, rounded rocks area possibility but they give no contrast to the soft-edged waves and should seldom be used.

One of the best ways to study rocks is to find a small version of the real one and take it back to the studio. Place a light on it and paint it from different angles. Notice that the rock can be broken down into block shapes with distinct tops and sides. It is a good idea to make each block a different size as well. Thinking in these terms should help you to avoid "blobs" and help you add character to your rocks.

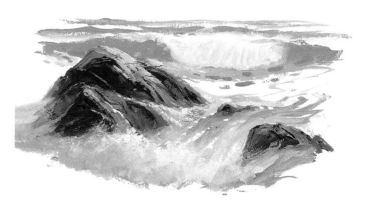

rounded rocks
Just so you will understand that rounded rocks can be used, especially if they are in your area, there is a way to paint them and still make them look rock-like. The trick is to avoid lumpy rocks, so make sure there are some hard edges, even though the overall shape is rounded. Also notice how light and shadow gives the appearance of tops and sides. To avoid a pyramid look, be sure that one side of the rock is longer than the other.

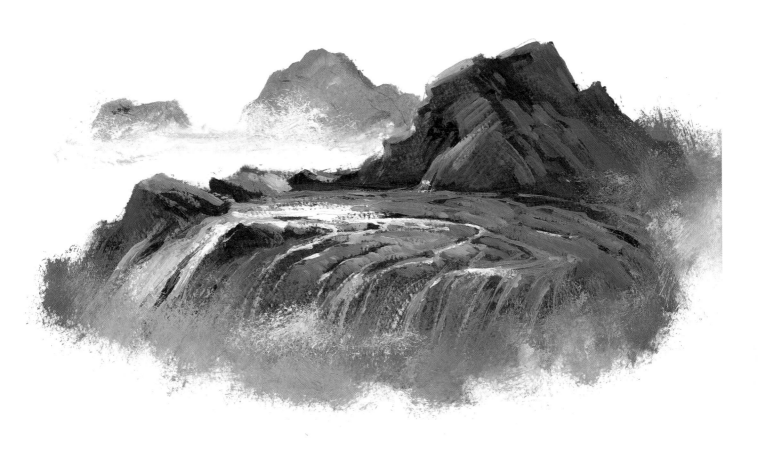

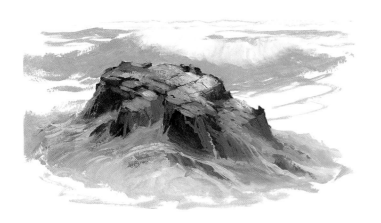

angular rocks
I prefer to paint angular, sharp edged rocks. Notice how the rock is in contrast to the wave. In this case, it is the star because it commands more attention. It is larger, darker, more colorful and has more detail than the wave. It is also playing its usual role of contrasting hardness with softness.

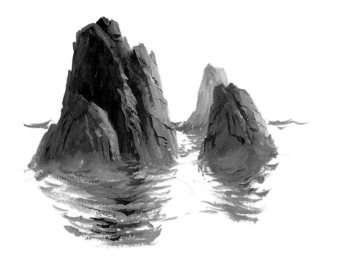

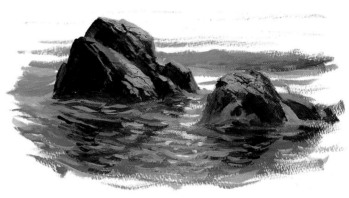

vertical rocks

Some areas will have vertical shaped rocks or you may choose to use them with a particular composition. Vertical rocks don't often have tops so their shapes must be distinguished by light and shadow. Even here, it is a good idea to show hard, angular edges. Another important note for any rock shape: these rocks were painted entirely with their base color and then broken into distinct shapes with the reflection of atmosphere. Notice how the light created distinct sides on the outer as well as the interior edges. When doing this be sure to vary the interior shapes to create a more interesting rock. After the light and atmosphere has been laid in, you can add texturing with cracks and irregularities.

rocks in clear water

The surf is rarely glass smooth so it is unlikely conditions would create a mirror image of a rock. Here we see a rock in slightly choppy water. Notice that the color of the rock is reflected downward and broken up by the small chops of the surf. The reflected area is a mixture of the rock color, sky color, and color of the water but the rock color dominates unless the water is more agitated. In that case there will be more sky and water being reflected. We look at rocks in foamy water on the facing page.

"When a wave collapses over a rock or group or rocks, it will momentarily take on the shape of those rocks."

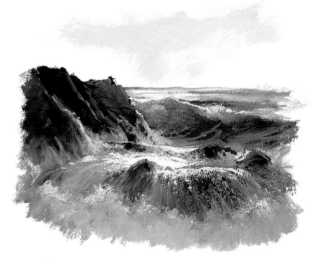

overwash

When a wave collapses over a rock or group of rocks, it will momentarily take on the shapes of those rocks. Here and there you may see the tips of the more pointed rocks with a more level wash over flatter ones. The more level washes of water will reflect the sunlight and the sky but the overflows will not. If the overflows are clear and thin they will allow the rock color to show through, but heavier foam will be white and either in sunlight or shadow. Here you can see large rocks above water and three smaller rocks poking above the overflow. There is a strong glare of sunlight on the flatter area of water. Notice the collapsed wave has flowed over the foreground rocks and then splashed upward, much like breaker foam. This is because it has struck the surf below and mixed with air as it bounded upward.

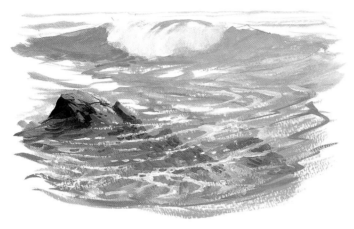

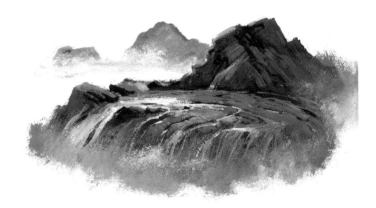

rocks under water

Sometimes the water is so clear that you can see a rock both above and below the surface. To show this effectively, you must follow these steps: First paint the rock above water; then, paint in the color of the water; next, paint the rock below the surface with a blend of the upper rock color and the water. Below the surface the rock will not have details or much sunlight and shadow.

To really give the effect of "under water", run the rock in one direction and then paint some thin trails over it, but in the opposite direction, as I have done here.

rocks in foamy water

It is important to avoid making rocks appear as if they are floating on the surface. Believe me, I have seen that phenomenon in more than one painting! Whether the rocks are in clear water or awash with foam, there should be the feeling that they go below the surface. With rocks in clear water, there is a line of thin foam or just a color change as shown on page 38. In foamy water here, the rock color blends a bit with the water at the base and the water sweeps up on the rock, which erases the base line that would have been there. In other words, do not have a distinct, sharp line between the bottom of the rock and the water below it. Blend the two colors and also show a little spray to soften the lower edge.

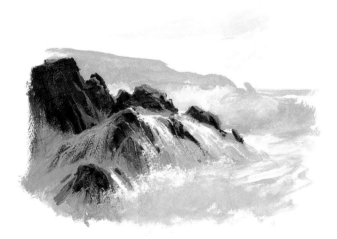

water spills

The moment after the wave collapses and overflows the rocks, more rock shapes are exposed and the water gushes heavily between the foam. Use sunlight and shadow to distinguish tops and sides just as you would with the rocks. This also shows the shapes and forms below the water. Again, as in the previous illustration, thinner water allows the rock color to show through. Also notice that there is still enough power in the falling water to show spray bouncing back from the surface.

trickles

After the initial overflow and the spills that follow, there is very little water left. The remaining water follows small cracks and valleys and trickles off the sides. Trickles may meander or leave small pools in depressions. Paint them in with light and shadow areas and show a dark line that indicates the side of the crack or a light line to show light edges. Trickles should be used sparingly. Too many will give a busy appearance and may look more like an overflow. Also, never stop falling water part way down. Whether it is overflow, spills, or trickles, once water falls over an edge it will continue falling until it reaches the bottom. The only exception is when water falls on to another rock, which may split up the water, but the additional trickles will continue to fall.

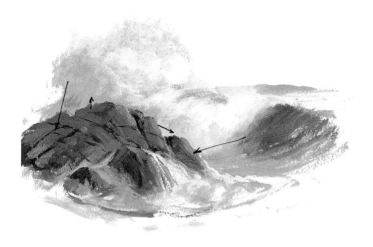

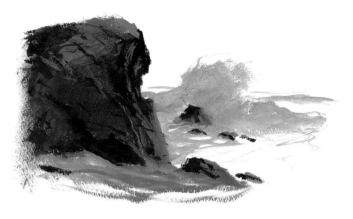

color exchange

Another way rocks can be used is to reflect their color onto other objects. Here, the warm sienna color reflects onto the white wave foam and gives it a warm glow. In this exchange, the color of the water and the shadowed foam reflect back on the wet rock. This is a way to create color harmony where you need it in a painting, as well as add interest to a focal point.

defiant rock

Rocks can bring mood into a painting when needed — just their shape alone may do it without your realizing it. For example, soft edged rocks are less threatening than hard edged ones; brightly colored rocks set a happier mood than somber, gray ones, and how rocks are placed against waves creates other moods. Here, a small, soft edged wave is about to meet a large, hard edged rock. The mood suggests the rock being defiant, or resisting the power of the sea. Notice its shape. The rock is dark and appears to be dug in at the base. It has an almost bull-headed appearance and the wave doesn't appear strong enough to batter it. Compare this with the illustration below.

overwhelmed rock

What a different mood this illustration has from the last one! Here the wave is large and looming and the rock is rounded and flattened down. It is about to be overwhelmed and appears to be shrinking from the attack. The mood created here shows the power of the sea over the land where previously the land resisted that power.

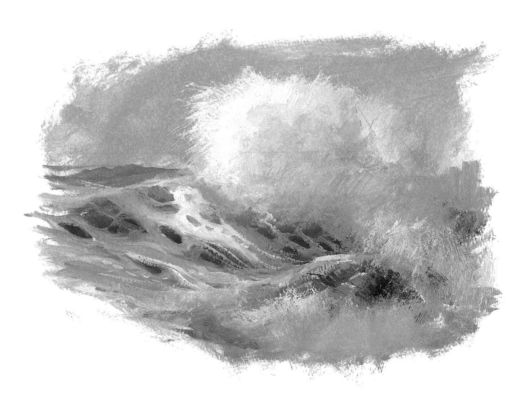

learning point

We will discuss mood much more in other chapters. It is important to understand this because it is so easy to put in the wrong colors, shapes, sizes and positions with objects and destroy the mood you wish to convey. For the present, just be aware that mood exists in everything you paint.

headlands

Landforms that reach into the ocean are called headlands and they will vary from place to place. In some areas they are almost entirely rock, or lava, as in the case of Hawaii. Some areas have tree-covered headlands and others are bare, grassy mounds. In any case, headlands are a part of seascapes and can be used for mood as well as interesting composition.

staging for distance

Headlands can be used to show stages of distance. Here the foreground is dark, the middle ground is quite a bit lighter, and the headland adds another value between the surf and the sky. If the headland were not there the white foam would be lost against the light sky. There may be times when you want a subtle change and times when you want great contrast. Placing an intermediate form such as a large rock may not always be the answer, so a headland may be used. When atmosphere is used to lighten the distance, a headland offers another stage for another value. This is using aerial perspective to good effect.

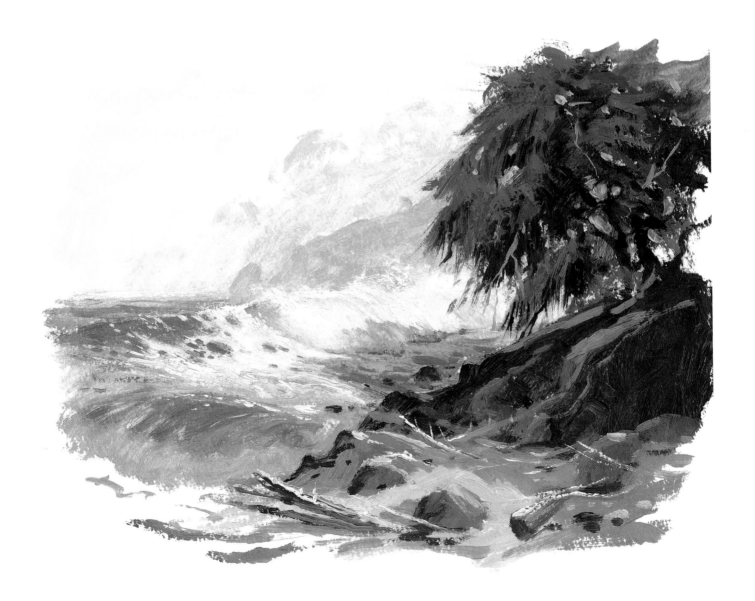

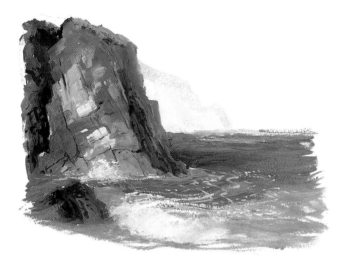

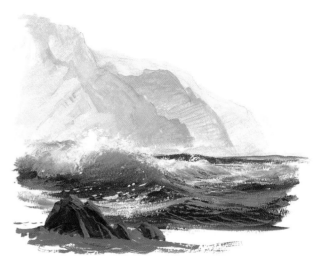

the bluff

Bluffs are between rocks and headlands in a composition. They are not free standing, as a rock may be, but come into the picture from one side or the other, as does a headland. This bluff is made so interesting because of its color, light, and shadow, that it has become the center of interest. If I had wanted the wave to be the focal point I would have played down the interest of the bluff and built up the wave so it was larger, with more contrast and had more attention to detail.

light headland

Using a light headland with a light sky is an easy way to break up a large area and still keep it light. The same would be for any value area. In this painting, the headland adds atmospheric interest only. It is not there to give contrast to the wave which has its own. Imagine how much light sky would be there if it were not for the headland!

dark headland

Using a headland as a dark staging area gives the most contrast to a light wave. This sky might give enough contrast, but the headland gives more and acts as a step between the wave and the sky. An added dark rock helps to define the center of interest. This headland is the same color and value as the nearest rock but has been lightened with the atmosphere — the color of the sky. See chapter 4 for more information on using atmosphere.

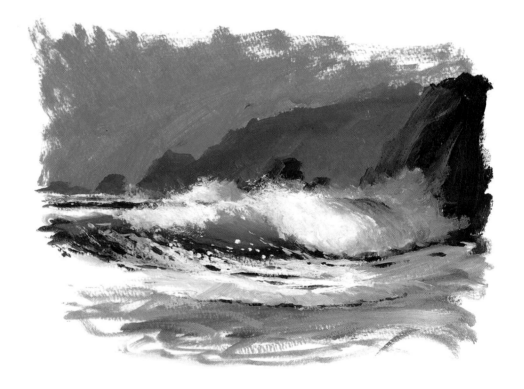

beaches

Beaches can be an important part of a seascape if that is what you want. If most of the painting is made up of beach, rocks and headlands, then you are painting seascapes with a shore theme rather than seascapes with a wave theme. That is perfectly all right if that is your desire. Some artists have made a career of painting fantastic beach paintings with people, tide pools and a fascinating attention to the leading edge of the water as it washes ashore.

water's edge

The end of the energy's journey comes with a last wash up on the beach. It pushes up as far as it can go, then backwashes to the surf to be pushed up again. Several things happen that are fun to paint: 1. The foam washing on shore may be thick and frothy at first and it takes light and shadow to define it. 2. The foam thins out as it reaches its end and splits up into holes or patterns of foam. 3. After all the water has receded, the beach has a line of foam and sometimes bits of debris that outline the shape of where it had been. Pebbles and small rocks appear in the last two stages as well.

In this illustration you can see all three stages as they might appear. The pebbles are few because too many would attract more attention than I wanted for this scene. Also notice there is a thin, lost and found dark line under the foam. This gives a base and defines the difference between the shadow side of the foam and the shadow cast by the foam.

wet sand

I love wet sand in a shore painting. I call it the "slick" and use it to reflect sky, rocks, people and breaking waves. The slick is a sheet of thin, clear water as opposed to foamy water. It acts like a mirror to anything above. You can see here that the large rock appears only in the slick area which is also reflecting the sky. The foamy water moves in and breaks into that mirror effect and covers any reflections. The foreground sand may also be wet but not enough to be reflective. Instead, I have shown it with water ripples caused by former surges of water. Adding a few small rocks and pebbles also helps to define the slick area as wet.

beach outlets

Small creeks and water runoffs make their way across beaches to the surf. They can add a lot of charm as well as break up large, uninteresting areas. Outlets, unless they are tiny trickles, may be painted the same as you would a slick. They reflect everything above them. Here, I reflected a large and a small rock and the lightness of the sky. There are a few dark pebbles in the middle ground but I softened the foreground pebbles in value and color so they appear to be under the water.

I use outlets to add interest or break up large spaces but they are most useful as lead-in paths to a center of interest. In fact, avoid having them lead away from a focal point. That would be like an actor taking attention away from the star.

driftwood

Many beaches have driftwood. Some pieces are so interesting they could be a subject unto themselves. In most cases, I use driftwood to add interest, or to point to the center of interest, or to break up uninteresting space. It is important to play down their shapes and textures unless they are the star, otherwise they will detract from the true star of the composition. Study driftwood carefully before painting it. Like waves and rocks, driftwood may have personality of its own and add a mood you may or may not like.

chapter 6

foam and spray

As your wave makes its final journey to the shore, it hands you the gifts of foam and spray to do with as YOU will.

As you know, the swells, waves and surf we love to paint are the result of moving energy that gives them their shape. Other influences, such as wind, currents, storm activity and the final breaking of the energy, will alter those shapes. The sizes may vary according to the nearness or amount of power that created the waves but most surface changes are due to foam and spray. Wind whips at the edges and causes froth, the falling water of the breaker thins out and mixes with air, and any agitation will do the same. Foam and spray are both the result of aeration, the mixing of air and water.

Foam, spray and foam patterns add limitless possibilities for enhancing seascape compositions. In most instances, foam creates a light area against a darker background. Wind whipped spray gives a sense of motion to the moving water. Foam patterns can break up large, uninteresting areas or they can be used like pathways that lead the eye. As you paint, you will find even more reasons to use foam and spray in your paintings.

whitecaps

Wind can whip up spray on swells at sea or breakers on shore. Out at sea, or beyond the nearby surf, the foam on the leading edge is often called "whitecaps". If there is a lot of foam and strong surface winds, the foam may blow away in long streamers called "mare's tails". Sometimes the wind just churns the leading edges and the swells move out from under it. This leaves thin blankets of foam, in what I call foam patterns. Here I have shown two swells moving in different directions, but notice how the wind sends the foam off in only one direction. There are some foam patterns in shadow under the larger swell. When you are painting swells in the background of your composition keep the whitecaps to a minimum or the area may become too busy.

When the energy that created the swell begins to collapse into what we call the "breaker", different types of foam are created. The following illustrations will show these different forms.

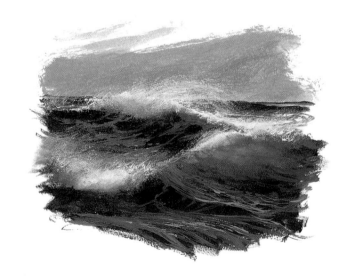

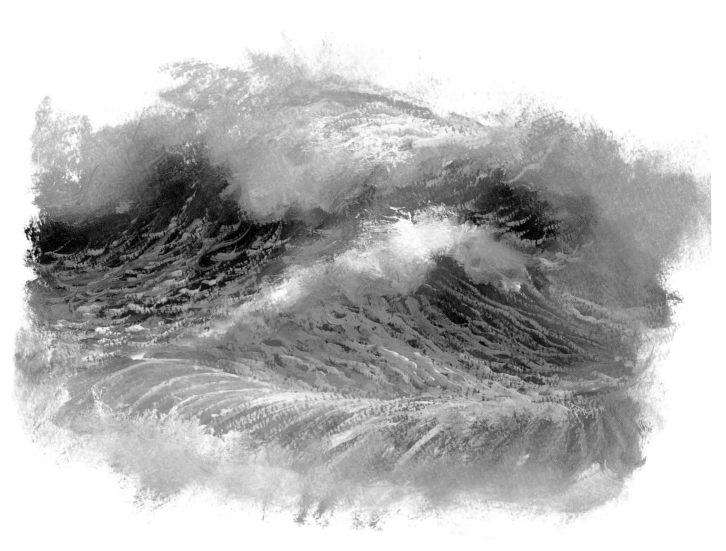

lace curtains

I call this effect the "lace curtain" because the foam falling from the top edge has spread apart making a lacy pattern. Note that the lacy look on the left is distinctly different from the breaker foam on the right. The lace curtain effect can be used on any edge of foam falling forward because it is already foam. The breaker form, on the other hand, isn't created until water falls and aerates. You can see that the wave color was already in place before the stringy lines of foam were painted over it. I usually use a small brush on edge or a rigger brush to paint thin foam lines.

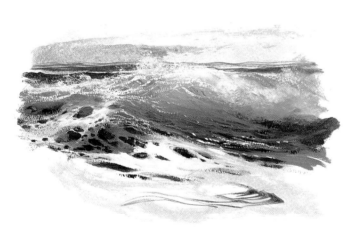

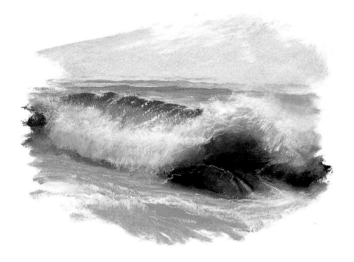

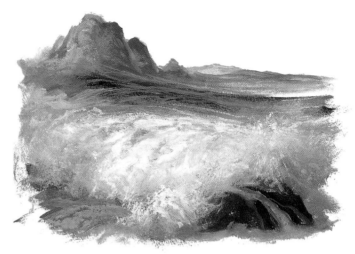

foam over a rock

First of all, please notice this example of a breaker is the same as the breaker on this page bottom right. It is seen from another angle but still has the same features as the one below. The difference is the way the wave is coming over a rock. Just before the wave collapses it creates a sort of cave and when this is over a rock, there are certain features of foam that can be used. First of all, I make sure the back portion of the rock and water is blended together and in shadow. Then, I paint the foam on the upper edge of the wave. In this case, I used some lace curtain effects and some soft edged wind whipped foam. Allowing some of the spray to fall over the rock makes it seem further back than the spray.

the roll

This illustration focuses on the falling water of the breaker. There are several things to be aware of:

1. The top edge of the water is dark green then lightens downwards because air has mixed with it.
2. There are spots of foam at the top that streak downward as the water falls. Notice these streaks are curved outward showing the rounded form of the roll.
3. The large mass of foam at the bottom of the roll is thick enough to obscure the water behind it. It is not only aerated from falling but also from hitting the trough and bouncing back up.
4. Observe that the edges of the breaker foam are very soft, and have almost no edges at all. I achieve this by dabbing the harder edges with the tip of a dry varnish brush or gently "whipping" the edges with the same brush.

collapsed wave

When the wave finally collapses the trapped air underneath can explode upward and then become roiling foam. There are still traces of the color of the water but mostly it is white foam, preferably in light and shadow. Notice that some of the rock shows through as well. This helps to define the foam as thin and somewhat transparent. The collapsed wave may not be as spectacular as the breaking wave but it can be used very effectively in a seascape. Collapsed waves are mostly found in the foreground so can be used to make that area more interesting. Sometimes I even feature one in a painting. (See the demonstration painting in chapter 10 called "Midday Fog".)

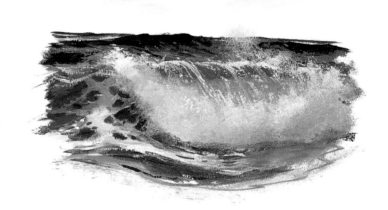

foreground surf

Too many times I have seen students paint a perfectly good wave in the middle area and then ask what should they do I do with all this foreground? The foreground is the surf and it can be alive with action. This area of collapsed waves creates different effects and it is necessary for you to learn them.

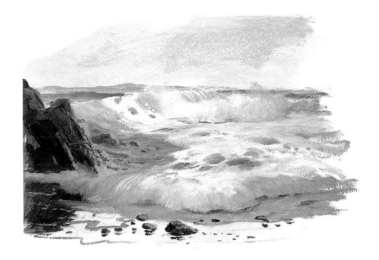

blanket foam

If the action is heavy from storm weaves, the surf can be very foamy.

When the wave collapses it continues to move as a thick blanket which gradually thins out and breaks apart. This illustration shows several things to observe about the surf. First, I painted part of it in shadow and part in sunlight. Next, I have shown the thickness of the blanket at the front by painting most of it in shadow and underscored with a thin, lost and found, line. Finally, I have shown a few holes in the foam where it is thinner and the color of the water can be seen. There shouldn't be many holes if most of the foam is thick. Each of these features can be used effectively to fill in an area that needs some attention to keep it from being uninteresting or even boring.

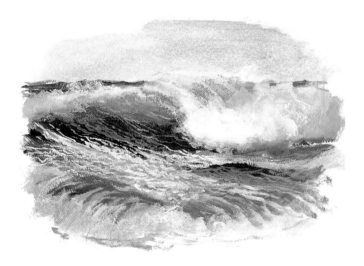

surface ripples

Sometimes the surface foam is thinner than in the previous picture, especially in the background where there has been time for it to dissolve a bit. Thin foam can be shown full of holes as will be seen in the illustration "holes for directions" on page 48, or it may be rippled, as in this illustration. Ripples are caused by wind, or the shattered energy that ripples the water. In either case, an effect of curvy, broken lines will appear. I use the side edge of a small brush loaded with paint and I wiggle it as I drag it across the surface. It is important to use a light touch so as not to dig into the underpaint.

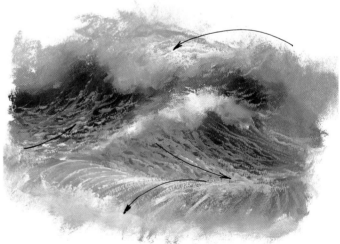

surface contours

One of the best uses of foam, whether it is blanket foam, ripples, or patterns, is to show the contours of the water below. Here I have used ripples in curving patterns to show how four directions of movement can be presented. At the top the highlighted ripples show the curve of the foam breaking forward. Underneath that wave I have used shadowed ripples to show the concave curve leading upward. The middle wave uses ripples and lines in shadow to show its contour leading to the right and the foreground roll uses foam lines to show the forward movement of the collapsing wave. When painting contour lines, always move your brush in the direction of movement.

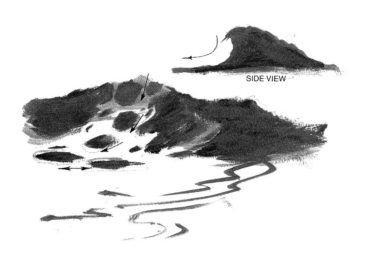

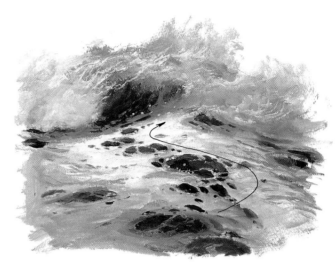

anatomy of foam holes

These lowly holes in foam are valuable assets to your painting. They help break up space, show contours, lead the eye, and add interest to your seascapes. They are rarely the star of the show but their supporting role is priceless. Holes, just like waves and rocks, have an anatomy of their own and it is best to understand this. First of all, there is perspective to consider, as shown here. Looking straight at a hole when it is in a vertical position gives a full view of its shape. Holes are never perfectly round but are more so when viewed directly in this way. As the hole is positioned further down the slope of the wave it starts to level off and the round shape is squeezed or slightly flattened .

Further down the face of the wave the holes are seen nearly level and the rounded shape now appears very flattened. The circle has become an ellipse. The other thing to remember is to make the holes follow the contour of the wave. Notice that the wave appears concave. This is because the foam trail curves to give that appearance.

holes for directions

In this illustration the blanket foam is thin and has split open showing the water through the holes. Rather than scattering the holes as might sometimes appear in the surf, I have used them as a direction lead-in. Their placement creates a path of sorts that leads the eye to the center of interest. When doing this, it is best to have different sizes of holes and a few spotted here and there outside of the pathway, otherwise the path would be too obvious. Did you notice the use of light and shadow and the lace curtain foam?

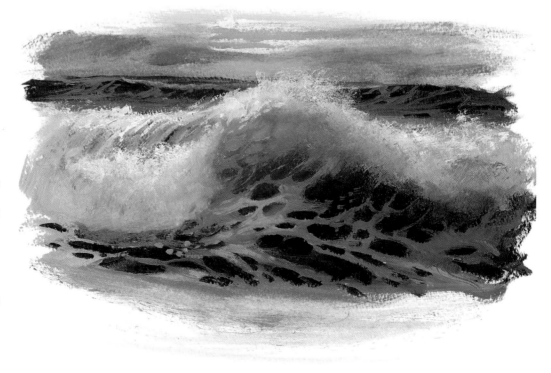

patterns on the wave face

When a wave moves into the surface area it picks up the foam patterns riding on the surface. Blanket foam is usually quite thin by now and full of holes. Here I have shown the foam on a breaker with warm back-lighting. The patterns have holes of different sizes and follow the contours of the wave face. The patterns are also in shadow but are reflecting the sky as well as the wave above.

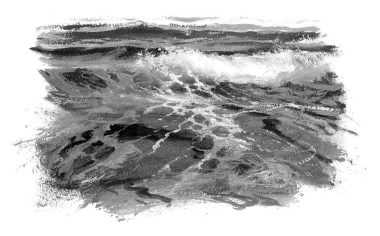

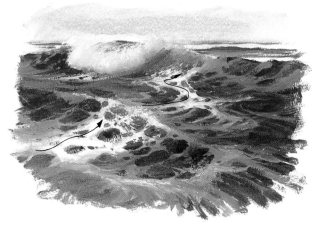

patterns over clear water

Sometimes when the waves are small and far apart, there is very little foam and a great deal of clear water. I like to paint the clear water without any white mixed in. I use my greens and blues in pure form and lighten them in places by thinning the mixture or wiping it down with a paper towel. Then I lay in two or three dark, curvy lines all in one direction. This will give the effect of underwater seaweed, rocks, or dark shadows. I then whip the paint softly with a dry varnish brush to remove any thick paint. Finally, I use a small brush, loaded with paint and apply the surface patterns over the water. I run their direction opposite to the underwater lines and that helps to define the depth of the water. Notice again how, I have used sunlight and shadow for my foam patterns.

patterns for directions

In the "holes for directions" illustration on page 48 I showed a series of holes in blanket foam that led the eye to the wave. In this illustration I have used a linear form of patterns, a trail of sorts, to do the same thing. This is the use of foam patterns over clear water when there is no blanket of foam. As you can see, there are more patterns than just a narrow trail but I have used sunlight to define the trail. Notice it not only leads to the wave but shows the contours of a minor wave and swell as it meanders along.

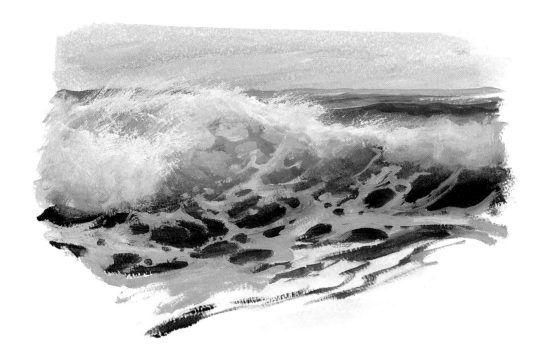

silhouette patterns

The same patterns on the face of the wave continue on the back side as well. They can only show up in the clear, translucent upper area of the wave and usually it takes backlighting to make them visible. Notice that the silhouette patterns are moving in a different direction from those on the wave face. That is because we are looking at the wave on an angle. To paint silhouette patterns, darken the color of the water they appear on rather than using another color. They are shadowing the clear water and preventing light from coming through. Again, use this effect cautiously to avoid a busy-busy wave face.

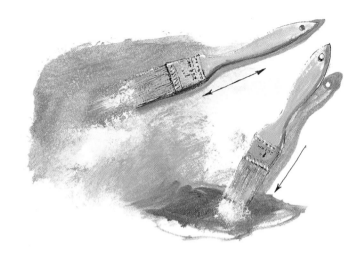

learning point

Trails, whether a series of holes in solid foam, or linear lines of foam, should take a slow journey to the center of interest. Nature is rarely in a hurry, and the meandering path is more enjoyable any day than the straight arrow that gets you there in a rush. You may also observe that the holes as well as the lines vary in shape and size and diminish as they recede.

spray and mist

So far we have looked into aerated wave foam, blanket foam and patterned, or trail foam. What is left is spray and mist, the last remnants of any foam scattered and aerated. It is usually without direction, mostly transparent, and has little or no definable edges.

dabbing mist

Painting spray and mist can be a problem. Too often I have seen a foam burst painted as a series of definite brushstrokes. The result, instead of looking like spray, appears to be a series of ragged brushstrokes. What I do is scrub in the basic shape of foam first, then dab the edges with a 1'' or 2'' dry varnish brush, depending on the size of the burst. Here the upper brush shows how it can be laid nearly flat and stroked back and forth to move and soften the edges of the foam. This takes a light touch with a lot of control. Don't keep going over the same spot too much or it will become muddied.

The lower brush in the illustration shows how you can jab the brush onto the canvas with white paint on it. This jabbing leaves behind a scattering of white that looks like scattered droplets.

mist over a rock

Here is the same wave featured in "the burst" opposite, but a moment later. Now the burst is a touch smaller, the buried rock hardly shows, and the burst is falling as mist over the front rock. I painted this in exactly the same way as the other illustration but then, using the dabbing technique, added more white droplets down over the green water and part of the foreground rock. Notice the spray over the rocks is without edges and is light enough for the rock to show through. This is where you dab carefully and do not go over and over the same spot which would create muddy water for sure.

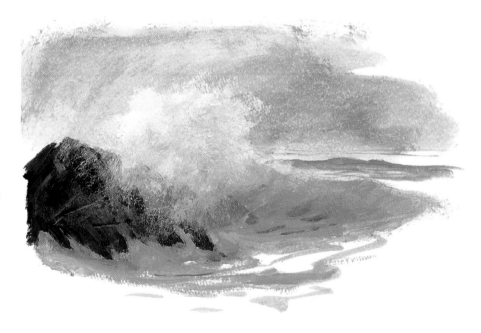

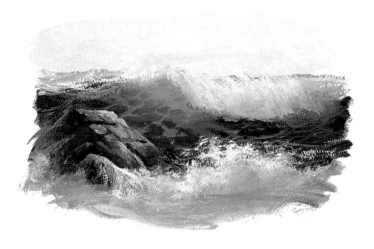

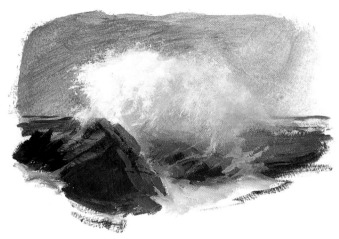

surf spray

Surf water or foam may fly upward because it has either hit a rock or has been whipped by the wind. I painted this effect by first scrubbing in the lower portion of the mist with the colors I needed. (In this case, a dab of ultramarine blue and viridian into white.) Next, I dabbed in the edges with white paint using the method shown in the previous illustration, dabbing with white paint on the tip of the otherwise dry varnish brush. I left no hard edges and allowed some areas to fade away in shadow.

the burst

One of the most fascinating moments in the journey of a wave is when it hits a rock and bursts skyward. The air is filled with aerated water and sometimes the light fragments it into a rainbow of colors. If you could see this action in slow motion you would observe that the water retains its color for a little while before gradually separating into droplets. Just as previously, I first painted in the color of the water and the rock. In this case I painted one rock right in the wave and another in front. The buried rock has caused the water to be burst upward. Next, I scrubbed in the rough shape of the burst using white for the light area and a touch of blue for the shadow side. I was careful not to cover all of the green water and buried rock. The last step was to use the techniques shown in the first "dabbing mist" illustration. I scattered the edges with a dry varnish brush and even blended out some edges completely. I then used the dabbing technique with a bit of white paint on the brush and created the droplet effect on the left side.

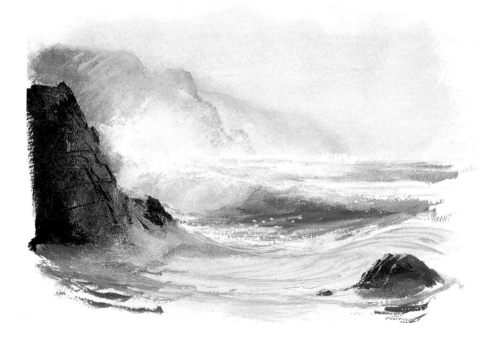

overall mist

overall mist is created in two ways. First, all areas of the background are faded with atmosphere, no matter what color it may be. In this case the atmosphere is a gray-blue with a lot of white. The headlands were first mixed using the same color as the foreground rock then lightened with the atmosphere color. Next, after painting in the wave and foreground foam, I used both the dragging and the dabbing motions to add white droplets to show an overall mist. Even the lighter areas on the background sea were misted so there are no hard lines. There is a softness and a sense of mystery when mist is in the air. After all, why should we show every detail in the background? Why not leave some things to the imagination of the viewer? In so doing we have created something only a very skilled photographer could achieve. Ordinary snapshots cannot do it.

color for seascapes

When you are planning a color scheme for your seascape, try to think in terms of a dominant color, a sub-dominant color and a third color, taking up the least space, as the star — the accent in the center of interest.

Everyone has favorite colors and every artist their favorite palette and arrangement of colors. I am no exception to this truth and my palette is the result of years of experimentation and choices made by personal preference. Of course, everyone wants their colors to work well with the subject matter and they will develop favorites for one thing that just won't work for others. For example, the colors in the surf in Hawaii may be totally wrong for Australia. Rocks in Alaska do not have the same shape, form or color as those found in California, and even rocks in northern California are different from those in central California, and so on. Therefore, this chapter lists colors that are my choices, but you may need to alter them for your own locale and your own preference.

In any case, the colors you and I use just do not come ready-made in the tube. We must mix and blend if we are to be true to what we see. While I cannot tell you which colours are best for you, I can recommend colors that I believe are more suitable to seascapes than others.

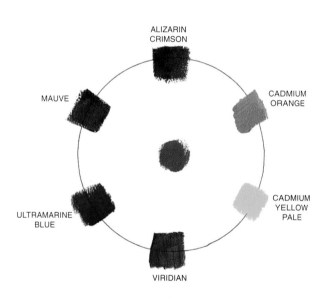

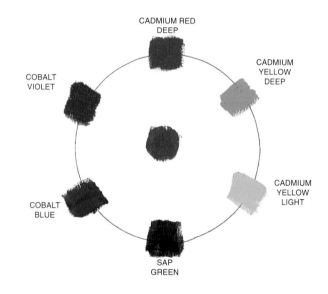

the transparent color wheel
I'm sure you must have seen many color wheels and I apologize for showing another. However, because we paint a transparent subject, I am convinced that transparent pigments are more suitable than opaque ones. Here's a simple wheel with pigments that are quite different. When applied thinly on the canvas, they allow the underpaint to show through. Cadmium yellow pale could have lemon yellow or cadmium yellow light as a substitute. Both viridian and ultramarine blue could have the phthalo colors as substitutes. Viridian may also be substituted with sap green, which is quite transparent. Cadmium orange is the least transparent color on this palette and I could easily omit it and mix something close with red and yellow. The central color is "neutral" and is mixed from any two of the opposite colors on the wheel. I should add that no colors are truly neutral — they are all colors unto themselves. This palette of colors is generally all I ever use, though I sometimes use others when painting in different locales.

alternate color wheel
This color wheel also has some transparent colors with sap green and cobalt violet but the other colors are more opaque. Cobalt blue is very nice for deep water effects, and cadmium red and yellow deep are great for mixing rock colors or tinting a sunny atmosphere. I might use these, and perhaps some on the following pages, for special effects or different locales. I must still say, however, if I were stuck on a desert island with only six color and white, I would choose my favorites and happily mix what I needed for my seascapes

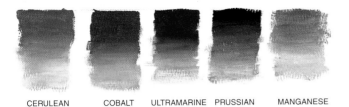

CERULEAN COBALT ULTRAMARINE PRUSSIAN MANGANESE

comparing blues

Here are five different tube colors which I am showing tinted with white. Any one of them can be used for water in seascapes but I believe some are better than others. First, most background water in the sea is blueish with very little green except where it may be momentarily translucent. For this, the darker blues, cobalt, ultramarine, and prussian blue work the best. Cerulean and manganese blue are a bit light for showing deep water. Any of these blues can be used with any of the greens in the next illustration for the translucent wave, though cobalt blue is less transparent when mixed with white. Cerulean and manganese blues are favorites of mine for seascape skies but there are times when I might use any of the others as well.

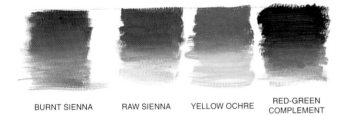

VIRIDIAN SAP PHTHALO CYANINE CADMIUM GREEN TURQUOISE

comparing greens

These five greens show more variety and I would use any of them for translucent water, except cadmium green, which is very opaque. I might use it for moss on rocks or seaweed but never in a translucent wave. Viridian is my choice of all times, but there are areas where sap green seems best. Phthalo green is very strong and unreal if used exclusively for water. I use the tiniest dab (a gnat's whisker), with viridian or the blues for nice effects. Turquoise is a nice color but doesn't match the colors in my locale. Perhaps it could be used in areas of white sand and very clear water. Keep in mind these colors are not intended to be used straight from the tube anyway. I might mix two or more of these together, both with other greens and other blues and even some other colors on the palette. The idea is to match the color you see before you as best you can and that requires some experimenting.

BURNT SIENNA RAW SIENNA YELLOW OCHRE RED-GREEN COMPLEMENT

earth colors

Earth colors are not suited for water but are best for rocks and land features. This illustration shows some that are ready-made in tubes, plus one I have mixed. Burnt sienna is really an orange and I use it with ultramarine blue for rich colored rocks. Raw sienna and yellow ochre can also be used but my preference is to mix an even richer dark color for rocks with the complementary colors, red and green. Sap green and alizarin crimson are my favorites. I can make the mixture cool in tone with more green or warmer in tone with more red. You will see it used in the demonstrations at the end of this book.

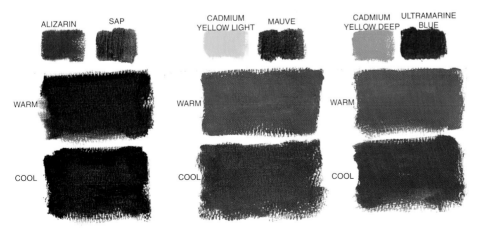

ALIZARIN SAP CADMIUM YELLOW LIGHT MAUVE CADMIUM YELLOW DEEP ULTRAMARINE BLUE

WARM WARM WARM

COOL COOL COOL

neutrals from complements

When mixing complementary colors, those opposite each other on the color wheel, you are automatically mixing a warm color with a cool one. Here, the first set of mixes shows the result of alizarin crimson and sap green. In the upper patch I have used more of the alizarin which is warm, and in the lower patch more of the sap green, which is cool. Both patches show a rich result from the blending, and both are more transparent in effect than the others in the illustration, which tend to be more opaque and dull.

subject colors

As I mentioned before, colors can vary from one place to another. They may also change depending on the colors under water or the atmosphere and time of day. Sunlight, for example, will vary in color depending on the time of day. Early morning sunlight can be quite warm, a yellow-white with even a touch of red. Midday sunlight has a little color and can be nearly white. Evening sunlight may be back to the warm colors of morning. It all depends on the amount of moisture and particles in the air and the location. Facing west, sunsets can be very warm with deep yellows and reds. Facing east, sunsets may be entirely different but you must decide, according to where you live.

This is also a good time to mention shadows which, in a way, are the opposite of sunlight. Shadows are generally transparent; that is, you can see details in them. They are never black and hardly ever brown. Since the days of the Impressionist artists, most of us use a color for shadows that is opposite on the sunlight color on the color wheel. For example, a yellowish sunlight would have a purplish shadow. A touch of orange in the sunlight would mean a bluish shadow and, yes, if there's a touch of red in the sunlight the shadows would most likely have a bit of green in them.

wave colors

Here are two possibilities for wave color. Each one is quite possible given certain conditions. The upper wave is painted with viridian and ultramarine blue with just a tiny bit of white applied to the upper portion of the wave. The water appears clear and without mud. The lower example is painted with sap green and ultramarine blue and just a touch of white in the upper area. While it also appears to be clear water, it has a yellow cast from the sap green and the darker area is changed even though ultramarine blue was used in both examples. The upper wave would probably appear in fairly clear water with little influence to it. The lower wave would most likely be tinted like this because of seaweed or mossy rocks beneath the surface. Even though there are other influences on a wave, it is best to start with a good, transparent color such as viridian or sap green and then introduce the influencing color into it. When this is done, avoid introducing too much white or the translucent effect will be lost.

rock colors

As mentioned before, rock color with vary from place to place but it is usually an earth tone. (Refer to earth colors illustration on page 53) I have two favorite ways to mix rock colors from complementaries. The rock on the left was underpainted with burnt sienna and ultramarine blue. Burnt sienna is really an orange and therefore a complement of blue. I mixed this with more of the sienna than blue which gave a warm tone to the rock. I could have used more blue and given the rock a cooler tone.

The rock on the right is nearly the same in appearance as the other rock but was underpainted with the complements of alizarin crimson and sap green. Again, I kept the rock a warm tone by using more red than green but could have made it cooler with more green. You might experiment with other earth colors and other complements to find the best colors for the rocks in your area.

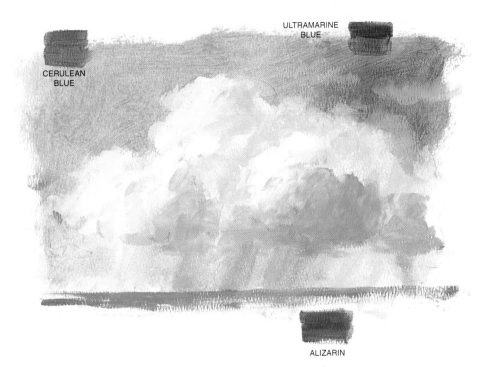

CERULEAN
BLUE

ULTRAMARINE
BLUE

ALIZARIN

skies with cerulean blue

In this illustration I show a sky that is cool, balanced with a bit of warmth. The majority of the sky is cerulean blue with just a bit of ultramarine blue to darken it on the upper right. The clouds are white but shaded with the two blue colors and just a touch of alizarin crimson. Skies are usually darker overhead and lighter toward the horizon line. This is because you are looking through less atmosphere overhead and more mist and distance over the horizon. The sky is usually lighter nearer to the sun than away from it because the sun lightens the moisture in the air. Notice the effect of falling rain from the clouds. This is something you can use to add interest or to introduce a mood into your painting.

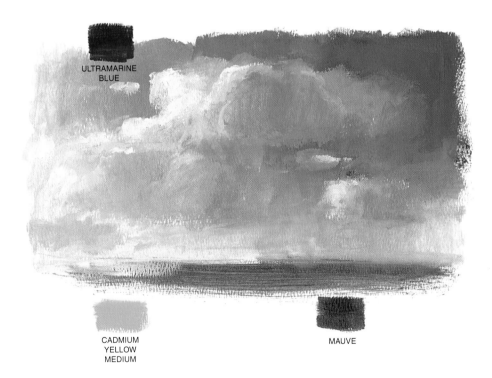

ULTRAMARINE
BLUE

CADMIUM
YELLOW
MEDIUM

MAUVE

skies with ultramarine blue

Ultamarine blue is a warmer color than cerulean blue and you will find times when it is the best choice. I have used fairly pure ultramarine in the upper right of the sky, then gradually lightened it with white and a touch of cadmium yellow medium. I wanted the clouds to be even warmer so I tinted the white with yellow for the sunlight side and with yellow and mauve for the shadow side. Again, the sky near the horizon and near the sun is lighter than the rest. This combination of colors is a triad with ultramarine blue and cadmium yellow medium as a near complement, (cadmium yellow deep is nearly an orange), and mauve which is adjacent to blue on the color wheel. Whenever a triad is used, that is, two complementary colors and one adjacent color, they will always be harmonious. We will discuss triads later. It is essential not to introduce another color in the painting that will clash with them. The addition of green, for example, would be a poor choice unless it was related to one of the colours in this triad.

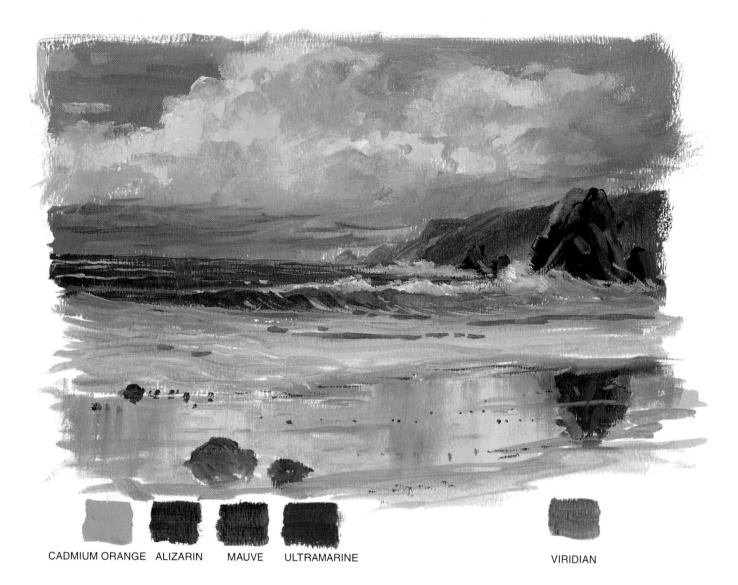

CADMIUM ORANGE ALIZARIN MAUVE ULTRAMARINE VIRIDIAN

"When painting a wave it is best to start with a good, transparent color such as viridian or sap green, and then introduce the influencing color into it."

warm-cool interplay

Here is a color combination using only five colors but making the warm colors dominant. The overall effect is a deep warm, orange, complemented with the cooler green and blue. I used cadmium orange and alizarin crimson with white for most of the sky and the wet sand reflections. I deepened the orange with mauve which I also used for the headlands. The background sea and the rocks are mixed from ultramarine blue and mauve. Finally there is a touch of viridian in the wave. The overall effect is not only a dominant warm complemented by cool but a dominant yellow-orange complemented by blue-green. The sky, including its reflection, also dominates the space in the sketch and is complemented by the sea and land, which takes up less space. Try to think in terms of something dominant and something sub-dominant. This avoids equal divisions which are far less interesting. Simplifying is always better design!

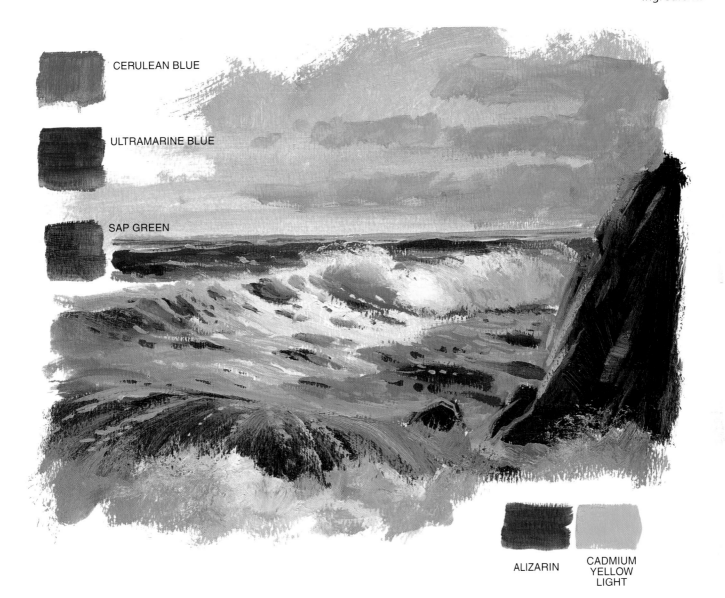

CERULEAN BLUE

ULTRAMARINE BLUE

SAP GREEN

ALIZARIN

CADMIUM
YELLOW
LIGHT

cool-warm interplay

The overall effect of this color scheme is cool from the use of cerulean blue, ultramarine blue and sap green. They are dominant but complemented by some warmth from alizarin crimson and a touch of cadmium yellow medium. Of course, I've also used white. It is important to note that when something is used in a dominant way, in this case, an overall cool temperature, the lesser used complement becomes the focal point and the dominant complement becomes a background for it. Majority does not rule! It is like having a very good day, but with one small, bad happening. Most likely the bad happening will be the focus of attention!

learning point

It is important to note that when something is used in a dominant way, in this case, an overall cool temperature, the lesser used complement becomes the focal point and the dominant complement becomes a background for it. Majority does not rule!

complementary color schemes

Here I show how each of the complements on the color wheel may be used for a dominant-subdominant color scheme. You may not want to use any of these the way they appear but you can see the effects of each combination with either warm or cool temperatures. Needless to say, the purple-yellow combination is less desirable than the others and of course, any of these may be altered for better effects.

In the first set on the left, I used alizarin and viridian with white. The upper example shows a dominance of warm tones complemented by the cooler tones in the center of interest, the wave. The lower example is the opposite. The middle examples are from ultramarine blue and cadmium orange. The upper one is dominantly cool with a touch of warmth in the center of interest and the lower one the opposite. In the right hand group, cadmium yellow pale and mauve are used both in dominant and sub-dominant roles. As an exercise, you might try similar studies but with different colors. Just be sure that they are complementary to each other. For example, instead of alizarin and viridian, you might try cadmium red and sap green, and so on

"As an exercise, you might try similar studies but with different colors. Just be sure that they are complementary to each other."

ALIZARIN VIRIDIAN

WARM WITH COOL

VIRIDIAN ALIZARIN

COOL WITH WARM

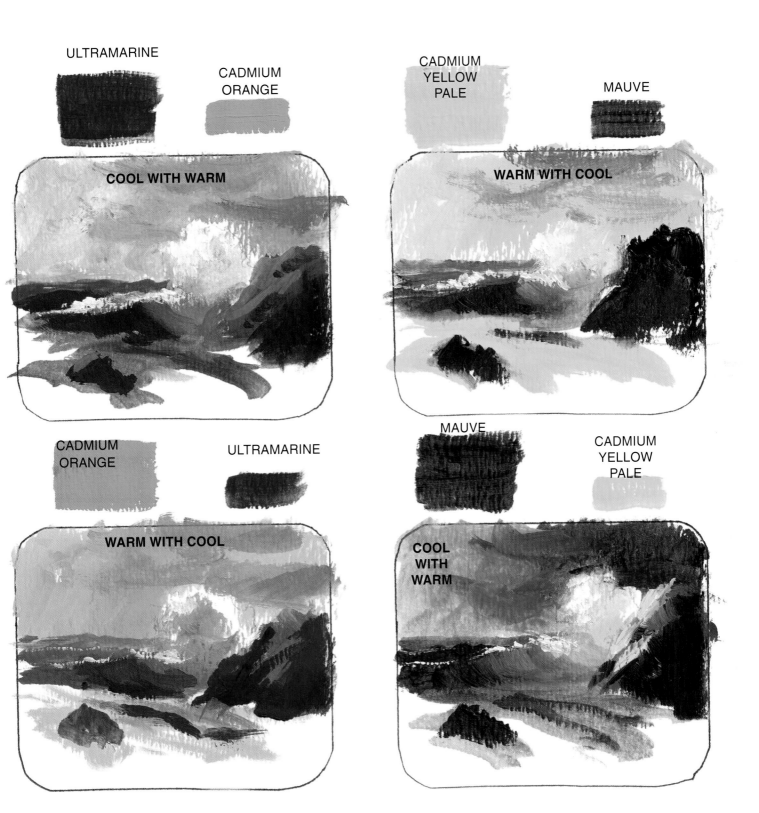

ULTRAMARINE

CADMIUM ORANGE

COOL WITH WARM

CADMIUM YELLOW PALE

MAUVE

WARM WITH COOL

CADMIUM ORANGE

ULTRAMARINE

WARM WITH COOL

MAUVE

CADMIUM YELLOW PALE

COOL WITH WARM

59

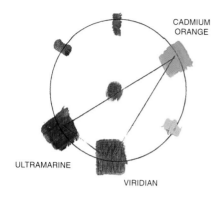

CADMIUM
ORANGE

ULTRAMARINE

VIRIDIAN

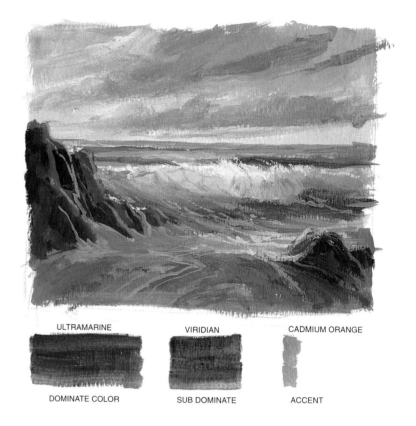

ULTRAMARINE	VIRIDIAN	CADMIUM ORANGE
DOMINATE COLOR	SUB DOMINATE	ACCENT

triads

So far we have been comparing only two complementary colors. Now let's introduce a third color for more harmony. As you know, complements use a primary color: red, yellow, or blue against a secondary color: green, purple, or orange. A triad adds one more color which can be either primary or secondary but adjacent on the wheel to whatever color you choose. For example, if the dominant color is red then the complementary color would be green. You could then choose a color on either side of the red or the green as a third color. What you must consider then, is which will be dominant, which sub-dominant with the third being used for an accent. In any case, you are assured of harmonious colors. Let's take a look at a couple of examples.

triad of blue and green with an orange accent

A triad is made up of a primary color and a secondary color. In this case I have used ultramarine blue as the dominant color and its complement of orange as the accent color. To make a triad I needed an adjacent color to the blue which is dominant. I chose green (viridian) and it became the sub-dominant color. As you can see in the sketch, the overall effect is a blue-green painting with a touch of orange which commands attention.

glow

When I first tried to catch the golden glow over the sea I very carefully took notes and made a color swab that I thought was it. Back at the studio I painted the entire sky that beautiful color but it was flat and had no glow at all. After much experimenting and head scratching I found that glow can be achieved only through contrast.

In the accompanying illustration the bar on the left shows how I proceeded to get the effect of the glowing sun. The first step was to paint a vertical swath in the center. In this case I used cadmium yellow medium and white. Step two was to add a little more yellow to the first mix and made a stripe on either side of the first one. I used straight cadmium yellow for the third stripe and added it to each side of step two. Step

four was made with a touch of alizarin on each side of the step three and the last step was to add a touch more red to the previous mix.

The bar on the right shows a gradual change from the light center to the darker, outer edges. I achieved this by carefully blending across the edges where each swath touched another. Use a soft, dry varnish or blending brush and carefully erase the line by moving horizontally back and forth. The final touch was to add an even lighter mix of yellow white with a dot of pure white in its center. With soft edges the circle now appears to be the sun glowing in a moisture-filled atmosphere. The effect of glow can be used in fog paintings or sunsets and sunrises, depending on where you are located.

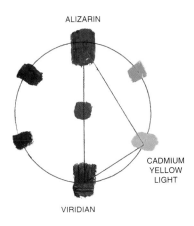

ALIZARIN

CADMIUM
YELLOW
LIGHT

VIRIDIAN

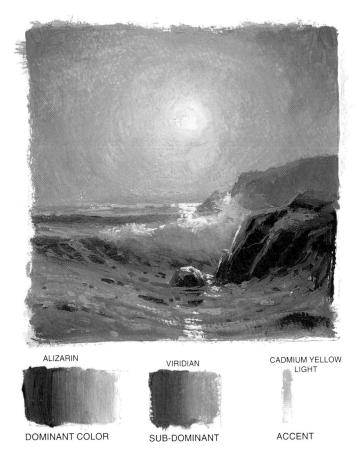

ALIZARIN	VIRIDIAN	CADMIUM YELLOW LIGHT
DOMINANT COLOR	SUB-DOMINANT	ACCENT

triad of red and green with a yellow accent

This sketch is made from just three colors: alizarin crimson, viridian, and cadmium yellow light. I have chosen to make red the dominant color, with green the sub-dominant color, and yellow as an accent. The red is dominant not only because it takes up the most space in the sky but also because it reflects down onto the water. The rocks, too, are mostly red but darkened with green. The yellow is reserved for the center of interest which is the path of sunlight leading to the wave where the yellow and green mix.

By now you can see that the choice of color is up to you. Regardless of what colors you use, it is best to think in terms of just three, knowing that other colors will find their way into the scheme of things. For good color harmony one color should dominate the space, a second one should take up less space and the third, which takes up the least space, will be the star, the accent in the centre of interest.

Colors are like personal friends and we need to know them well. The more we work with them, the more familiar they become. Eventually we find some we like better than others and are more comfortable to be around. There are limitless combinations of colors and they all have merit but if we find our own personal group with occasional variations they will become as important as our signature.

Finally, it is important to use transparent colors for painting water. Use white and opaque colors for skies, rocks, beaches, and headlands. Skies can reflect upon the water but should never take away all of the clear color, especially in the waves.

5 4 3 2 1 2 3 4 5

6

chapter 8

composition for seascapes

Once you have established three values and three spaces they combine to make six possibilities for harmonious design.

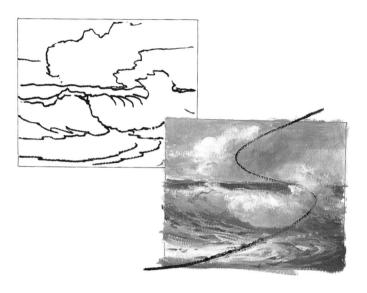

J ust as there are certain colors that work better for seascapes, there are certain compositions that are better suited as well. Compositions are more than just pleasing arrangements of objects in a picture plane. We are not just showing a scene with waves, skies , and landforms; a snap-shot can do that. We are showing a moment in time and that moment carries a mood or a feeling that will be felt by the viewer. This chapter is probably the most important chapter in the book because no matter how well you can draw or arrange colors, the painting will fall apart without a good composition

Line, color, and values all carry moods according to how they are used. You have already seen in chapter 7 that colors can be either warm or cool and by making one dominant over the other you can send a message or a mood. The sea by itself can carry any mood felt by man; It can be angry, happy, quiet, noisy, or anything else we can feel just by the way we arrange the component parts. The component parts of the subject are: water, sky, and landforms made up of rocks, beaches and headlands. They are arranged in space as background, middle ground, and foreground. We work with warm, cool, and neutral colors, and values are broken down to light, medium, and dark. Lines can be either obvious or implied but also carry moods by how they are used. This chapter will show you these important elements and how to use them.

outline and implied line

In this illustration you can see that the drawing on the left outlines the clouds, the wave, and some of the foreground. The sketch on the right has filled in the outlined shapes but there is an implied line. If you follow the angle of the clouds to the foam burst and down to the angle of the surf you will see that they form the famous S-curve that has been used so often in paintings. This is not an obvious line but implied or suggested, and the eye has a natural tendency to want to follow it. The S-curve has been so popular because it is a slow, mean-dering line that suggests an unhurried, peaceful view of the world. Of course there are other lines and implied lines in the composition but this one is dominant over the others. Horizontal lines are also used, but not as much, so they become sub-dominant.

tranquil lines

There is nothing more restful than lying down. When we base our composition with implied horizontal lines we will be conveying a restful mood. There is very little movement in horizontal lines and it is best to have a curve or a small vertical to balance the dominant effect it has. In this sketch, the sky, the beach, the wave, and even the rocks are horizontal but you will notice the curve of the foam draws the eye to the wave. Once again, the least used component draws the atten-tion while the rest become background.

opposing lines

Lines opposing one another project the feeling of conflict. They are not in harmony and going in the same direction, but rather crash into each other. This use of implied lines is perfect for storms, or moods of anger, or opposition. Here you can see how the angle of the dark, moody sky opposes the wave and the wave is about to crash into rocks of another angle. This is a case of three elements: sky, water, and land, at odds with each other. You might also notice the three areas of background, middle ground and foreground.

moving lines

A seascape without moving lines, even a little bit, is static and unreal. Implied lines can give the viewer the feeling of motion without them realizing what the artist has done. Notice how the lines created by the clouds, the wave and the foreground water are very similar to the conflict lines in the previous illustration. The difference is that these lines are rounded and gentle, where the previous lines are straighter and angled more sharply. The sea is a moving force of energy and the lines implied here suggest the undulating motion of up and down that is so typical of a heavy surf.

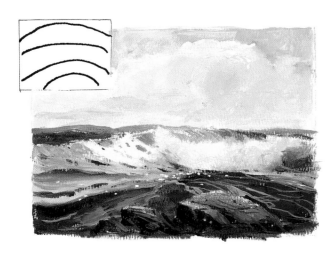

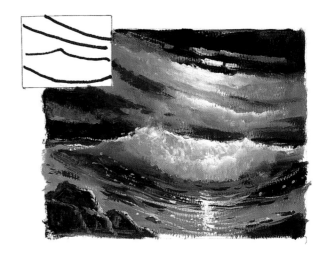

buoyant lines

When implied lines create rising arcs there is a sense of uplifting or buoyancy. Notice the rocks in the foreground are arranged to create the first implied arc. Next, the swelling surf makes another arc and even though the wave foam is falling in the opposite direction, the overall shape of the wave is also arced upward. Finally, the clouds of the background form the last arc. The wave foam falling downward is the necessary balance to everything else moving upward and of course, draws attention. I like to use rising arcs in morning scenes and give the feeling of a promising new day with great expectations. Notice here that the painting starts out dark in the foreground and becomes lighter and lighter. If it were the opposite, the uprising feeling would probably be destroyed.

downward lines

Downward arcs can be depressing if they are too severe. When I use them I either slant them a bit or give them very little arc as I have done here, where they provide a gentle mood to night time and seem to have a swaying motion. It is the end of the day and a time to relax, to "sleep, perchance to dream". Putting Shakespeare aside for the moment, please notice the vertical line created by the reflecting light of the moon. It provides the balance to oppose the dominance of the arcs and at the same time commands attention.

other lines

Compare the three sketches on the left to those on the right. They are the same outline in each case but look at the difference. The upper sketches of a wave show how a pathway leading to it can be either fast or slow. You would select the one that would suit the mood of your painting but not use both in the same composition. The middle sketch shows the difference between nervous and calming lines. Again, you would have to be aware of both. If you added a line of jagged trees to a painting you wanted to be calm, you would lose the mood. In the bottom sketches the importance of having an opposing direction is shown. The sketch on the right has the clouds moving in the opposite direction of the wave and surf. This gives a better balance to the composition that has all the lines moving in one direction.

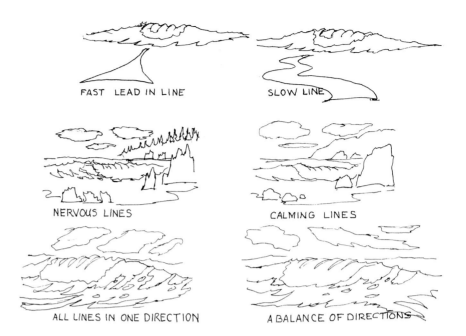

FAST LEAD IN LINE SLOW LINE

NERVOUS LINES CALMING LINES

ALL LINES IN ONE DIRECTION A BALANCE OF DIRECTIONS

using direct and indirect lines

In this illustration the two compositions are exactly the same except for the way the eye is led into the center of interest. In the composition on the left I have use a series of rocks that indirectly draw a line to the wave. They are like stepping stones and not as obvious as a complete line. On the right the lead-in to the wave is a pattern of foam. Though it curves, it is a more obvious line. Either one is acceptable and both should be treated as I have used them here: running through both sunlight and shadow, varied in sizes and textures, and curving.

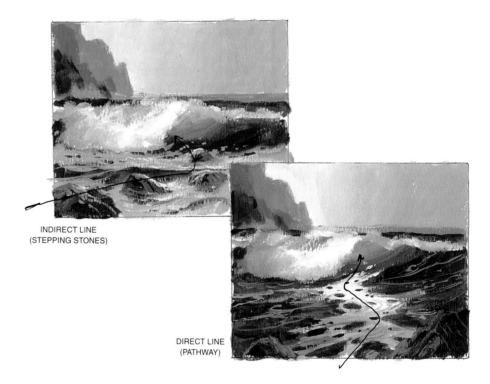

INDIRECT LINE
(STEPPING STONES)

DIRECT LINE
(PATHWAY)

learning point

At this time it must be obvious that lines carry moods and there can be many variations besides what has been shown. The rule is to choose a mood and make the majority of lines follow it. Then you can insert an opposite line to attract attention where you want to focus. Again, this is the use of dominance being balanced by an attention-getting opposite. You should also be aware of as many mood lines as possible so you don't mix in too many. For example, introducing nervous lines where you want quiet rest.

values

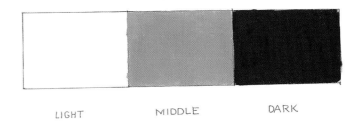

Most books will tell you there are ten values ranging in steps from white through black and this is basically true. However, for the purposes of composing, it is much easier to think in terms of only three: light, medium and dark. All the other values will fall into place as you paint. Lets look at what happens when we think of three values together with three areas of a composition.

three values

Here are the light, medium, and dark values rather than white, grey, and black. The reason for thinking this way is because you may not want your lightest value to be white or the darkest value to be black. You can select values from anywhere on the scale of ten but wherever they are, there should still be a division between the lightest and the darkest. Also, you need to think in terms of one being dominant, one sub-dominant, and one as an accent just like everything else.

three areas

Spaces can also be simplified to only three. Think of a background, a foreground, and a middle ground, or center of interest. Sometimes you may want all three areas with the center of interest placed within any of the three. In other instances you may simply want a background and foreground with the center of interest. It still comes out as three areas. As with values and colors, space should also be divided between dominant and sub-dominant. In this case either the background or the foreground should take up more area of the composition than the other. This avoids equal spacing which is monotonous and uninteresting.

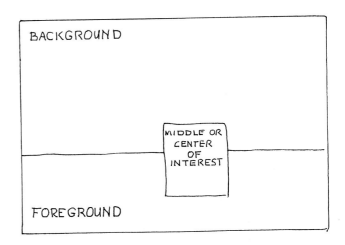

DOMINANT BACKGROUND

SUB DOMINANT FOREGROUND

SUB DOMINANT BACKGROUND

DOMINANT FOREGROUND

EVENLY SPACED AREAS

spacing areas

This illustration shows three possibilities in dividing space. The example on the left shows a simple composition with a wave as the center of interest. The wave is below the horizon line which makes the background the dominant area and the foreground the sub-dominant one.

The middle example places the wave above the horizon line and the foreground becomes the dominant area with the background the sub-dominant. Either composition works well. You just have to be prepared to have something to fill in those areas without distracting from the center of interest.

The example on the right shows the wave and the horizon line dead center. The focal point is in the exact center of the area and the background and foreground have equal space. You can see that it is uncomfortable to look at. It is like placing the star of the show at center stage without any supporting cast. You would become bored in a very short time.

combining threesomes

Once you have established three values and three spaces they combine to make six possibilities for harmonious design. Any one of the value and space possibilities combined with three main colors will assure you a successful composition. Remember, other values and colors will emerge as you paint.

MIDDLE VALUE BACKGROUND
LIGHT VALUE FOREGROUND

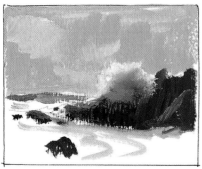

DARK VALUE BACKGROUND
LIGHT VALUE FOREGROUND

MIDDLE VALUE BACKGROUND
DARK VALUE FOREGROUND

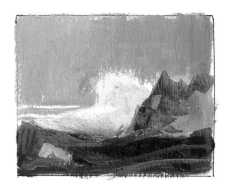

DARK FOCAL POINT

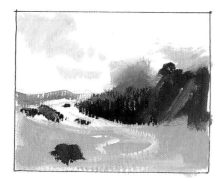

MIDDLE VALUE FOCAL POINT

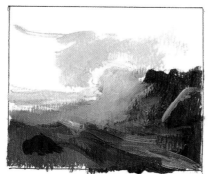

LIGHT FOCAL POINT

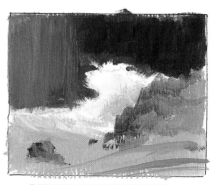

LIGHT VALUE BACKGROUND
MIDDLE VALUE FOREGROUND

LIGHT VALUE BACKGROUND
DARK VALUE FOREGROUND

DARK VALUE BACKGROUND
MIDDLE VALUE FOREGROUND

combining areas and values

These six compositions are based on a dominant background, a sub-dominant foreground, and the center of interest in the middle ground. Remember, you can reverse them and place the center of interest in other areas. I have also used the same colors for each of these examples. Now you can see how moving the values creates different moods. With the first set on the left, there is a dark focal point with a middle value background and a light foreground at the top.

The lower example reverses the back and front values.

The second set has a middle value focal point.

The top example has a dark background with a light foreground. The lower example reverses those values. The set on the right shows a light center of interest.

The upper example has a middle value background with a dark foreground, The reverse is true of the lower sketch.

The focal point, or center of interest, works best with contrast which is ensured when it is either dark or light and shows up against its opposite. When the focal point is of a middle

value, there is only a half step to either the dark or light around it and shows up less. In those instances the center of interest will need extra attention — I'll show you how to do this in a later chapter. Now you have seen how combining three spaces, values, and colors can simplify your compositions. You can assure successful paintings by thinking things out before jumping in with brush and paints. First choose your subject, the mood you want for it, then find the colors and the values that will support that theme. When in doubt for a value composition, refer to this illustration.

exceptions

The exceptions to having strong light, dark, and middle values are to push all the values closer together. This produces an over-value composition where you still use three main values but in a subtle way, as shown in the next three illustrations.

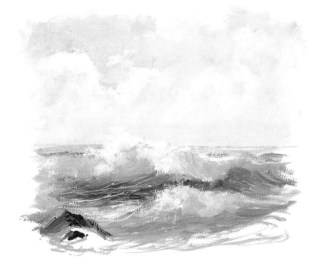

light composition

This composition still uses light, dark, and middle values but there is only a touch of dark and the middle values are very close to the light values. The overall effect is a very light composition. The mood that comes from this is light, airy, and very atmospheric. This composition also has soft edges and the wave is gentle. The rock is non-threatening so there is a sense of softness, even happiness. Remember the upward moving implied lines shown previously? You can see the same implied line in this sketch.

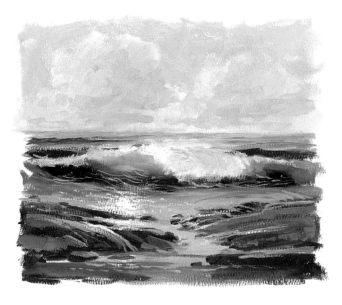

middle value composition

This composition doesn't rely on three strong values either. Instead, it is an overall middle value painting with light and dark areas that are neither strong light nor strong dark values. Therefore it "reads" as a middle value painting. Now for a critical moment: is the wave too close to the center of the painting? Are the background and foreground too equal in area? We must always be judging our own work. In that way we can be sure to continue improving.

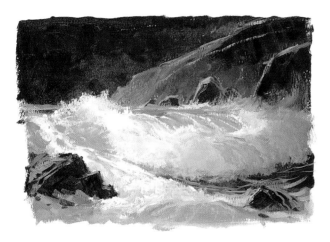

dark composition

Even though there are light and middle values, this composition still "reads" as dark. That is because dark values are dominant and the sub-dominant middle values are fairly dark themselves. If you squint your eyes at this sketch and make the edges blur, you will see that not only are the sky and rocks dark, but so is the shadowed foam. In other words, some of the middle values appear as dark. I have allowed the light to be very strong against the dark sky which ensures that area to be the focal point. This sketch is intended to be a night scene with a full moon out of the picture frame. The mood could be romantic but the wave is too large and active for that. Notice the implied lines are downward moving as shown on page 63. There is a lot of energy here but it is not uplifting. Perhaps you may feel a sense of foreboding. Very dark values overhead can cause that. I have given the edge of the wave a good shot of light which counters the depressing feeling somewhat so the mood isn't totally oppressive.

focal points

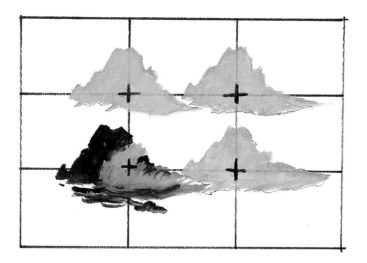

choices for focal points

In placing your focal point or center of interest it is best to avoid the center of the composition which would leave everything else of equal size. It is also best to avoid placing it too close to the edges which would be like the star of the show off to one side and nearly unnoticed. If you divide your canvas into thirds as shown in here, each of the four places where they cross one another would be a good location. The rock shown here could be in any of the four positions and have a good surrounding.

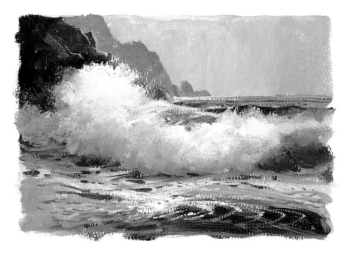

focal point with contrast

As I have mentioned before, contrast almost always commands attention. If you place the lightest light value against the darkest dark value, it will be the star. That doesn't mean you can't have the same light or dark values elsewhere in the composition; It only means they should not be next to each other or they will also demand attention. Remember, one star at a time or the scene will become too busy and confusing. Think of a window display in a ritzy store where they show one major item with a few accessories and compare that to a five-and-dime display of dozens of items. Let's choose simplicity over confusion.

focal point with color

Another way to create a focal point without value contrast is to have a contrast of color. Here, the overall blue color of the painting is contrasted with a spot of orange on the rocks. This leads the eye to where you want it. It is a good idea to echo that color elsewhere so that it won't be too obvious. Remember in chapter 7 we discussed making the accent the opposite of the dominant color. This is an example.

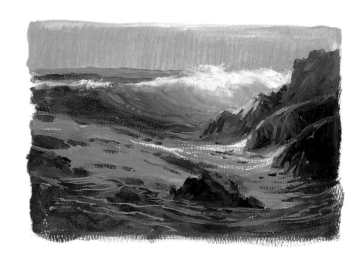

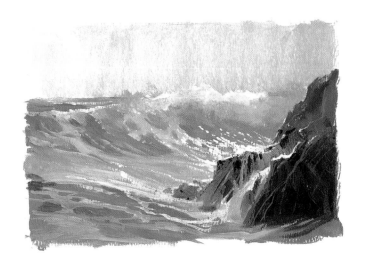

focal point with detail

Adding more detail to an area will also draw attention. If you are working with an overall value rather than contrasting values, this works very well. In this illustration I could have chosen the wave to be the center of interest but instead, I chose the area just below it. I shadowed down the white foam so it wouldn't contrast with the upper edge of the rock, then added sparkle to the surf and sharp edges and details to the rock. The attention goes to the rock rather than to the wave. Remember, you can always justify the use of shadows to control what is light or not light in a painting. There will always be a cloud in the sky or a rock or some projection that isn't visible in the picture plain but stands somewhere between the source of light and an object. You are the director.

some last thoughts

Composition can be very complex but you now know that you can simplify it and enhance your paintings. As you advance you will find favorite avenues for your compositions: favorite lines, values, colors and moods. The more you paint the more personal your paintings will become, and if you are consistent with your choices people will come to recognize your work without stepping close to look at the signature. That is a fine reward for a lot of practice! Also as you advance, you will find other ways than those I have given and if you are dedicated, you will not stop learning.

The main lesson in this chapter, besides learning to compose successful paintings, is to understand that painting is not mere picture making. You are a personality with individual and unique experiences. You see things in ways no one else sees and you express your thoughts in your way only. The more you practice and master your techniques, the easier it is to convey the real messages which are the moods and emotions you alone felt when you saw something that others missed. It could be the way the sunlight refracted in a burst of foam, or the unique way some foam patterns climbed over a wave, or the way you felt simply standing before the awesome power of the sea. In any case, you will have gone far beyond simply copying an image.

"The focal point, or center of interest, works best with contrast, which is ensured when it is either dark or light and shows up against its opposite."

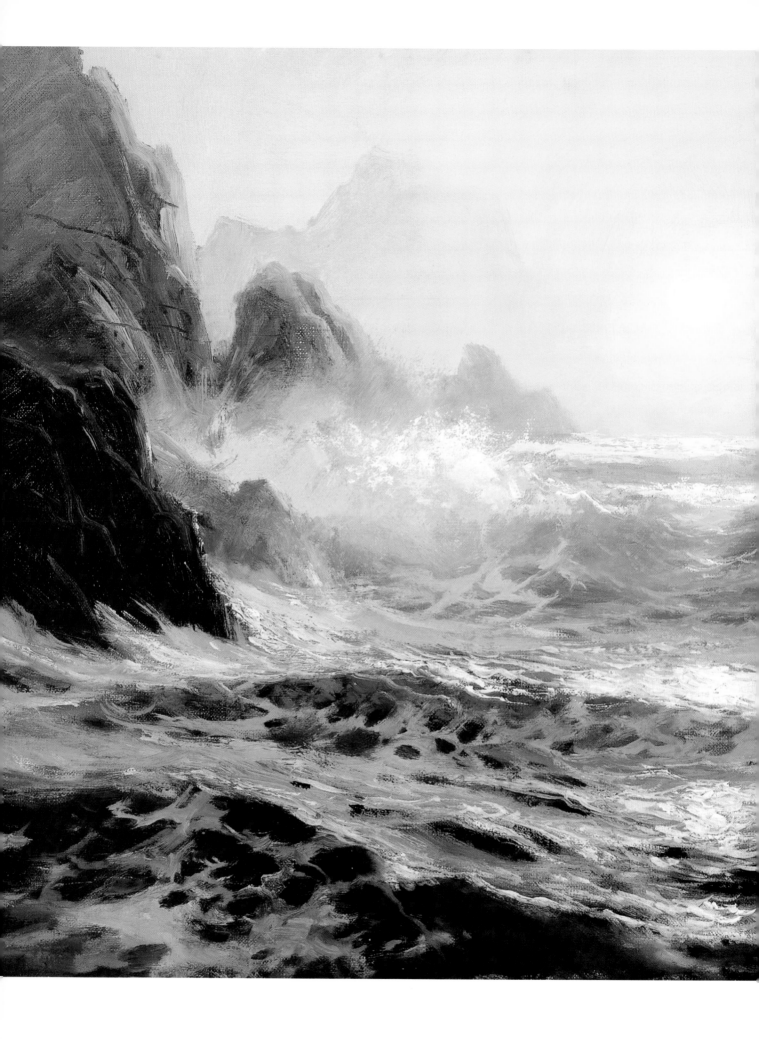

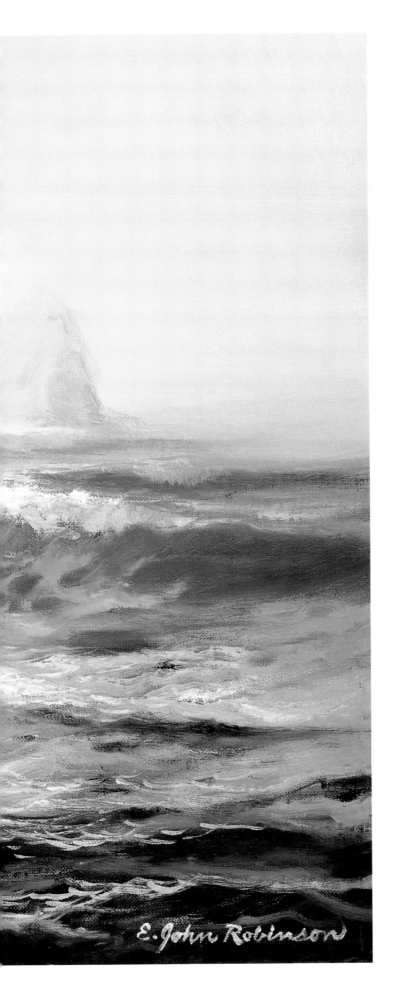

section 3

demonstrations

"Twilight Mist", 24 x 30'' (61 x 76cm)

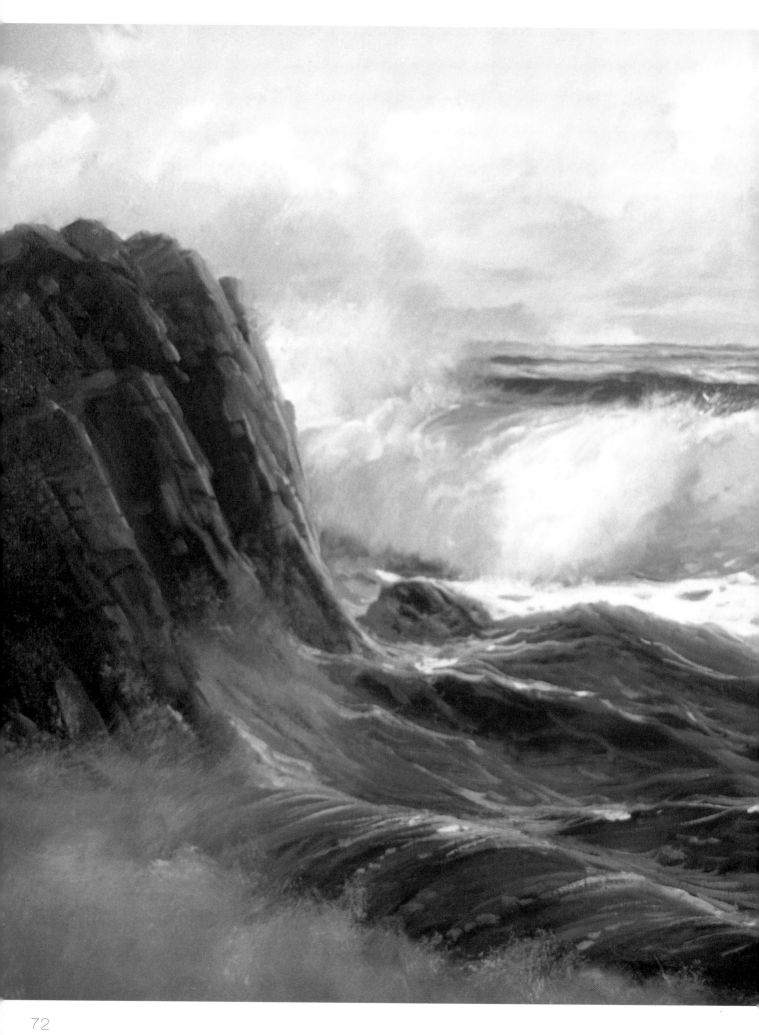

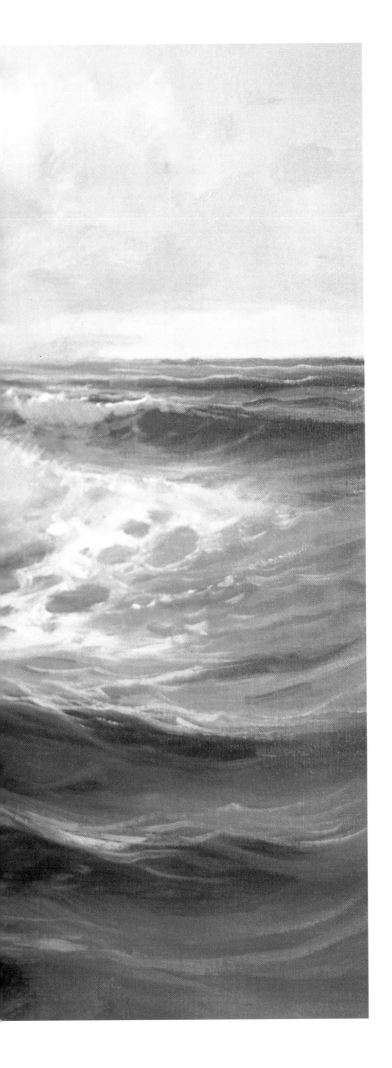

DEMONSTRATION

rising tide

Unless you work to a simple game plan you will have a chaotic, confusing set of colors and values and you'll be struggling for hours trying to correct what you don't even comprehend.

A rising tide is sometimes called a flood tide. The gravitational pull of the moon has relaxed and the seas gradually rise as the waves rush to shore. The air is filled with energy and resounds to the thunder of water against rocks. I have coupled this buoyant and exciting feeling with a warm atmosphere and the beginning of a new day.

outline and mood line

I have kept the outline very simple. I found long ago that it is a waste of my time putting too many details in a line drawing because it takes away the ongoing creativity of painting if all the details are worked out ahead of time. The mood line (or lines) determine the feelings I want to convey. In this painting I want to express the heavy energy as well as an uplifting feeling. Therefore, I have given the major shapes of the surf, the wave, and the clouds, upward curving lines. This series of arcs creates a feeling of rising movement which is perfect for a morning theme.

values and proportions

I chose a dominant middle value. The sub-dominant value is dark and the accent value is light. It is my intention to have the dark value in the foreground so that as the eye moves upward the values become lighter, with the very lightest values reserved for the center of interest. Also, I have kept the middle values on the lighter side of the scale, which helps the mood of buoyancy and the rising tide effect.

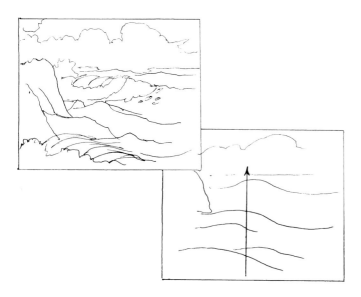

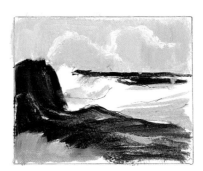

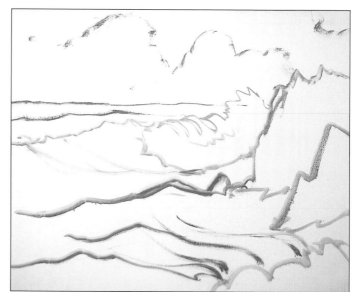

step one: outline

I stapled my canvas over a 16 x 20'' frame of stretcher strips. The outline was drawn with thinned ultramarine blue using a #4 filbert bristle brush. Though the lines are few and lack detail they outline exactly where each of the subjects will be: the sky and clouds, the wave with its foam, the foreground surf, and the rocks. Any more would be in the way because my method of painting is to first scrub in rather carelessly the under paint and then come back later for the details.

center of interest and direction of sunlight

I always like to work out where the light is coming from and where I want to focus attention, or the center of interest. If you look back to the chapter 8 illustration, you will see that there are four good choices for the placement of a center of interest. In this painting I wanted the attention to be the breaking wave and will use the contrast of the dark rocks against the white foam so I placed the center of interest in the upper, top quadrant of the composition. As this is morning on the west coast, I placed the sun low and behind the viewer's left shoulder.

color scheme

Color plays a big part in carrying a mood. I want this uplifting mood to be warm without being hot so will tint any warm colors with white. The color of the sunlight will be cadmium yellow pale with a tiny touch of alizarin into white. The other colors: cerulean blue, ultramarine blue, viridian, and sap green are all cool in temperature. The dominant color for the painting will be a light value blue. The sub-dominant color and value will be the rocks which are made up of alizarin, sap green, and purples mixed from red and blue. The accent color will be a light value of warm yellow from the mixture for sunlight.

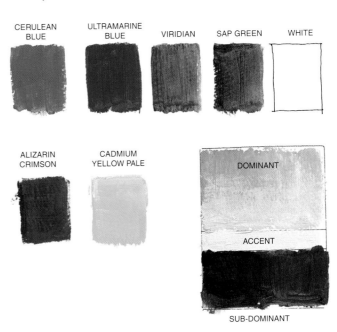

step two: dark values

I started with the rocks and mixed alizarin and sap green with a touch more alizarin for a warmer temperature. I scrubbed in the color with a #8 filbert, starting out with plenty of paint and continuing across until the paint thinned and became lighter. I used no white paint at all. In fact, I recommend that you do not use white in the under paint of either rocks or clear water. For the surf and the background sea, I used only ultramarine blue and viridian, then added a touch of cerulean blue for variety and added it to the wave face as well. Notice how clear the water looks. If I had added white at this point there would be no transparent effect and the painting would soon become chalky.

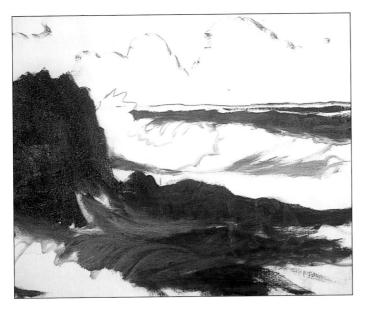

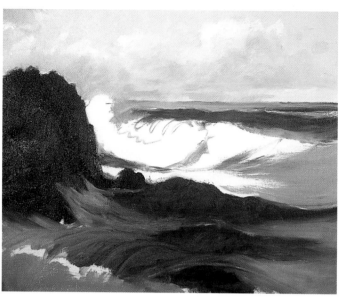

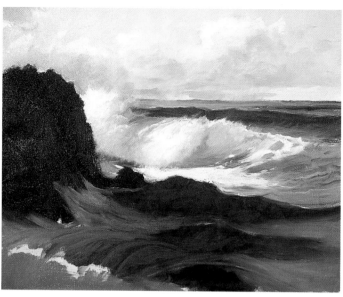

step three: atmosphere

I can now paint in my sky and use all the white paint I want. White lightens the colors and helps push them back. The reason I wanted my clear water and rocks in first is because they will both reflect the sky and to do that, they must be in place first. I started by making a "pile" of sky color from white and cerulean blue then painted the area around the clouds. I then added a touch of cadmium yellow pale as I worked to the left, the area of the sun. I used a #6 filbert for both the sky area and the clouds. The sunny side of the clouds is a mix of cadmium yellow pale into white, which is the color I have chosen for the sunlight, and I made a pile of that as well. I then added a very tiny touch of alizarin to give a warmer effect to the light. For the shadow side of the clouds I added ultramarine blue to some of the cerulean-white from my pile of sky color. I scrubbed it in with variations by adding either more ultramarine or more cerulean.

Once a pile of sunlight color is made along with piles of color for the sky and atmosphere, they can then be dipped into for the rest of the painting. I used a #4 filbert and added the sky and atmosphere colors down on the background sea and the surf. Notice that I did not cover up my clear water. I reflected the sky colors in the troughs between the swells.

step four: the breaker

First I painted the sunlit areas of the foam with a #4 filbert by dipping into my pile of sunlight, cadmium yellow pale and white. The color of the water without foam is cerulean blue into more of the sunlight color. I deepened it at the base of the wave with ultramarine blue. The foam edges were very rough so I softened them with a dry varnish brush. The rock is casting a shadow on the breaker foam and I painted it by adding a touch of alizarin to some shadow color from my pile of atmosphere. I wanted it warmer because the warmth of the rock would be reflected, even in shadow.

"I want to express the heavy energy as well as an uplifting feeling."

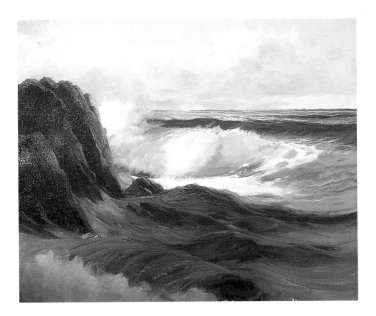

step five: more reflections

Then I began more serious reflecting that began to outline areas and to give shapes. For this I mostly used a #2 rigger brush. I could also use a small watercolor brush or the edge of a #2 filbert. In any case, I used a light touch which would go over the under paint without blending in. (Be careful not to use the tip of the brush because it will definitely push the paint into the other colors and you will not have clean lines.) The sky overhead is darker than farther out so I added some ultramarine blue to the pile of cloud color. I then used the #2 rigger to define the upper edges of the swells in the background and in the surf. I added reflected colors on the rock with a #2 filbert. Again I darkened the cloud colors with ultramarine. Notice that the lines over the foreground collapsed wave follow the contour of its shape and those lines become lost in the foam, which was the cloud color with more white added. Because this is a shadow area I have not used the sunlight color for highlighting.

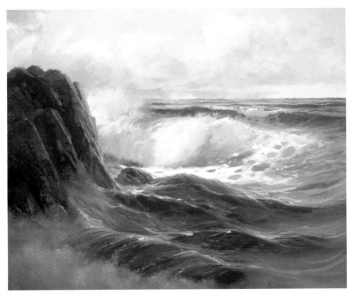

step six: final details

Still using my #2 rigger brush I reflected the lighter colors of the sky, (the pile of cerulean blue, white, and a touch of yellow), and a bit from the pile of sunlight color. Look ahead to the next detail to see how I applied those lines to the surf. I also reflected some bounced light from the wave foam to the rock. (When doing this it is important to think of the contours, cracks, and edges of the rock and follow them with your brush.) I next added interest to the wave by painting a few holes in the foam and softening some more edges, especially the little burst on the left side. You can get a better look at the holes in the next picture. The final touch was to highlight the foreground roll and soften the edges of the foam. Again, I used a dry varnish brush to whip away hard edges.

close-up detail

This gives you a better view of the center of interest. Notice how the holes in the foam follow the contour of the wave, note the softness of the moving edges, the use of sunlight and shadow to avoid monotony, and the anatomy of the wave you learned about in chapter 3 .

At this point I can pretty well judge the success or failure of my painting by noting how well I stuck to my game plan. Does the painting give the feeling of warm light? Of energy? And do the color and value work well together? If I had not worked out some of these questions ahead of time, the painting could have had a chaotic, confusing set of colors and values and then I would be struggling for hours and hours trying to correct what I don't even comprehend. I would never suggest that you must work out every last detail before starting because that would take away all the creativity in the process of painting. I do, however, strongly suggest that you have at least a simple game plan.

chapter 10

DEMONSTRATION

quiet moments

For a quiet mood, compose with fewer lines, values and colors, and pinpoint the center of interest without hard contrasts.

Sometimes we need times of quiet and repose to balance all the noise and bustle we find ourselves in. Nature can provide this. Fog is one of those reprieves from chaos and has become the subject of poets and artists alike.

Summer on the west coast can mean warm air and cool currents and the result is a blanket of fog at the shore. It is a quieting mood and suggests a composition with a simple statement. In this demonstration you will see how I have composed with fewer lines, values, and colors, and have pinpointed the center of interest without hard contrasts. The result should be a statement of quietness that is felt by the viewer.

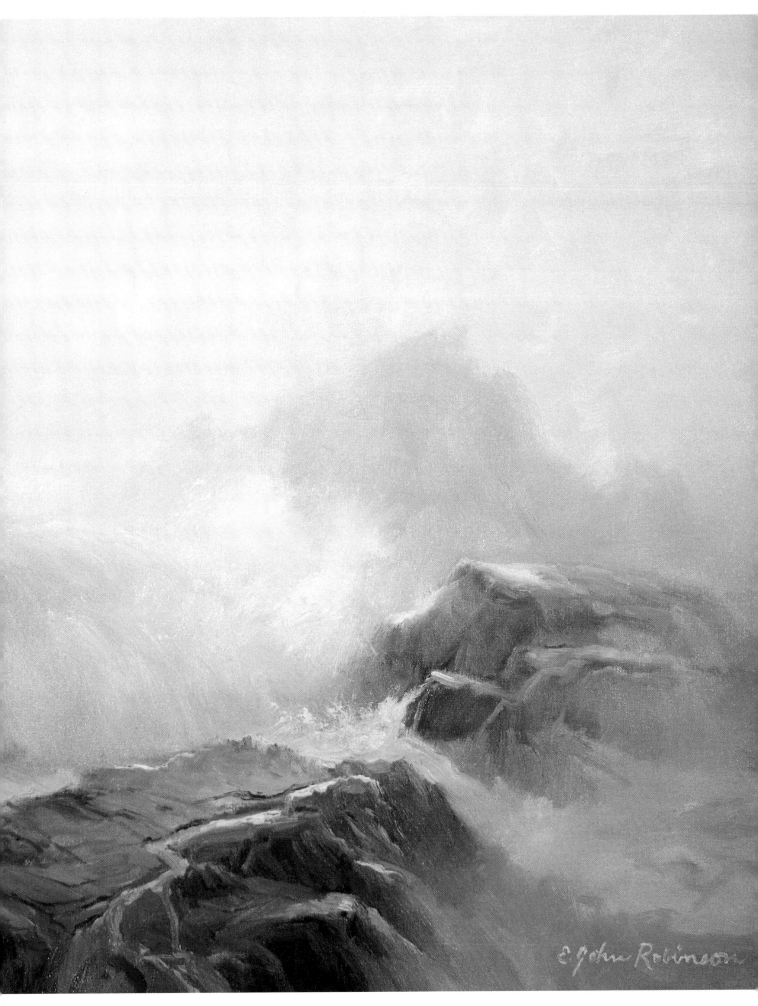

E. John Robinson

outline and mood line

The outline for a fog subject does not need many lines to begin with because there will be few actual lines when it's finished. As you can see, I merely indicated where the wave and the rocks are located against an obscure background. There should still be implied mood lines even in a fog scene and I have arranged the objects to create a movement that leads the eye only to the near middle ground and then back again. The viewer's eye is led to the center of interest but can go no further so returns to the foreground. In other words, I have controlled what can or cannot be seen. Even in compositions without fog, you can take control merely by deciding how much attention you pay to one area as opposed to others.

values

In order to keep a quiet mood I do not want any strong contrast so will keep all the values close. That means the middle value should not be much darker than the light value, and the dark values should not be placed too near the light areas. I planned to have dominant light middle values, the dark values to be sub-dominant and the light value to be the accent and in the center of interest. I also arranged the space so that the darkest value would be in the near foreground with the light-middle value acting as both middle and background. The focal point becomes an accent in the middle ground area.

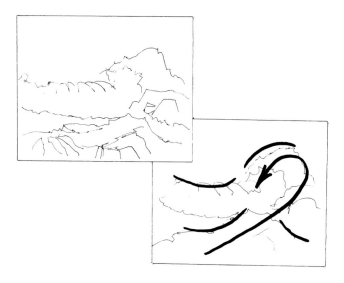

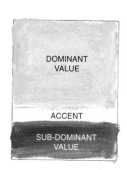

DOMINANT VALUE

ACCENT

SUB-DOMINANT VALUE

step one: toner and outline

After stretching a 16 x 20'' canvas, I gave it a light tone of thinned cadmium yellow light. I wiped it down with a paper towel and it was ready for the outline immediately. The idea of toning a canvas is to create an effect. In this case, I wanted some sunlight color to show faintly through the fog, and if I don't overpaint the toner too heavily, the influence should be there. I used burnt sienna and a #2 filbert brush to draw in the few lines I needed and to indicate where the sides of the rocks would be. Remember, foreground rocks usually show tops and sides.

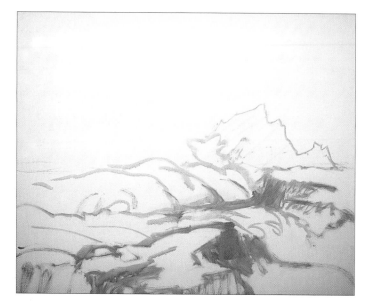

center of interest and direction of sunlight

I chose to have the sun directly above and out of sight but somehow finding a window in the fog and shining on a small area. I call this spot lighting and it is a very effective way of focusing attention where you want it. In this case the center of interest is placed in the lower right quadrant of the composition. That brings it closer to the foreground but away from an equal division of the space.

color scheme

Just as there are few values for a fog composition, there should be few colors as well. Remember, fog is a cloud of moisture and obscures detail as well giving a lighter tint to all colors. I probably could have done without the burnt sienna but planned to use it as an accent for the center of interest. The cadmium yellow light would give a slight color to the sunlight and help accent the center of interest. I would use a little bit of viridian in the water but mostly in the atmosphere with alizarin to achieve a pearly grey. I had ultramarine blue on the palette to mix with alizarin or burnt sienna for the rocks. Nearly all these colors would be heavily tinted with white. The dominant color would be a pearly-grey; the sub-dominant color would be a rich dark made of alizarin, ultramarine blue and burnt sienna. The accent color would be a touch of cadmium yellow light into white.

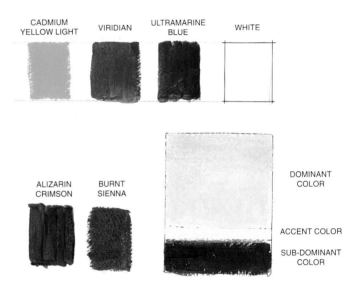

step two: values

In a painting where values are to fade out quickly, it is important to start with the darkest value that will be used. That way you will know how much lighter each succeeding value must be. In this composition the darkest values would be in the rocks and closest to the viewer. I had already scrubbed some burnt sienna on the rocks in step one so I mixed ultramarine blue and alizarin and applied it over the underpaint and toner. I used no white but controlled the values by the amount of paint and scrubbing. The darkest areas were heavily painted but the lighter areas had less paint and were scrubbed in, which tends to lighten them. The rock at the center of interest was mostly burnt sienna with a touch of the red-blue mixture. The farthest rock was scrubbed in with less paint and the yellow toner can still be seen as a part of it. I used a #6 filbert for all of this work.

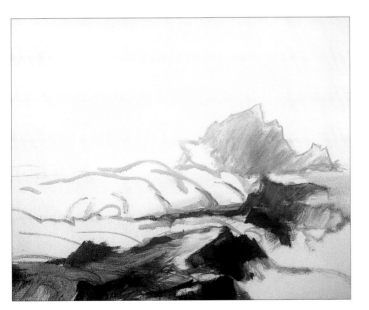

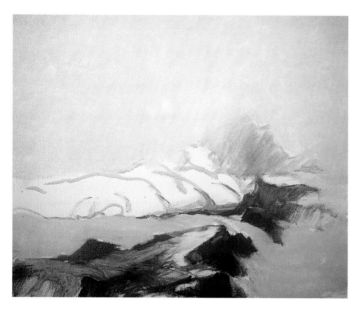

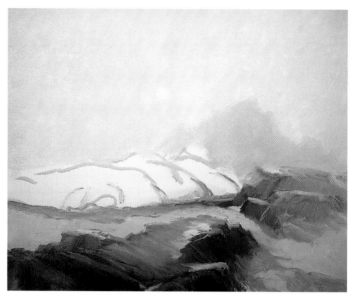

step three: atmosphere

For this painting I needed a good sized pile of atmosphere on my palette. I started with a good amount of pure white then, with a mixing knife, added a small amount of alizarin with an equal amount of viridian. You must start with just a dab because it is better to add more dabs of color than to add more white. I found that out when I got my first set of oils as a child. I squeezed out a lot of blue paint for a sky then realized it was too dark. By the time I got it light enough I had a huge pile and no more white paint in my set.

In this case I wanted a slight tint of red in my atmosphere through the area the sun would shine so mixed less green at first. When I had the right hue and value, I painted a vertical path of sky over the center of interest. Next, I added a bit more viridian to the pile and worked in a vertical area on each side of the first path. I was still using a #8 filbert.

I continued to add a bit more green and worked in paths on each side until the entire background was covered. I then blended the areas together with a light hazing from my dry varnish brush. The result was a foggy, grey, atmosphere that was warm in the path of light and gradually became cooler away from the light. Finally, I added some ultramarine blue to some of the atmosphere color and scrubbed in the foreground surf that would reflect the sky above.

step four: rocks

My first obligation was to blend the distant rock into the atmosphere. For this I merely took paint from my pile of atmosphere, added a touch of ultramarine blue, and applied it over the under paint. I wanted the rock to be mostly obscured in the fog so made sure it was barely darker than the atmosphere and had no hard edges. The foreground rocks needed more definition so I mixed a modified purple from alizarin and ultramarine blue and added a touch of burnt sienna. With this and a #6 filbert I added the darkest area of the rocks and defined some edges that weren't previously there. Next I applied some atmosphere darkened with ultramarine blue on the tops of the rocks which would reflect the sky. It also defined some minor tops and edges. I left the area of rocks unpainted where I would later add sunlight color.

"Remember, fog is a cloud of moisture and obscures detail as well as giving a lighter tint to all colors."

learning points

- The idea of toning a canvas is to create an effect. Here, I wanted some sunlight color to show faintly through the fog,
- This is a case where white foam in shadow is actually darker than the background.

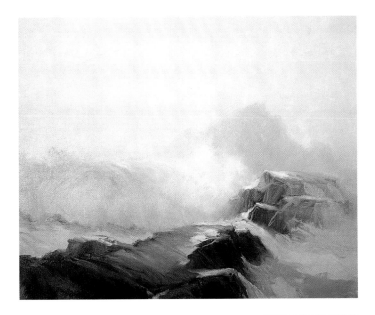

step five: breaker and sunlight

It was time to make a pile of sunlight so I blended a small dab of cadmium yellow light into white with my palette knife. (Again, start out frugally or you may have to keep adding a lot more white.) Then, with a #6 filbert, I scrubbed in the sunlit foam on the collapsing breaker. I softened the edges immediately with my dry varnish brush. I added ultramarine blue and a dab of viridian to more of the atmosphere mixture and painted the shadow side of the breaker foam. For the roll that falls into the foam I added a bit more green and made my brush follow the contours as I applied the paint. I softened the edges of all the foam. Notice that this is a case where white foam in shadow is actually darker than the background. You may also notice I underscored the wave foam with a soft-edged darker line with a bit more blue added to the foam color. Before going on I added a touch of the sunlight color to the rock in the center of interest.

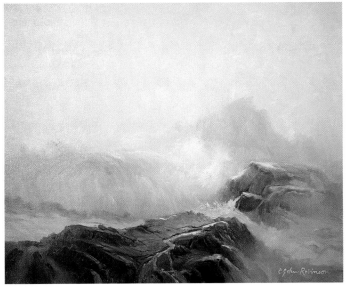

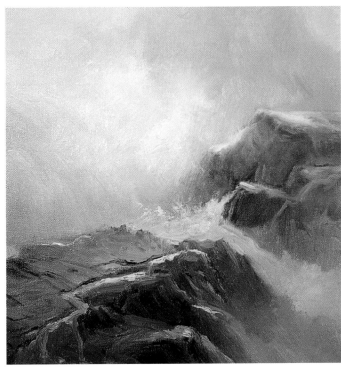

step six: details

Using a #2 filbert, I reshaped the rocks a bit. I first used the darker rock color for some edges and then lightened the rock where the sunlight would touch it, using the pure sunlight color. Next, I defined some cracks with the rock color then painted in some trickles. The trickles started out with the sunlight color near the wave and then changed to shadow color in the foreground. I used a #2 rigger brush for both the trickles and a few highlights on the rocks. The last step was to add some sunlight color to the surf near the center of interest and to blend away all hard edges except in the immediate foreground.

close-up

This close-up view is the focal point, or center of interest. As you can see, there is very little contrast to make it show up, either in values or colors. What does bring attention is the purity of the burnt sienna as opposed to the tinted colors in the rest of the painting. It is also the only area of where sunlight is concentrated. Though there are more details in the foreground rock, it directs the eye to the center of interest rather than detracts from it. The overall impression is a quiet mood. Though cool colors dominate, warm colors balance it against a near neutral grey. Soft edges dominate over hard edges, and unfilled or quiet space dominates over active space.

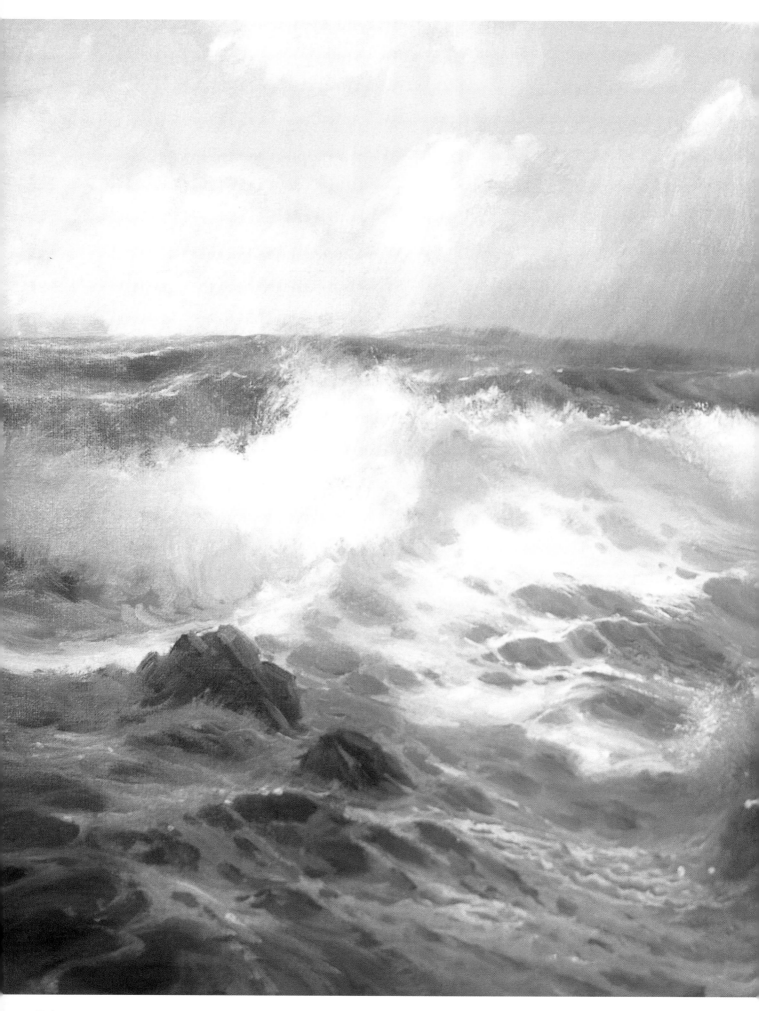

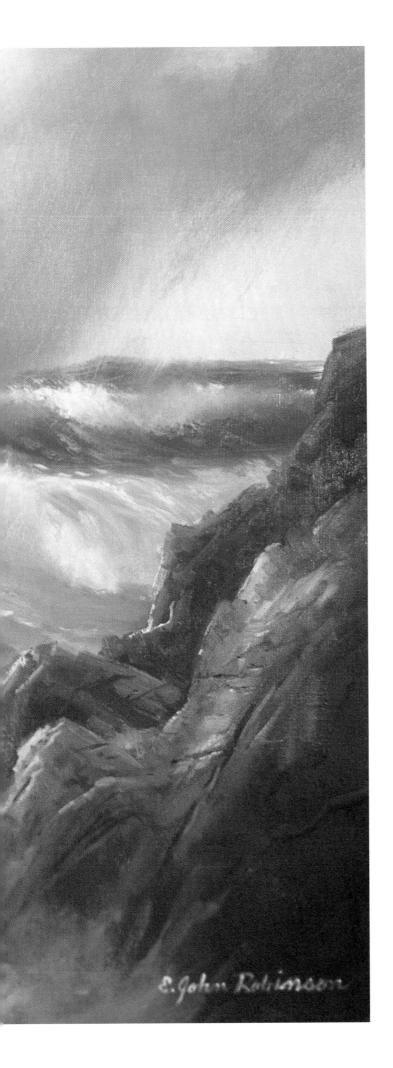

DEMONSTRATION

passing storm

How to emphasise the center of interest using soft edges, careful use of light and shadow, angles, and subtle colors.

I love the energy and the action mood of a storm. What I don't like is a somber, cold, and dark rendition that leaves me somber and cold. Instead, I like to depict the action just after the storm has passed and the sun breaks through. The energy is still at its peak, and forces are slamming against forces, but there is a bright side to it all: the sun is out and we know peace will be restored.

outline and mood lines

As you know, lines are created by the edges or direction of an object, so when you want to slant a line in any particular direction, you simply tilt the wave, or rock, or cloud, or even the implied line between shadow and sunlight. Because my aim in this painting is to depict action I want a lot of tilted lines that suggest movement, rather than the restfulness of a horizontal line or the unmoving mood of a straight vertical one. I will therefore use opposing lines, (see chapter 8), that pit one element against the other. As you can see here the passing clouds create a line that is directly opposed to the line made by the tilt of the wave. The wave and the surf move in a line opposed to the tilt of the rock. Together there is an implied mood of conflict.

values and proportions

Middle values, a bit on the dark side, will dominate the composition and light values will be sub-dominant. The dark values will accent the composition but will not be the center of interest. Instead, the center of interest will depend on detail for focus but will be helped by having dark values surrounding it. As usual with most of my paintings, I want a wave or a burst or even a corner of a wave as the center of interest.

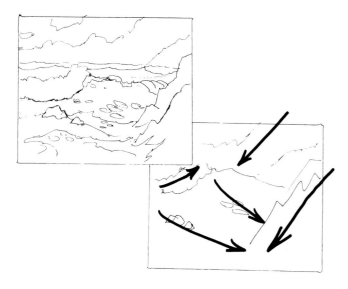

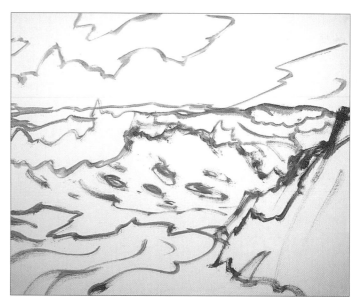

step one: outline

"Passing Storm" will be on a 16 x 20" stretched canvas. I used thinned ultramarine blue to place where I want each object in the composition. Once again, I did not go into any detail.

center of interest and direction of sunlight

I chose to place the sun low over the horizon but off to the left where it can't be seen. In that way I created another angle in the way the sun crosses the composition. By assuming there are bluffs or large rocks also to the left but unseen, the sun can then cast shadows across the surf where I need darker values. I have always said: 1: compositions are much more interesting if divided between sunlight and shadow. 2: shadows can always be justified either by clouds or objects in the composition or from objects outside of the picture frame. These are our choices as artists. I chose the upper left quadrant for the center of interest. By placing it there, the viewer focuses upon it then sees the storm that created it. I didn't want the sunny and soft-edged waves to be right up against the dark and hard-edged rocks.

color scheme

The overall dominant colors will be blue-green from viridian and ultramarine blue. The sub-dominant colors will be a dark rock color mixed from burnt sienna and ultramarine blue. The accent color will be the sunlight which is cadmium yellow medium in white. I will also use a dab of alizarin to warm some areas and a dab of phthalo green to accent a bit of the wave in the center of interest. This will be a dominantly cool painting with warm colors for contrast. Because this is a theme of contrasts and energy, I will want some fairly pure colors such as in the rocks and the clear water in opposition to the sunlit colors of the clouds and wave.

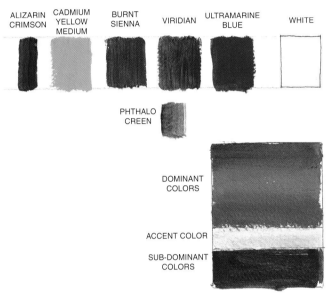

step two: dark values

I decided at this point that I needed two more small rocks on the left to give a better balance of dark values so I painted them and the large rocks first. I used a #8 filbert and scrubbed a mixture of burnt sienna and ultramarine blue onto the rock forms. I thinned the same mixture a bit to make it lighter for the areas that would later be touched by sunlight. I would not add details until much later. Next, I mixed viridian and ultramarine blue, cleaned my brush thoroughly, then applied it to the background sea and the surf, including a few holes in the blanket foam. Even though I would later go over these areas with reflected lights, I still wanted the effect of clear water so did not use any white paint. After adding small touches of phthalo green for variety, I knocked down any heavy paint with my dry varnish brush. This made it much easier to apply paint over the first layer without digging in and blending.

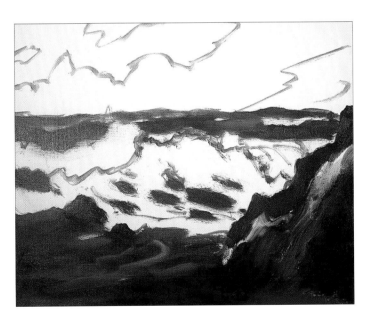

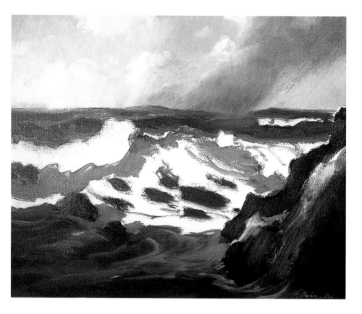

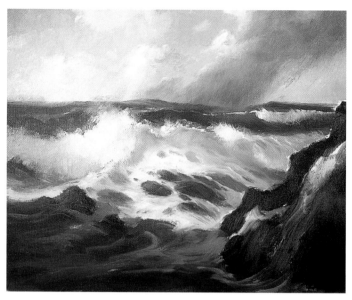

step three: sky and atmosphere

It was time to make those piles again. My sunlight pile was made from a touch of cadmium yellow medium into white, and the atmosphere color was ultramarine blue and white. With a #8 filbert I first painted the sky around the clouds. Then I added more ultramarine blue with a touch of alizarin for the dark forms of the clouds. The light, or sunny side, was pure sunlight from my sunlight pile. After softening the edges with a dry varnish brush, I applied some of the atmosphere color to the area of troughs in the background, applied a few movement lines in the foreground surf, and applied some shadows on the wave. (Be sure you clean your brush thoroughly between each application of a mixture of color, otherwise everything will begin to blend together and eventually become muddy.)

step four: the wave

Storms are great for agitating the surf and creating blankets of foam. In this case the energy of the wave had moved in and lifted the blanket and very little of the clear water can show through. I first applied color from my pile of sunlight with a touch of alizarin for all of the sunny areas.

Still using a #8 filbert I roughed in the shadows with the atmosphere color and a touch of alizarin which gave more warmth to the sunlight in the center of interest. I toned down some of the darker foam holes with a very tiny dab of phthalo into white, then added a few more light holes in the upper shadow area of the wave. The last thing to do was to soften the edges and blur the moving portion of the top of the eave.

"The purpose — a warm, sunlit scene of heavy energy and action — seems to have been achieved."

learning points

- Hard edges call attention to themselves.
- Phthalo green can be overwhelming but the tiniest dab into white creates a beautiful colour if used in moderation.
- Leave some things unplanned and you will inject more creativity into the process.
- Have a plan but allow for re-evaluations and changes.

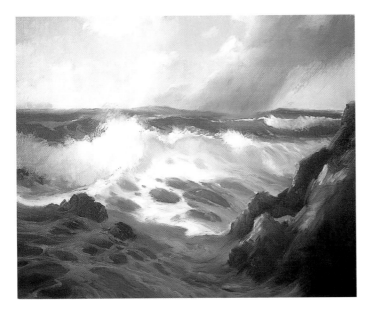

step five: rock and surf patterns

I redefined the large rock by applying some sharp edges with burnt sienna and ultramarine blue. I did the same with the smaller rocks but with less blue. I then mixed burnt sienna into some of the sunlight color and laid in sunlit shapes on the larger rock and a touch on the smaller ones as well. My next job was to lay in the linear foam patterns in the surf. (chapter 6 illustrations give examples of both surf patterns over clear water and blanket foam). I used the sky color plus a bit more ultramarine blue and let my brush follow the contours of the foreground movement. I used the edge of a #6 filbert with a very light touch and the patterns went over the wet underpaint without blending in. I did not use the tip of the brush nor did I go over and over a pattern which would have muddied the colors. Notice the slope of the patterns maintains the implied line from the small rocks towards the larger one.

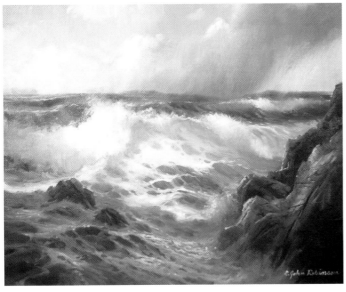

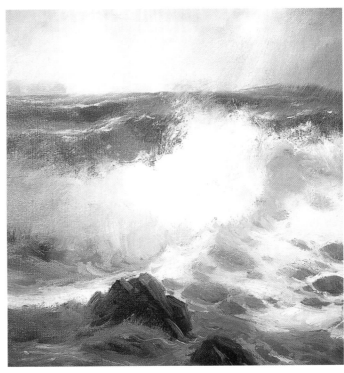

step six: final details

This was a good time to step back and make some judgments about the progress of the painting. I saw that some troublesome areas could be corrected with the final touches but the clouds bothered me. I finally decided that there were too many patches of sunlight which drew the eye up and out of the painting. I corrected this by shadowing out some of the sunlight on the main cloud then softened some more edges. Hard edges call attention to themselves. I didn't do too much more on the sunny part of the wave, just a little softening and a couple more holes for a better pattern. I spent the most time on the surf patterns. I added a lot of reflected sky and sunlight lines creating ripples and movement. Though I added a lot more than was there I still left clean, clear, water without the muddying effects of white. I used my #2 rigger brush for the finer lines and a dry varnish brush for softening the surf against the rocks. The last touches were lines and textures on the rocks. I again used the rigger brush and either lighter or darker versions of the base color I was going over.

close-up detail

This is a close-up view of the center of interest. Notice the softness of edges, the use of light and shadow, the angles, and the subtle use of colors. Phthalo green can be overwhelming but this shows how the tiniest dab into white creates a beautiful color if used in moderation. The purpose — a warm, sunlit scene of heavy energy and action — seems to have been achieved. It is important to note that changes were made along the way. I can also say that by leaving some things unplanned you will have more creativity in the process. Have a plan but allow for re-evaluations and changes.

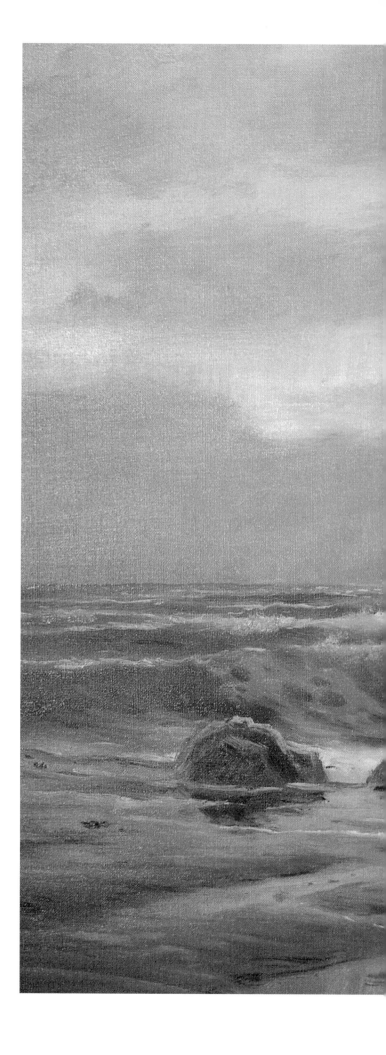

chapter 12

DEMONSTRATION

evening reflections

A restful mood is neither very light nor very dark, so the dominant value will be a middle one. Here's how it's done.

The sea is a mirror for our own moods and emotions. It can reflect what we feel or it actions can influence how we feel, so as artists we must be aware them. We should explore the different moods and not get stuck painting the same one over and over.

I recall the time I had an exhibition that consisted mostly of storm paintings and moonlight. A concerned kind patron inquired as to my wellbeing, wondering if I was having a problem. Actually, I was fascinated by the action of storms but it made me stop and wonder myself.

"Evening Reflections" was intended to be simply a quiet time near sunset and a time to reflect on the day. It should be restful and without any threat so I decided to place the viewer well away from any action.

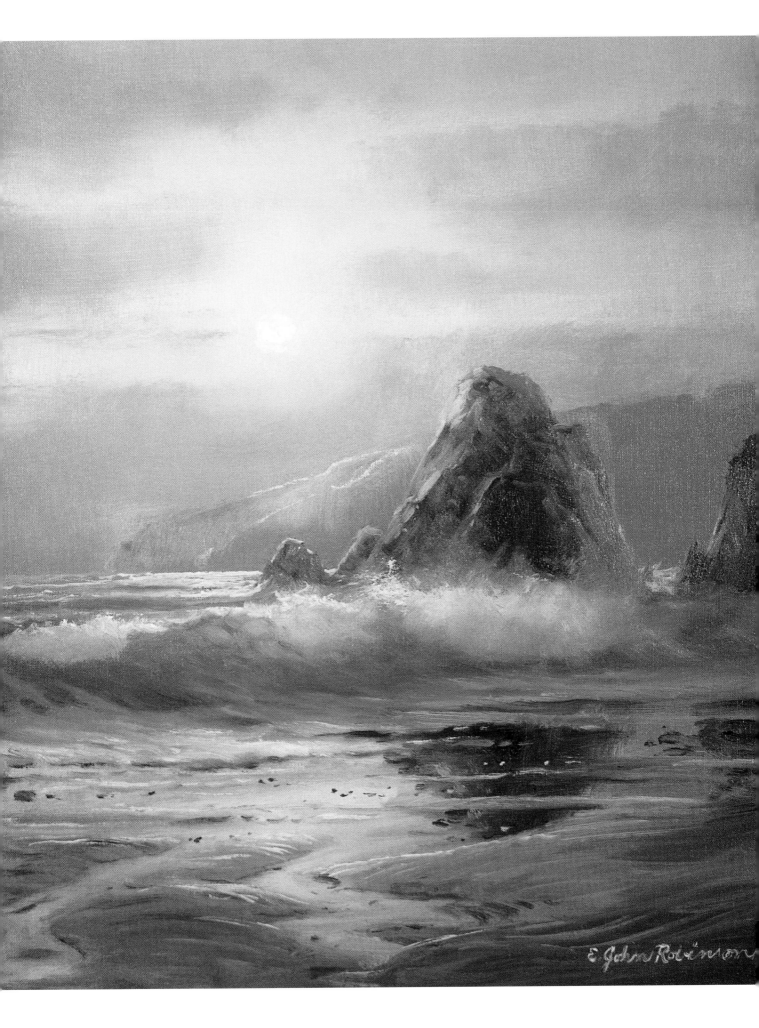

outline and mood lines

Horizontal lines suggest repose, or resting, so I have given them a dominant role. I also need a diagonal and a vertical for balance, otherwise the horizontal lines would be monotonous. Placing a vertical rock with a slanting headland behind it not only gave the balance needed but suggested a place for a focal point. Any time you change a direction, it commands attention because the eye is automatically drawn to the change. The outline of the composition merely stays within the suggested mood lines. Adding the foreground paths of water also helped the balance, but were placed there mainly to lead the eye to the focal point, or center of interest.

values and proportions

A restful mood is neither very light nor very dark so the dominant value will be a middle one. The sub-dominant value will be light because there will be a good deal of sunlight from the position of the sun. The accent, or the least used value, will be dark and will command attention and balance the overall values. The lightest light value placed against the darkest dark value will also draw the eye to that point.

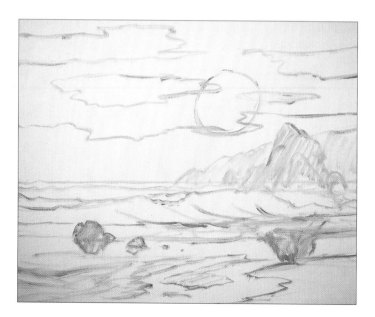

step one: outline

I began by toning this 18 x 24" canvas with a light wash of alizarin crimson. I used a 2" varnish brush and a lot of thinner with the red. I then wiped it down with paper towels which dried it and made it even lighter. The purpose was to have some warmth showing through subsequent layers of paint. I then drew a simple outline and with a #2 filbert and burnt sienna I roughed in where the dark values would be, and indicated the position of the sun.

92

center of interest and direction of sunlight

Already the center of interest has been well established with both line and value. By placing the sun off center and reflecting it downward another line is implied that is vertical to the horizontal wave. Where they meet is right where everything else meets or shows change, so there can be no doubt what is the center of interest. Notice that the dividing lines leave four spaces, or areas of the composition, and that each is different. This makes the composition balanced the way nature works — nothing is repetitive or equal and it can therefore be called informal. Man has invented formality with straight lines, equal divisions, and geometric shapes. There is a place for both in the world but when we paint nature, I believe it is better to follow nature's way.

color scheme

If I am resting I like to feel warm rather than cold so I chose to make this painting a warm one. The fact that the sun is not far from the horizon could mean warmer colors, so I will use alizarin crimson, cadmium yellow deep and light, and burnt sienna. I intend to balance all these warm colors with the cool temperature of ultramarine blue. A restful painting should not have hot temperatures so I must be careful not to overuse the red. Yellow-orange will dominate, a warm purple from blue and red will be sub-dominant and the least used will be blue. which balances well with orange. I will temper the colors with white.

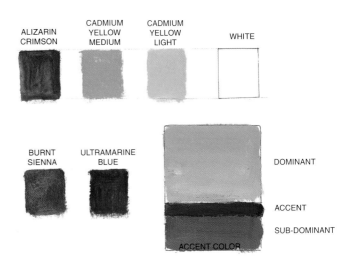

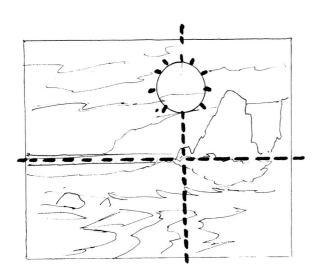

step two: background sky and sun glow

For the method of painting a sun glow please refer back to chapter 7. I use the same procedure here, but with different colors. Using a #8 filbert, I started with a touch of cadmium yellow light into white and filled in the circle I had drawn in the outline. I next added a touch of cadmium yellow deep to the same mixture and worked outward for a short distance on both sides of the sun area. As the glow spreads it should become cooler in temperature so I added a bit of purple to the yellow-white mixture. (I made the purple from alizarin and ultramarine blue.) Notice how the value changes very little because I added a bit of white at each stage until I reached the edges of the canvas. As I painted in each stage I repeated the exact area in the
foreground that would reflect the sky. I left the clouds for the next step. The final touch was to blend with a dry varnish brush all the divisions of color application so no edges would show.

step three: clouds

Clouds should change color and value as they recede from the sun. The clouds nearest the sun are alizarin and a touch of ultramarine into white. I applied the mixture with a #6 filbert and scrubbed the edges slightly into the yellow sky. This suggested the influence of the sun's color. As I painted the clouds outward from the sun I dropped the yellow and then lessened the amount of red. By adding a bit of ultramarine the clouds gradually become cooler towards the outer edges. I used the same mixture, which by then was ultramarine blue with a touch of alizarin into white, and painted the background headland and the background sea. (You may notice that both gradually become redder towards the area of the sun.) I reflected the darker cloud mixture on the outer edges of the wet sand areas and finished both the clouds and the reflections by softening their edges with a dry varnish brush. The last touch was to add a small circle of pure white for the sun.

step four: rocks and beach

Burnt sienna is the base color of the rocks. I first scrubbed in both the rocks and their reflections, then added alizarin on the sides nearest the sun, and ultramarine on the shadow side. Using a #6 filbert I actually blended the colors right on the canvas. On the shadow side I also applied some reflected light using the color from the darker clouds.

The beach area was scrubbed in with a #8 filbert using mostly burnt sienna. Just as I did with the rocks, I added alizarin in the area of the sun reflections, and ultramarine on the outer edges. I left the water trails as they were, which reflected the golden light of the sky

"Any time you change a direction, it commands attention because the eye is automatically drawn to the change."

learning points

- The sub-dominant value will be light because there will be a good deal of sunlight from the position of the sun.
- The accent, or the least used value, will be dark and will command attention and balance the overall values.
- The lightest light value placed against the darkest dark value will also draw the eye to that point.

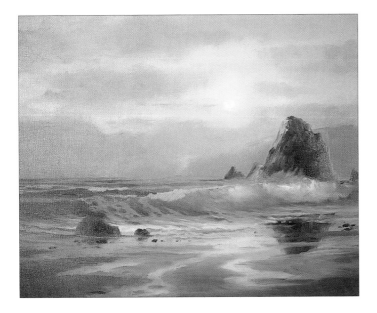

step five: the wave

I painted the background swells in first. I used a #4 filbert and ultramarine with a touch of alizarin. I left the reddish color under the sun the way it was because I'll didn't want dark blue in the area of the sun's reflections. The base color of the wave was ultramarine blue with a touch of alizarin, except in the area of translucent water. There I used cadmium yellow light and white and darkened it at the bottom with ultramarine. I then blended the lighter water outward and into the base color on either side. This blending of yellow into blue gave a hint of green to the wave which is quite acceptable. The wave foam and foam patterns were roughed in with a #2 filbert using ultramarine into white. I used more blue however, for the patterns because they were laid over the dark wave and I used the same color for the blanket foam in front of the wave. In the translucent area I used a #2 rigger brush and painted a few silhouette patterns for interest. (see chapter 6.)

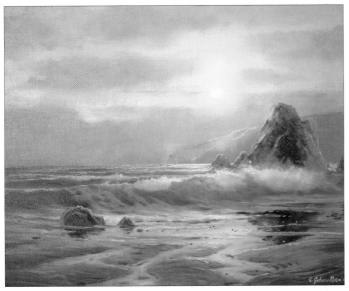

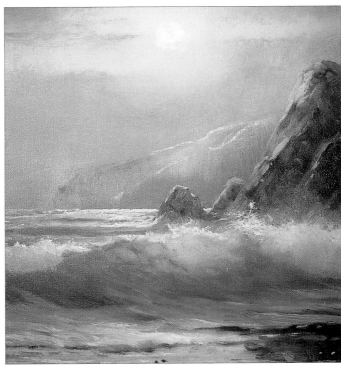

step six: final details

The final touches were mostly the addition of sunlight using a #2 rigger brush. I started in the background sea and reflected the glow of the sun using a touch of cadmium yellow light into white. I also laid in a touch of light on the distant headlands and the sunny side of the rocks. Next, I painted the upper area of the wave foam with the same sunlight color but dabbed it with a varnish brush as I showed in chapter 6. The beach also got some thin reflection lines but in a true vertical position to the sun. Outward from the sun's path I added reflected sky and cloud colors. The lines followed what would appear as sand ripples. A few more pebbles, a little more softening of some edges, and the painting was completed. Anything more would be too much for what should be a restful and reflective mood.

close-up detail

You can see in this close-up of the center of interest the importance of pre-planning. There is no doubt as to the focal point because of contrasts of line, edges, values and color. This area also has the most attention to detail. Surrounding this is the quieter dominance of less details and reflective colors that gives the painting its mood.

chapter 13

DEMONSTRATION

moving shoreward

Learn how to use lines that join one another in a harmony of motion, but without falling into the trap of creating conflict where one line opposes another.

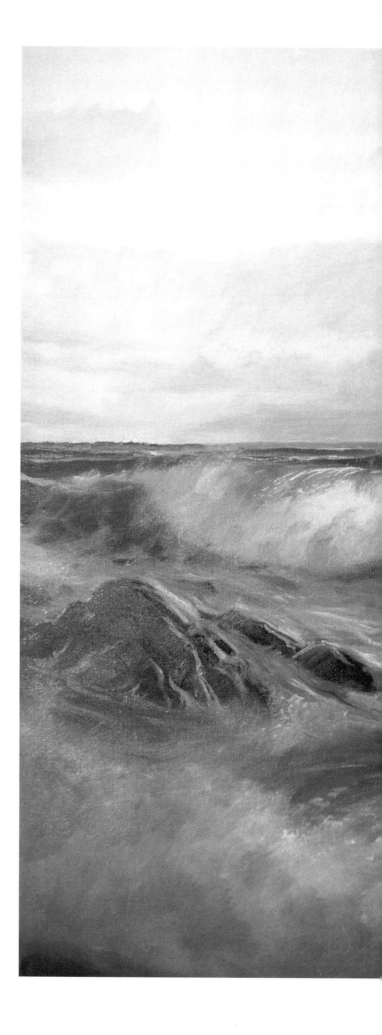

Is motion a mood or a condition? I know that the physical movement of surging water is a condition, but I also believe it creates a mood within us. A gently rocking crib can lull an infant to sleep and a violently rocking boat can make one ill. Somewhere in between there is a feeling that simply conveys the ongoing changes of the universe, a journey of sorts, the energy of life. To me, there is no better way to express this mood than the motions in the surf.

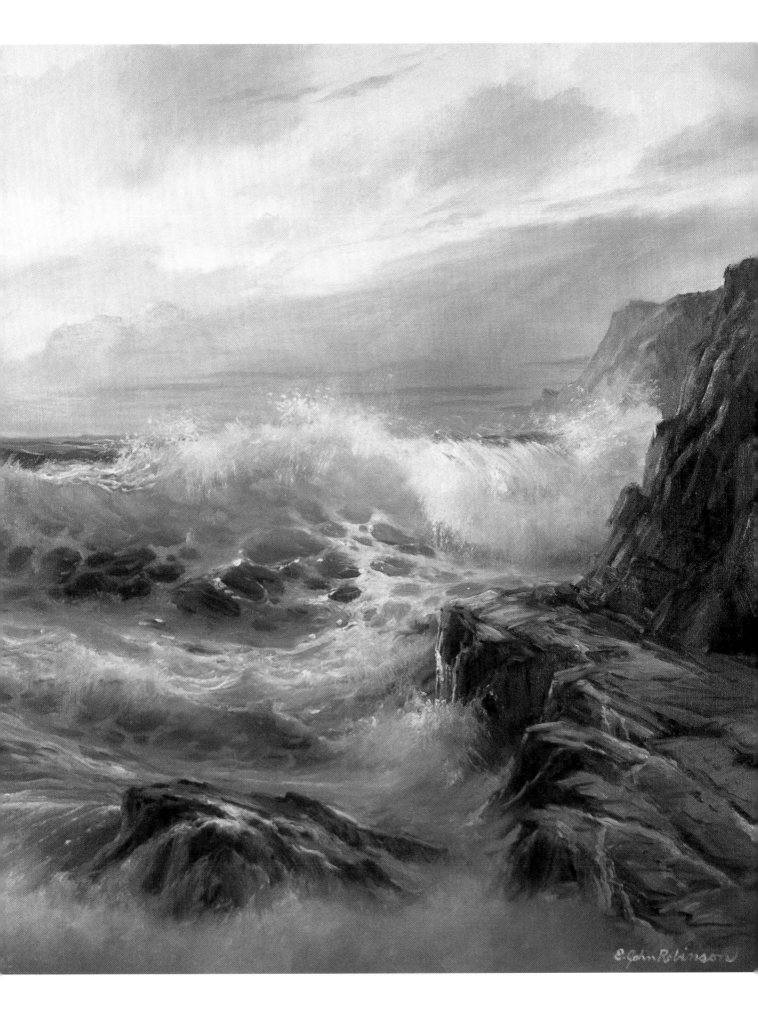

outline and mood line

To express the feeling of gentle motion I arrange the players in this drama so that they create moving lines. The sky, the sea, and the rocks, all curve as they meet each other. The curves are gentle and suggest a rocking or swaying motion, exactly what can happen in a surf charged with energy. The edge of the major rock sweeps down and converges with the arc created by a surf swell. The smaller rocks line up to form another arc rising to meet the main rock, and its outer edge leads back and points to the wave. Instead of conflict where a line opposes another, these lines join one another in a harmony of motion.

values and proportions

I don't want this mood of gentle motion to be dark or threatening so I plan to have a dominant light-middle value with a very light accent. The sub-dominant values will be dark but nothing near black. Even though the surf will be quite active, I still don't want it to seem angry or stormy so I keep the values close together and reduce contrast and boldness. It is important to know that the artist is the director and is in charge of placement, lighting the placement of the players, the lighting effects and anything necessary to set a particular mood on this stage, the canvas.

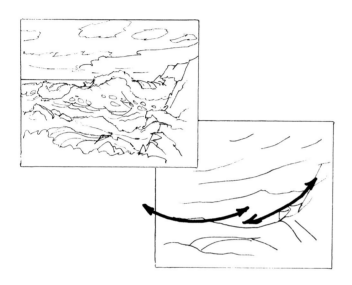

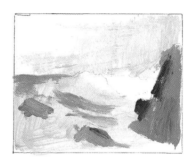

step one: outline and value wash

I stretched my canvas over a 24 x 30" frame. Instead of toning or just drawing in an outline, I added a value wash so you can see another approach to beginning a painting.

A value wash is much like painting a watercolor except I use just one color. I simply wet the canvas with paint thinner using a 2" varnish brush, then worked in ultramarine very quickly. I could add more pigment for darker areas or more thinner for lighter ones. I could also correct or add rough lines by lifting off the pigment with a paper towel. It wasn't necessary to go into any detail because it would all be covered up later. I chose blue because it related to the overall color dominance. Had my painting been planned with a warm dominance, I could have used any of the warmer colors for the value wash.

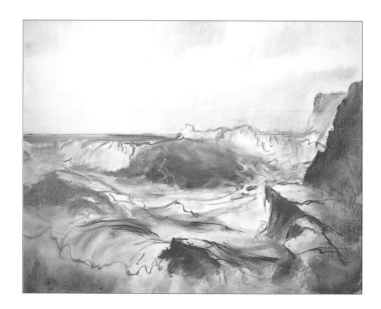

center of interest and direction of sunlight

I place my center of interest in the upper, right hand quadrant of the canvas. This will give a larger foreground area for depicting the motion of the surf. The horizon line and the major rocks meet where I want a portion of the wave to be spotlighted for a focal point. By placing the sun off stage, above, and to the left, it will shine on a slant toward the center of interest. It will also be used to highlight rocks and foam which will add to the curving of the implied lines.

color scheme

I planned to use a good deal of white in this painting to keep the colors subdued. Again, the mood is not bold or angry; it is gentle and my colors must be low key and cool. The dominant color will be a light blue made from ultramarine and white. As orange is the complement of blue, I will use burnt sienna. Viridian and alizarin will be the only other colors used and they will not play a dominant role. If used sparingly viridian will mix well with the blue and alizarin, and will warm any of the other colors. Pure white will be the accent.

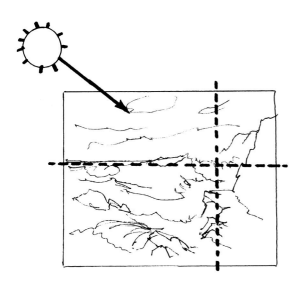

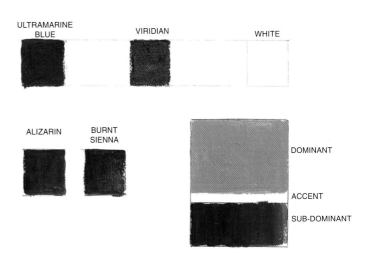

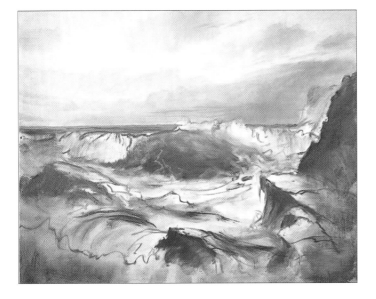

step two: the sky

After washing in my watery looking sky I decided to keep the effect. I began by mixing a large pile of white with a touch of alizarin for warmth. Then I used my #8 filbert and painted across the entire sky except for the clouds. I started on the left, near the area of the sun and worked to the right. As I approached the right side I added a small amount of ultramarine. This gave the sky a warm light that gradually became cooler. The clouds were ultramarine into white. I added a tiny amount of alizarin to those nearer the sun but not the rest. I darkened the clouds away from the sun with more blue, all with a #6 filbert. I added some wispy clouds to enhance the movement and then softened the edges with my dry, clean, varnish brush. The overall effect is a low key sky with gently arcing clouds. It holds no threat of storm but appears more like a clearing atmosphere.

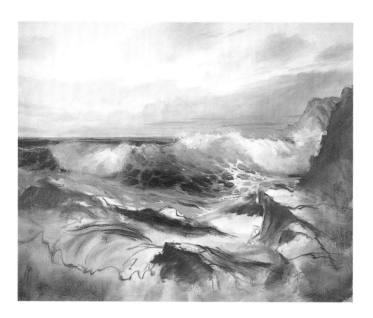

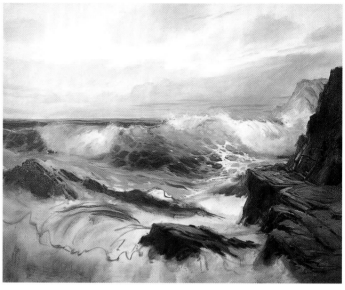

step three: the wave

I painted this wave with the same steps shown in chapter 3. This one is just more complex. I started with ultramarine and viridian for the darker portions of the wave and used no white until I painted in the translucent area. In that area I added a tiny touch of phthalo green which I didn't even list for this painting. This shows that the artist must still be flexible in spite of the game plan. I was still using a #6 filbert and after cleaning the blue-green from it, painted the wave foam with pure white. I then shadowed the white with ultramarine blue. The foam trails were ultramarine and white but darker than the shadowed foam except for the patterns in sunlight which were pure white. For the background sea I went back to the blue-green I had mixed for the wave and cut in swells with the edge of my brush.

Everything would get more detail later.

step four: the rocks

If you scrub burnt sienna over a wash of ultramarine it will give a rich color if you allow some of the blue to show through. I used a #6 filbert and scrubbed lightly so all the pigment didn't blend in. Next, I mixed ultramarine and alizarin for a rich purple and scrubbed in the dark portions of the rock. For the tops I added some white to burnt sienna for the lighter portion and used the cloud color of blue and white for the shadows. The cracks were either the purple I had used for the dark areas or the blue-sienna. I used a #2 filbert and dragged the pigment with the thin, flat edge of the brush. The smaller rocks were painted the same as the larger ones but the background bluff was just a darker version of the darkest cloud.

"Even though the surf will be quite active, I still don't want it to seem angry or stormy, so I keep the values close together and reduce contrast and boldness."

judgment time

When everything is roughed in or nearing completion, it is a good time to step back and see if anything needs correcting other than the final details to come. Are the values correct? Does the color harmonize? Is there anything that keeps drawing attention that shouldn't be? It is good to step back and evaluate, even go away for awhile. When you come back after a rest you may see something you had overlooked because you were too close and involved for too long.

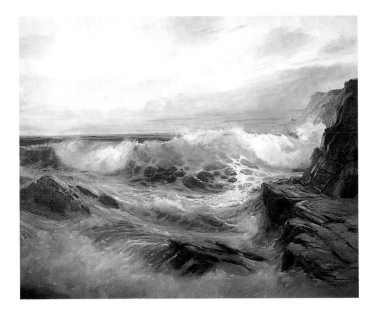

step five: the surf

I wasn't satisfied with the background bluff after painting in the rocks because it faded into the atmosphere too quickly so I added a bit of rock color. I made sure it was still much lighter than the foreground rock but carried the color. For painting the surf, refer back to chapter 6 that explains about foam and ripples. I used the same ideas but in this case scrubbed in viridian and ultramarine for the water with a #4 filbert and then over laid the light and shadowed ripples and contours with a #2 rigger brush. The collapsed wave foam in the foreground was white, shadowed with ultramarine. I softened the upper edges with my varnish brush.

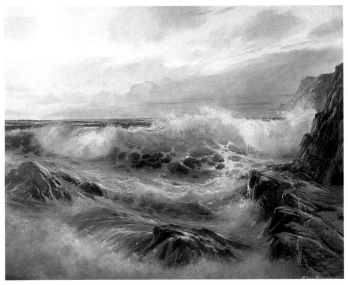

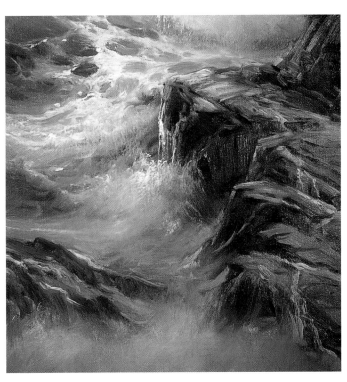

step six: final details

Only minor touches were needed to complete the painting. I added some light touches of pure white with my rigger brush to the background sea and also to the surf where I wanted light to glint. I added a bit of the lace curtain effect to the wave. (Refer to chapter 6,) I also added a bit more spray on the wave foam by dabbing in more white with my varnish brush. All of the rocks need more work so I added sky reflections, glints of light, textures, and more cracks

The next final touch was to add trickles. I used my rigger brush and painted in either white or blue-white and followed cracks or allowed the trickles to fall over crevasses. I was still not satisfied with the wave so went back and added some clear holes again using a touch of phthalo green with white, finally I and some more silhouette patterns. I hazed them so they wouldn't be hard edged or distract from the center of interest.

close-up detail

This close-up shows a portion of the rock on the right. Referring back to chapter 5, will explain just how the understanding of these details can enhance any painting. Notice that the rocks look solid and have hard edges. This gives contrast to the dominant softness in the rest of the painting. Also notice that everything has its place in sunshine or shadow and above all, the rocks have tops and sides. This portion of rock also plays the role of pointing to the center of interest. It has details such as the backlit water falling from the outer tip which is very near the focal point and at the same time harmonizes with the rest of the painting by reflecting the dominant blue color. Everything has a role to play and must play it well.

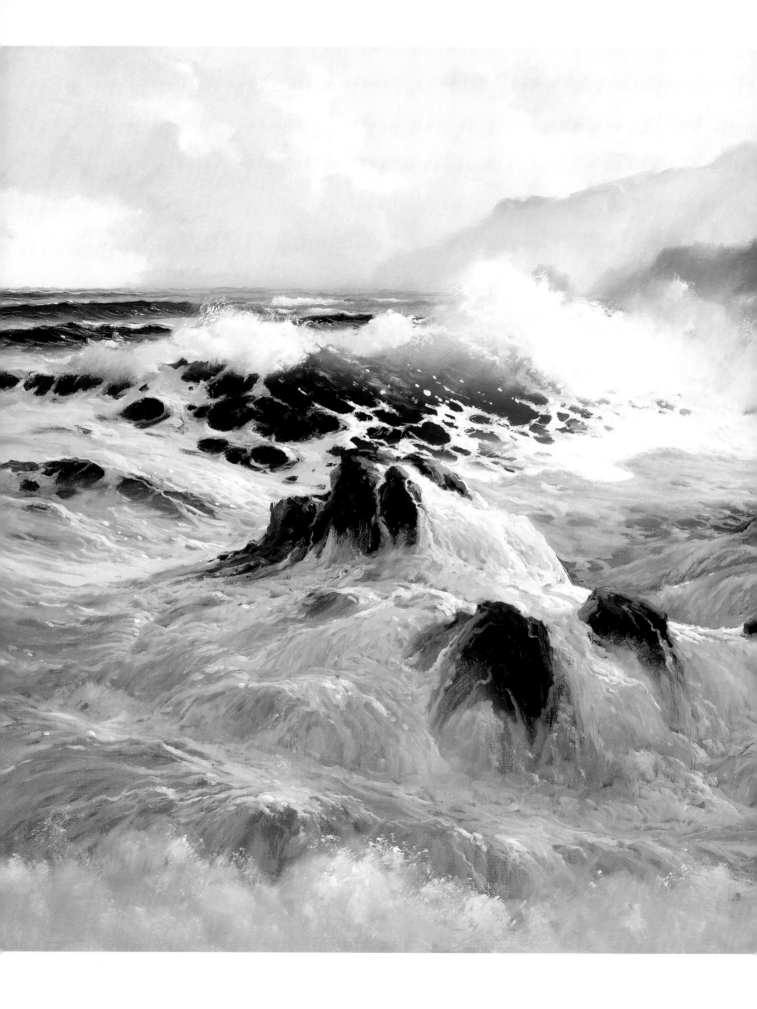

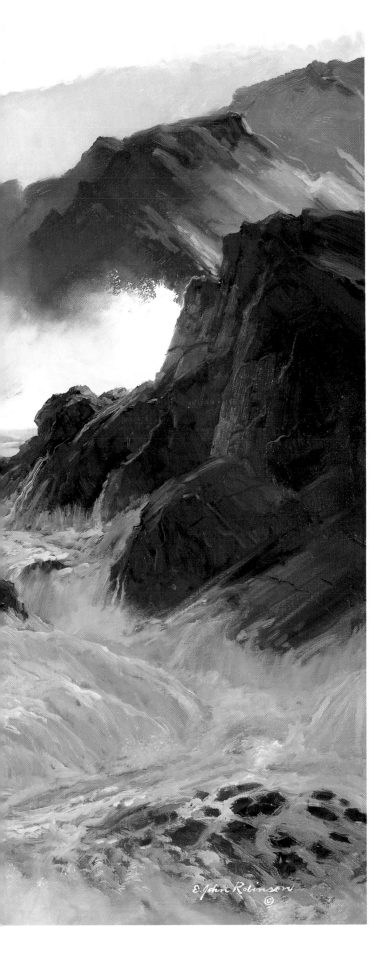

section 4

gallery

"North Coast Breakers", oil, 30 x 40" (76 x 102cm)

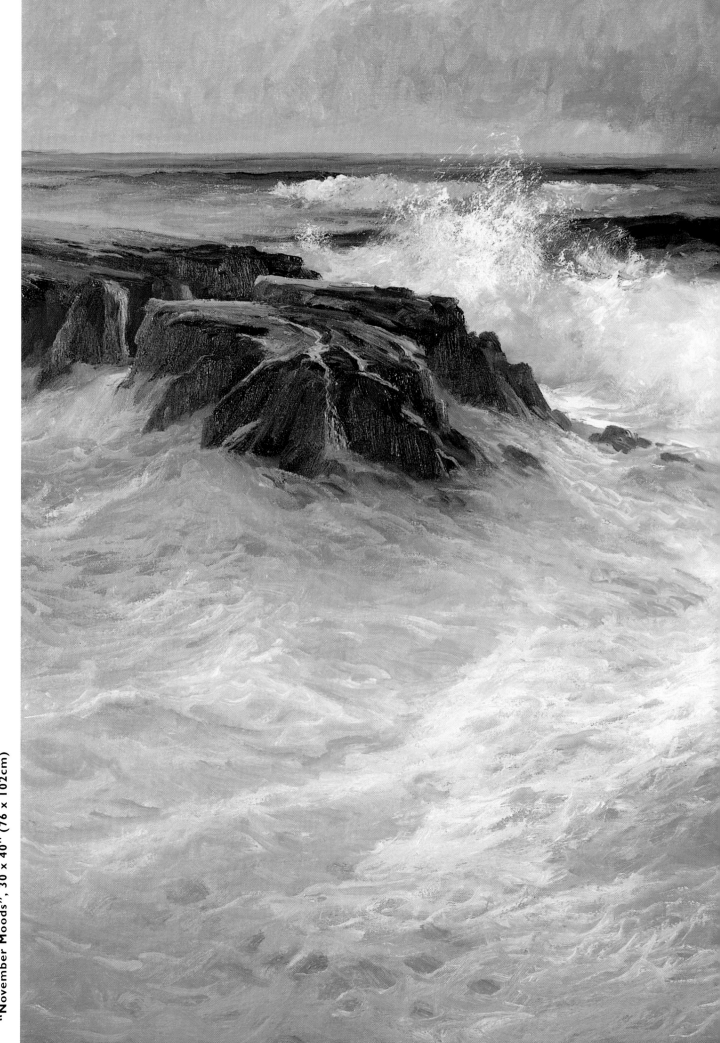

"November Moods", 30 x 40" (76 x 102cm)

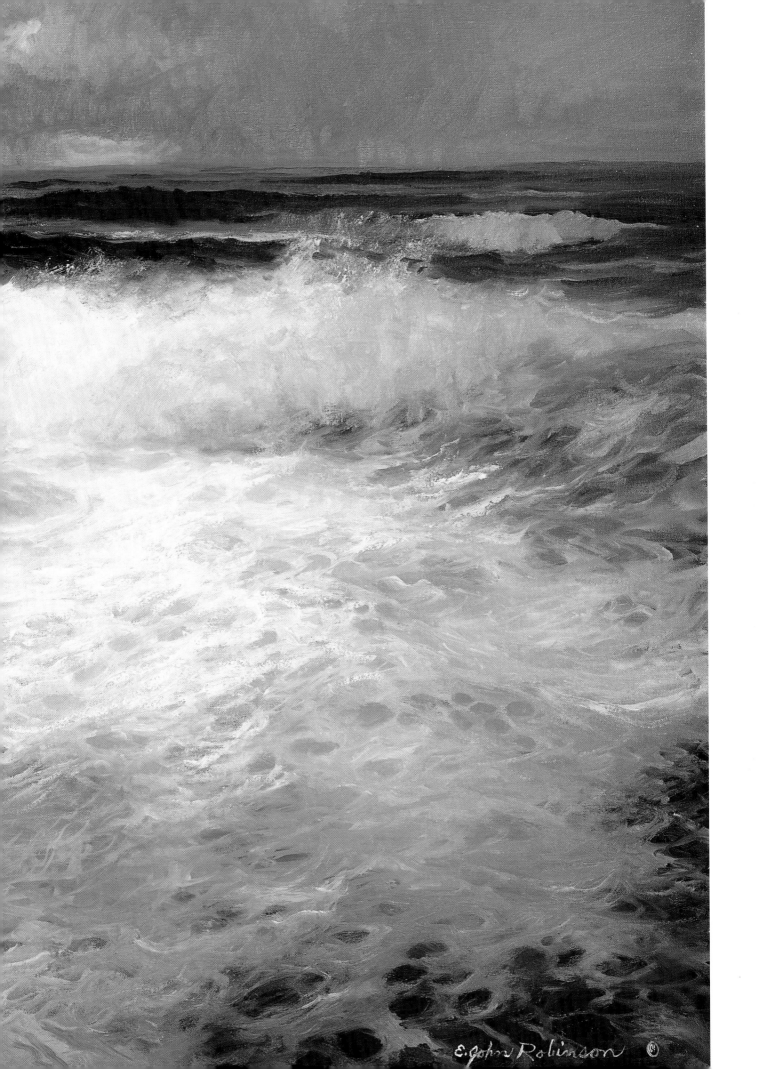

E. John Robinson ©

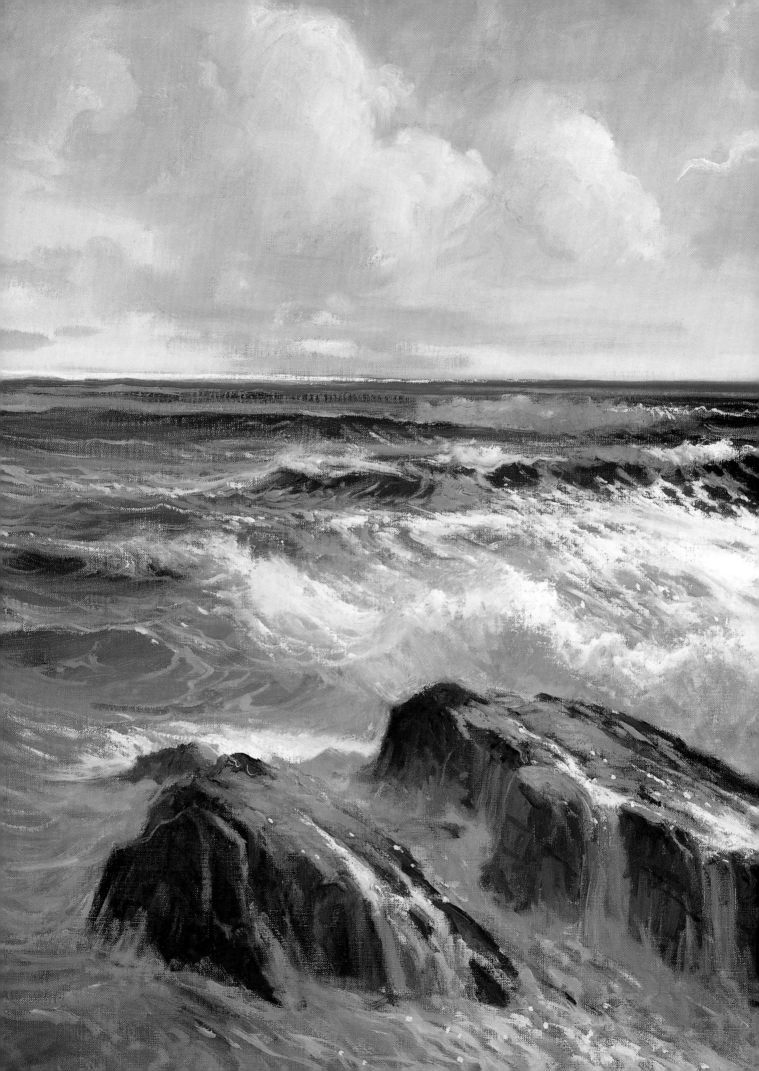

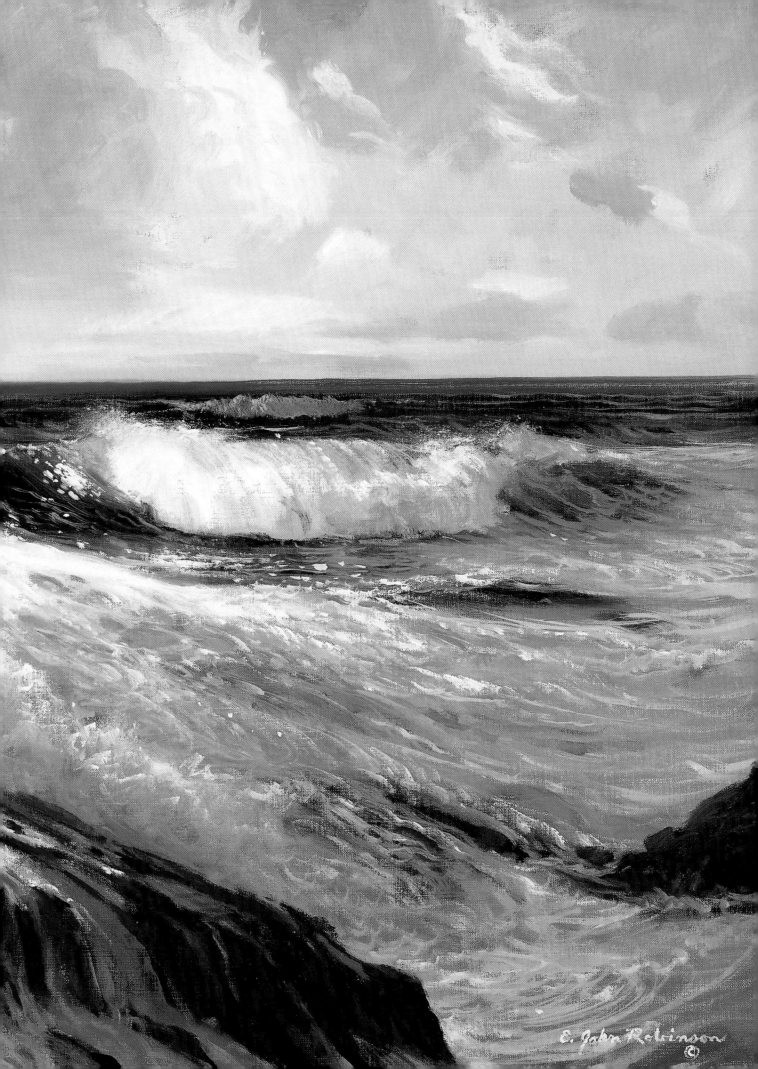

E. John Robinson

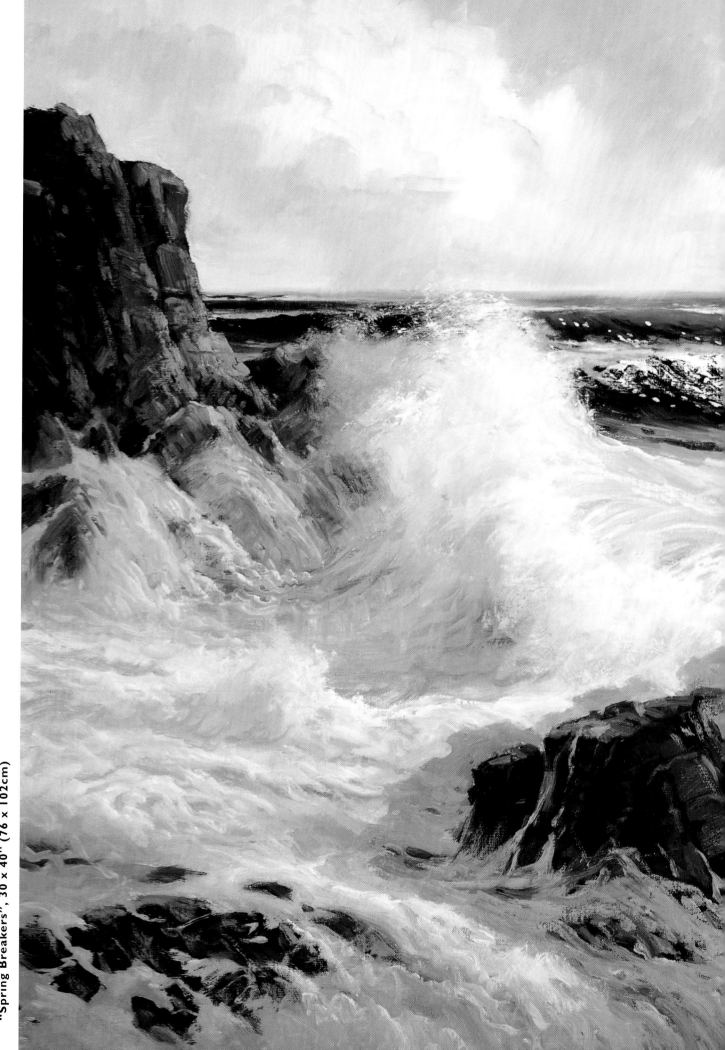

"Spring Breakers", 30 x 40" (76 x 102cm)

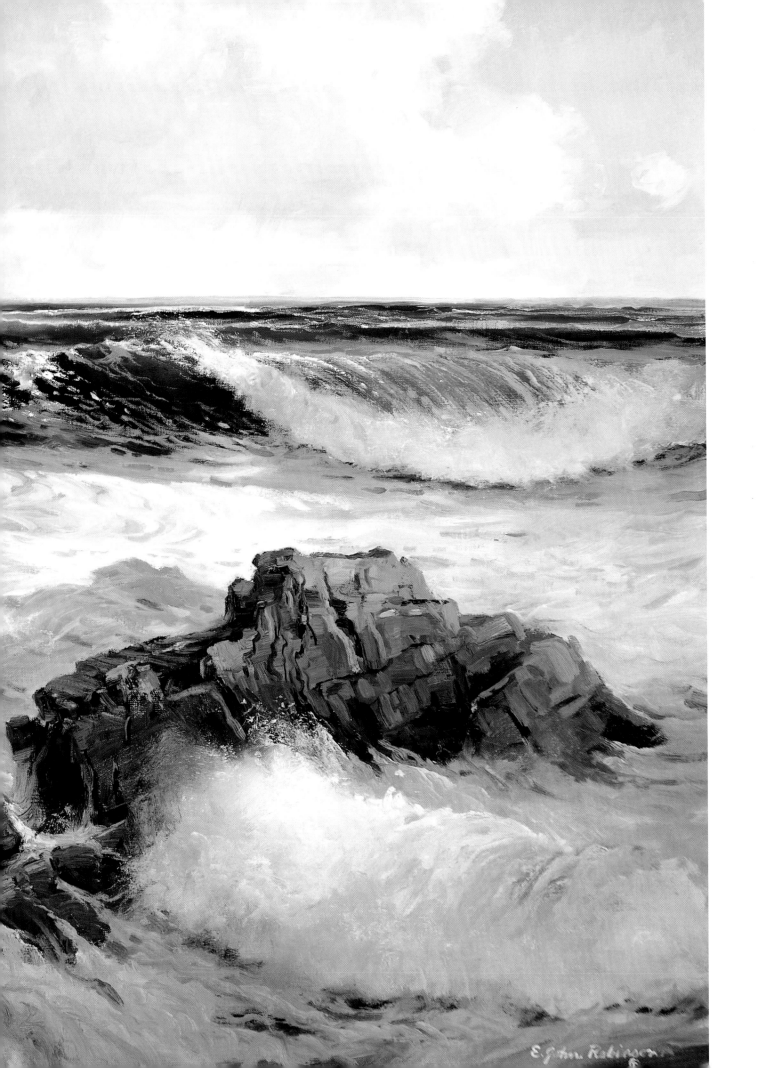

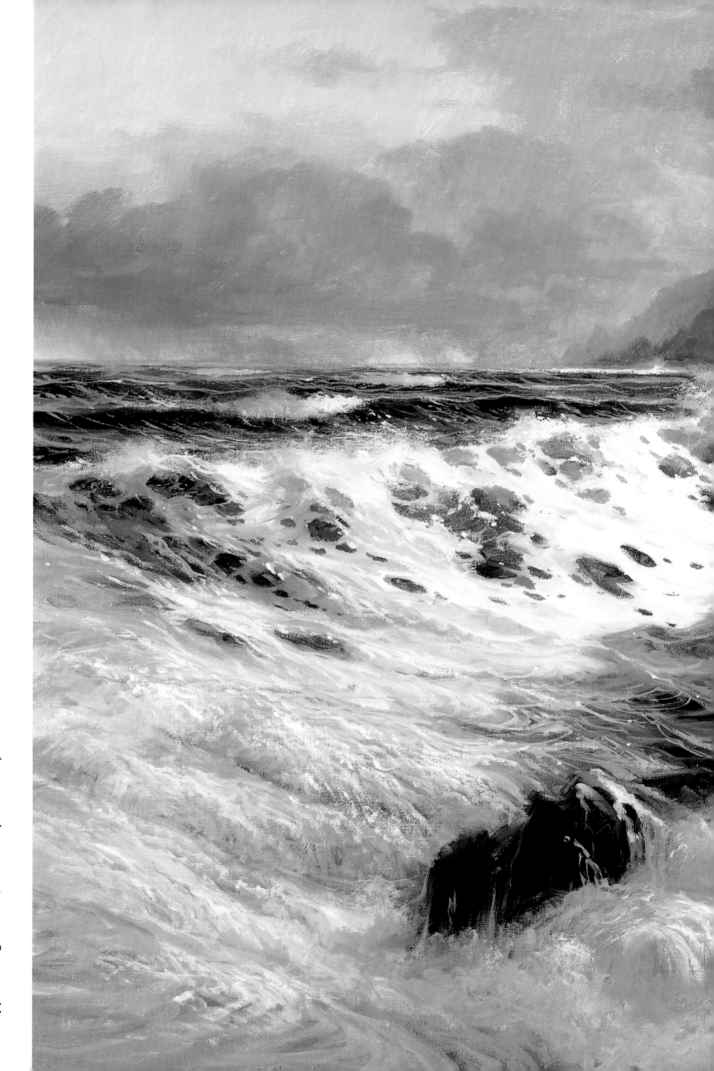

"Approaching Storm", 24 x 30" (61 x 76cm)

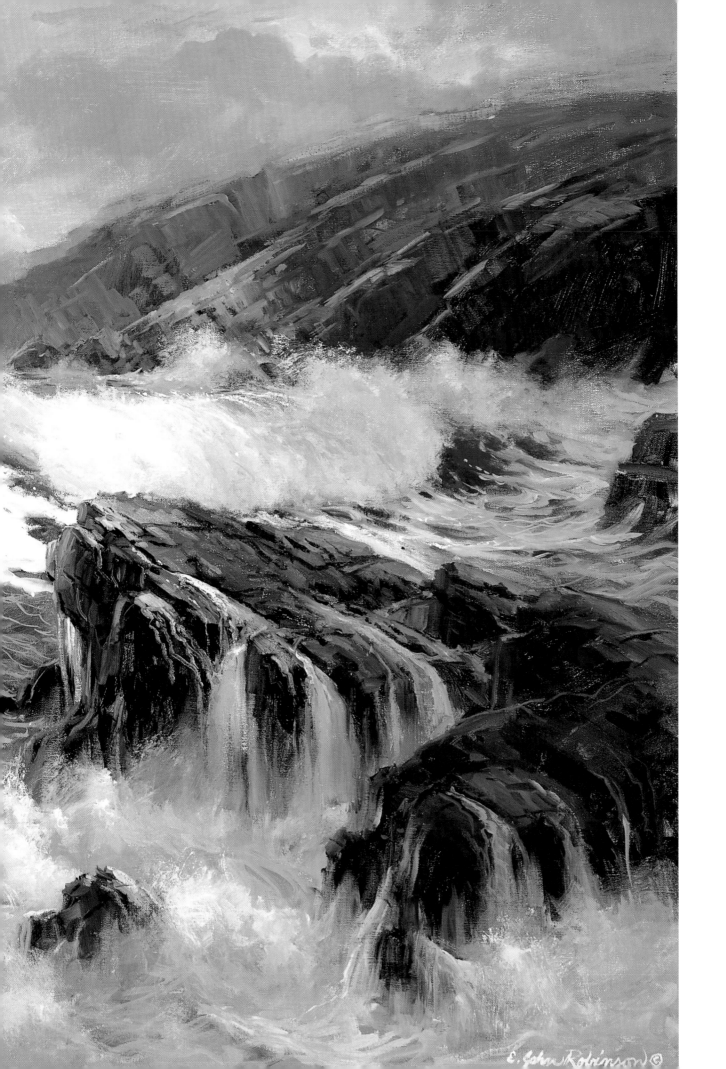

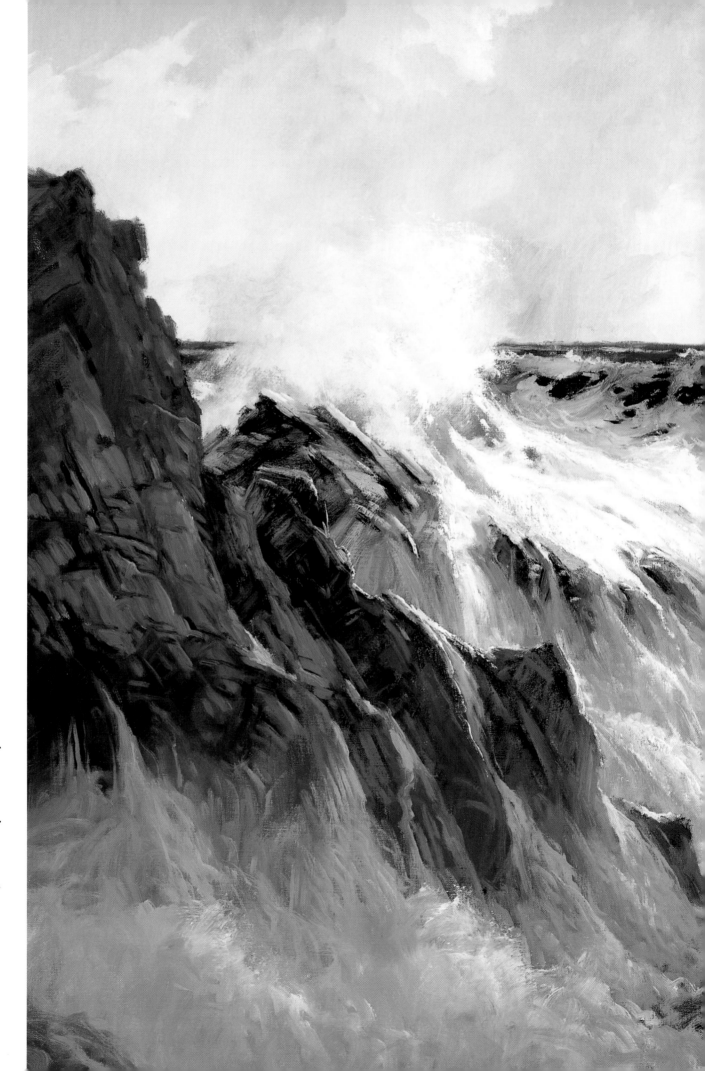

"March Storm Waves", 30 x 40" (76 x 102cm)

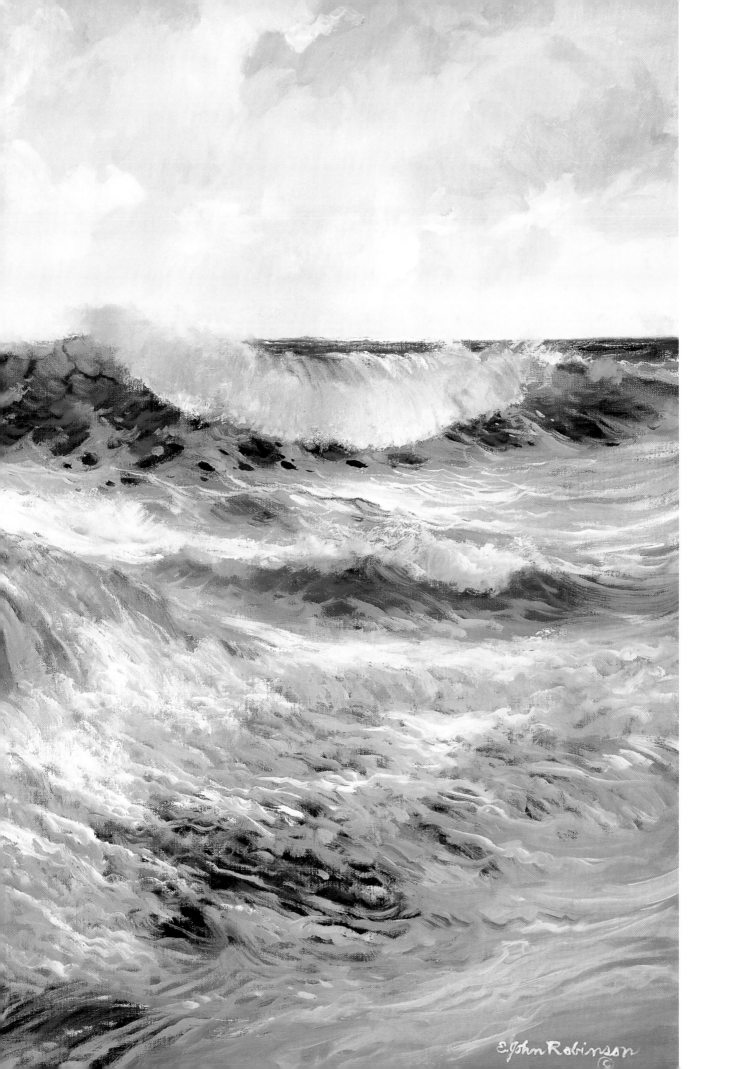
E. John Robinson

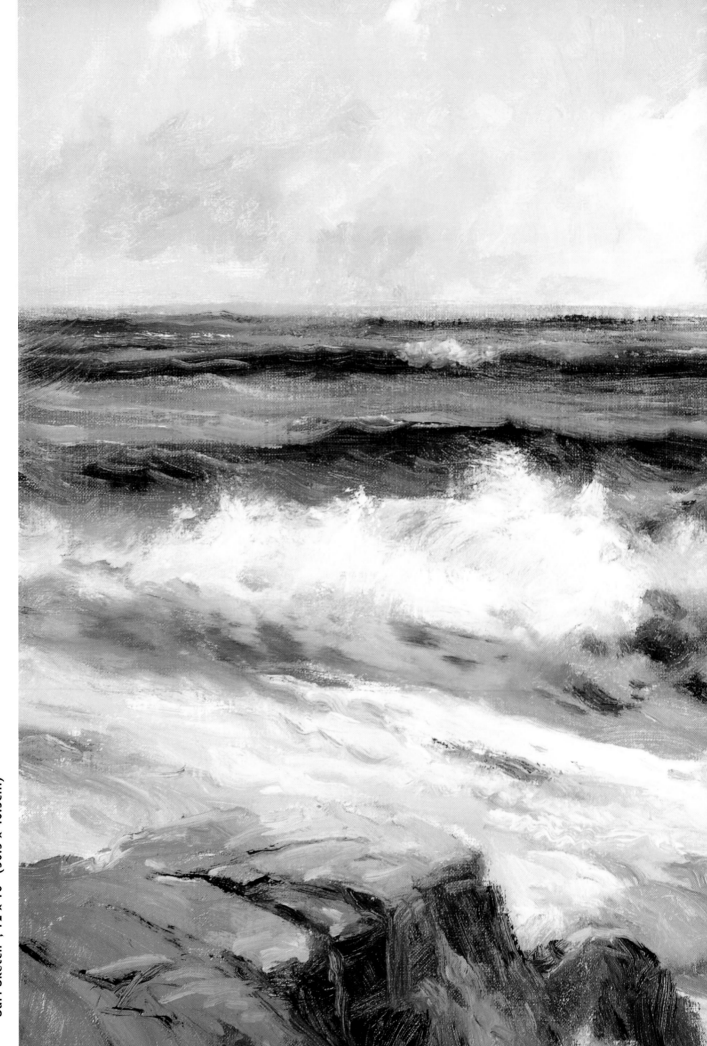

"Surf Sketch", 12 x 16" (30.5 x 40.5cm)

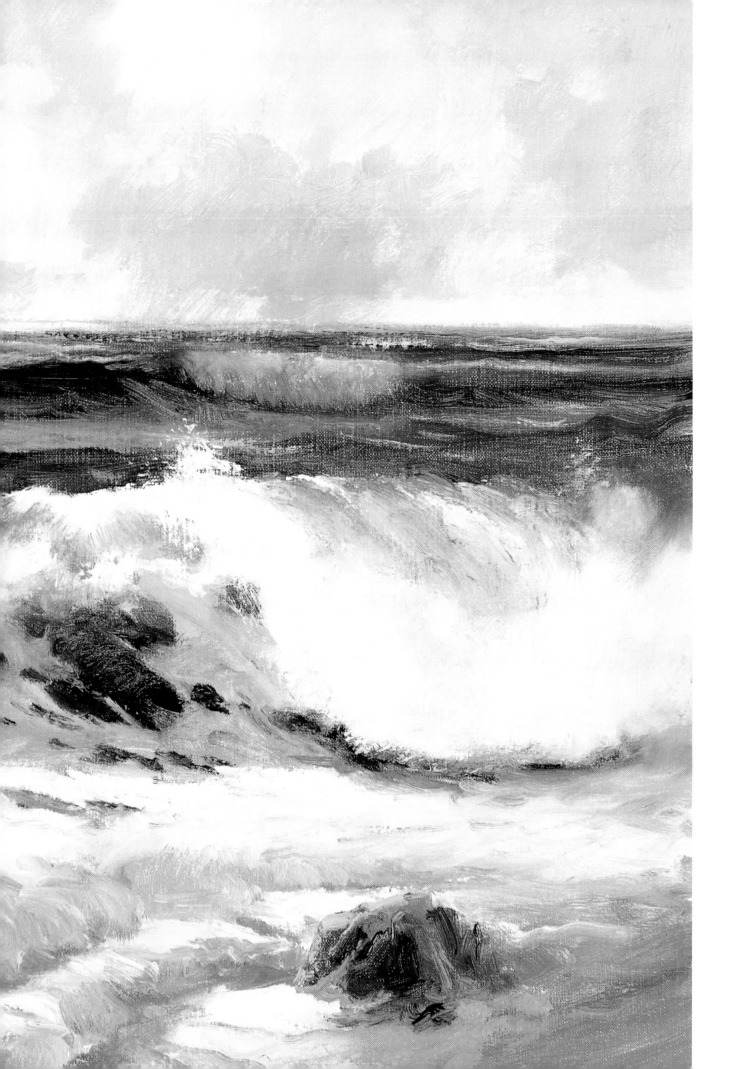

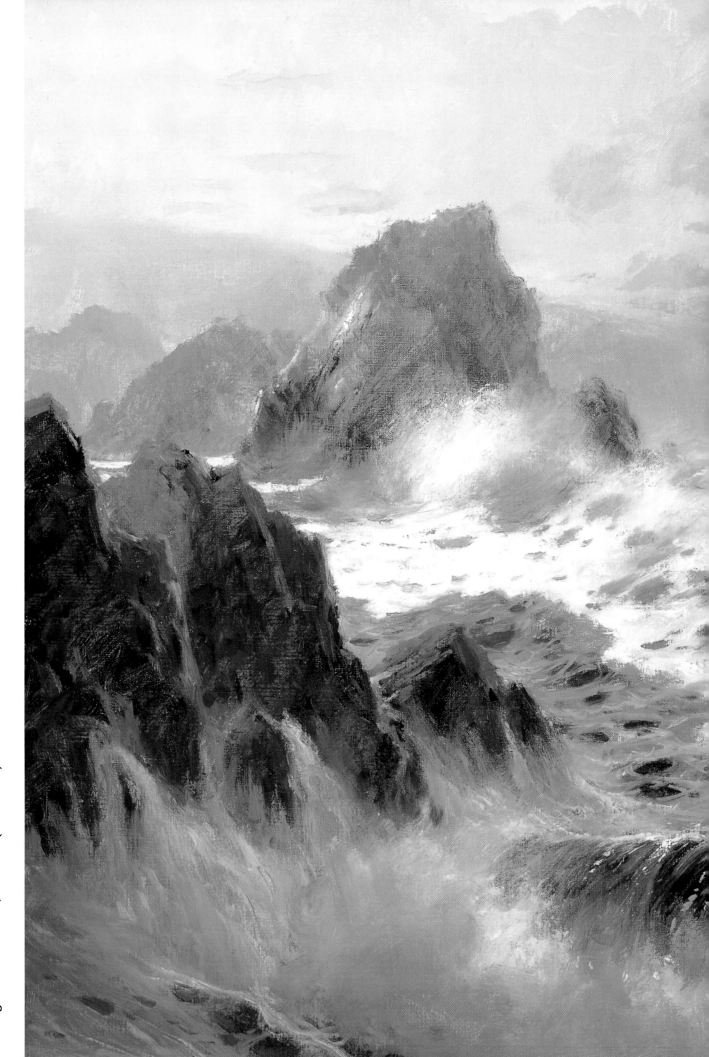

"Against the Rocks", 24 x 30" (61 x 76cm)

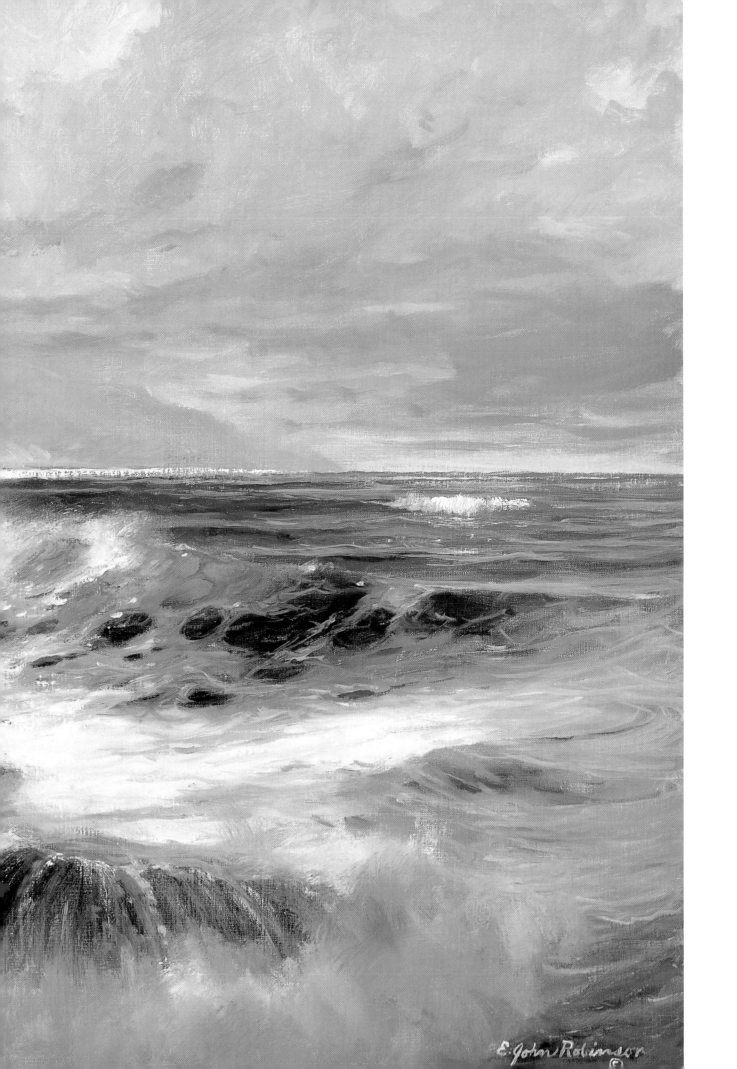

E. John Robinson

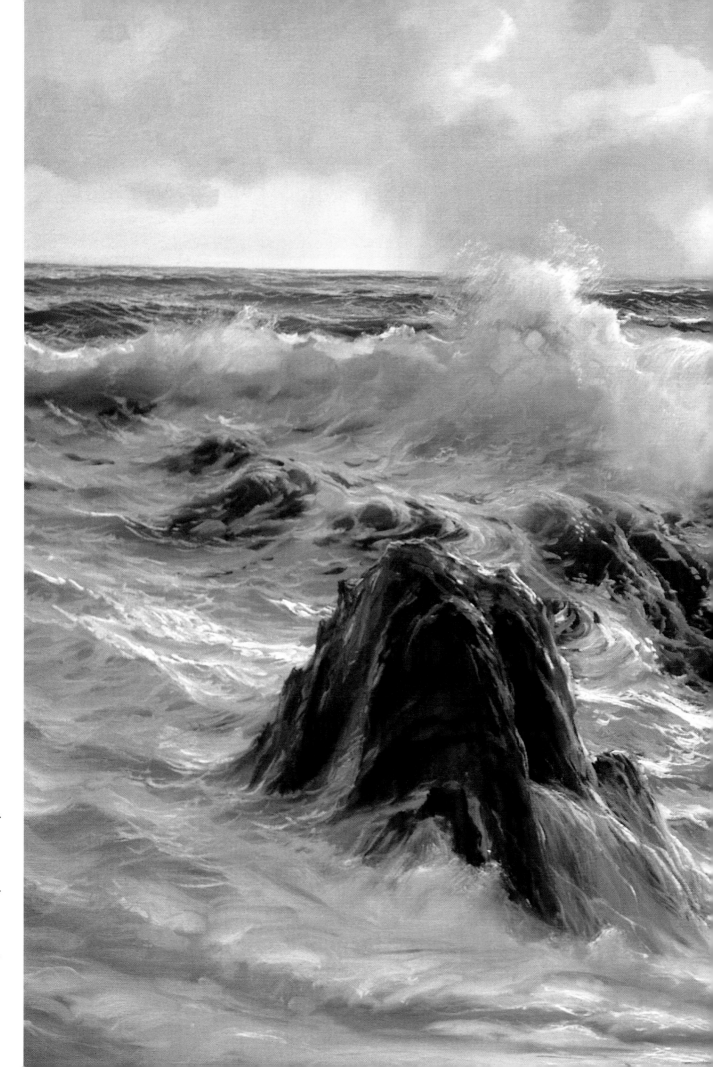

"Eventide", 30 x 40" (76 x 102cm)

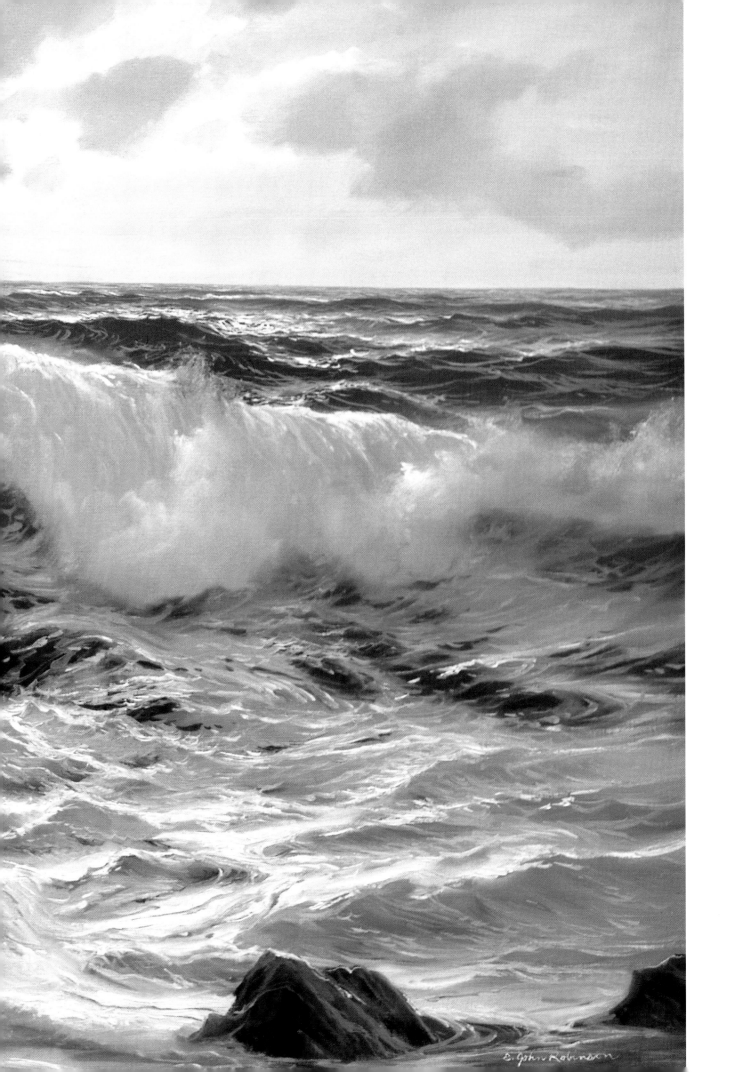

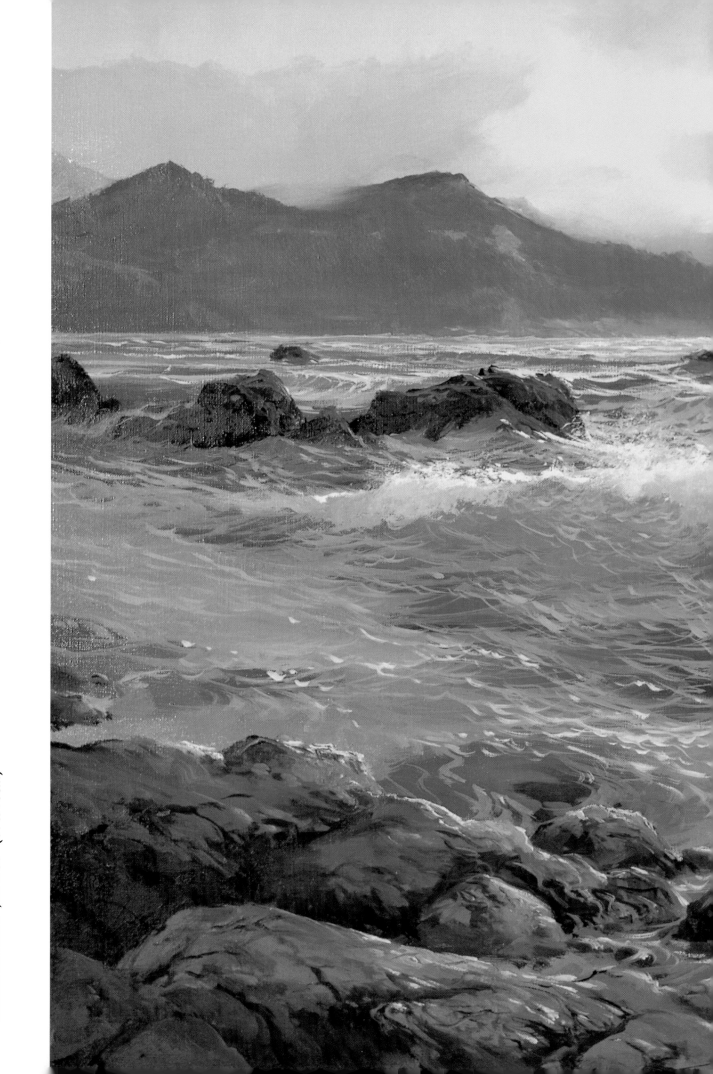

"Carmel Sundown", 24 x 30" (61 x 76cm)

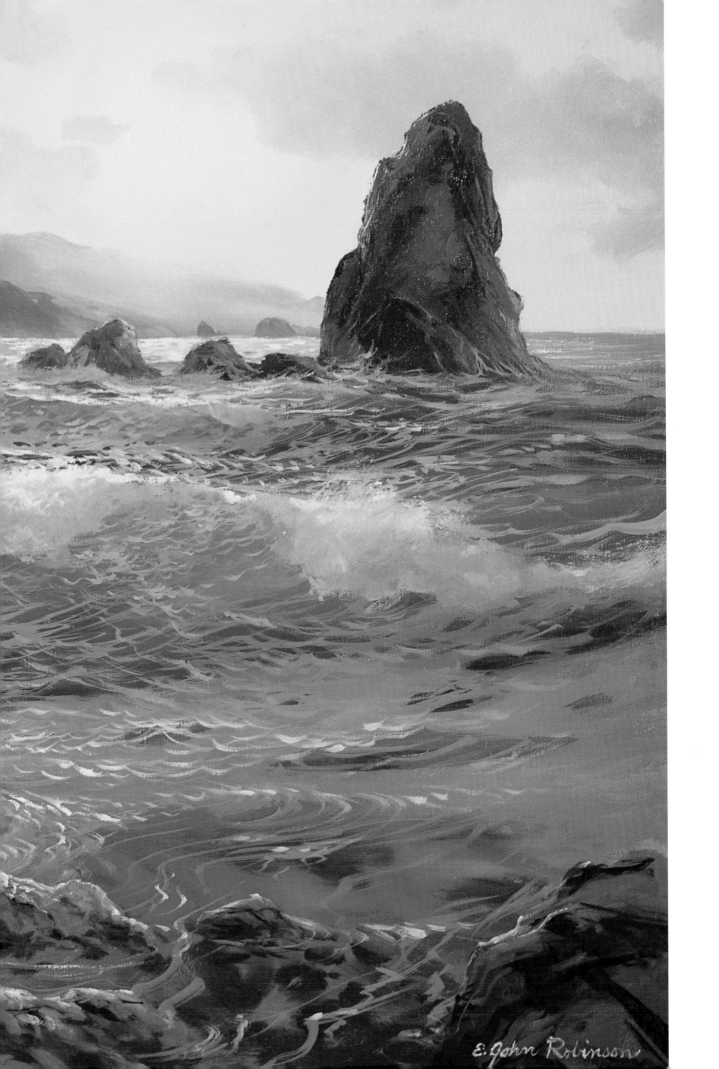

E. John Robinson

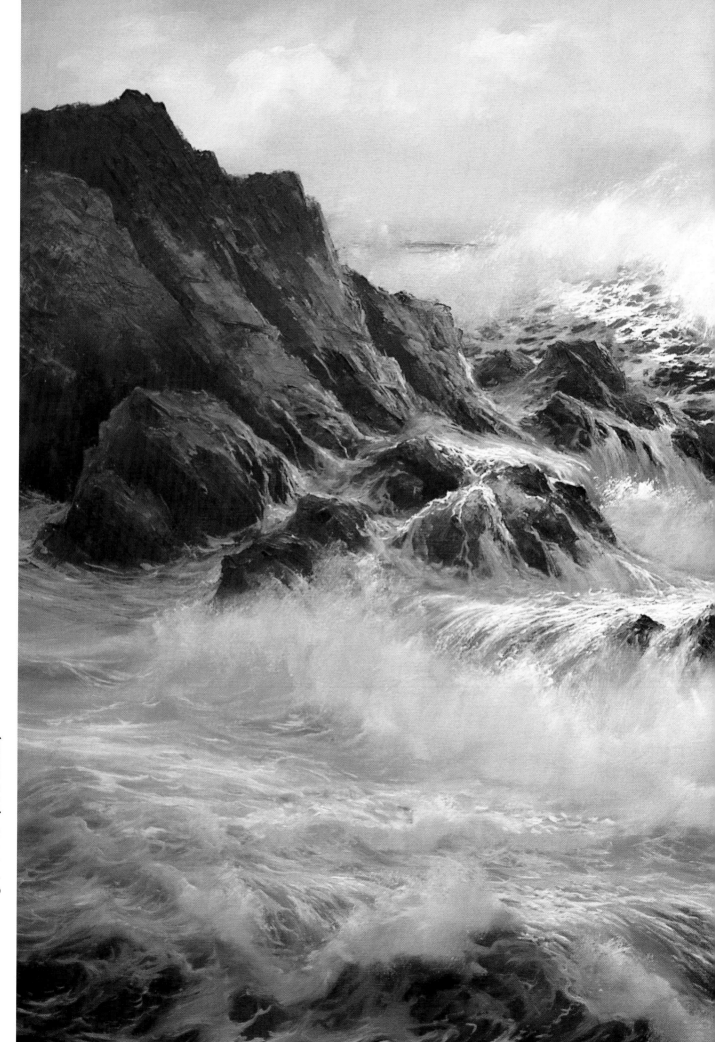

"Mendocino Morning", 36 x 48" (91 x 122cm)

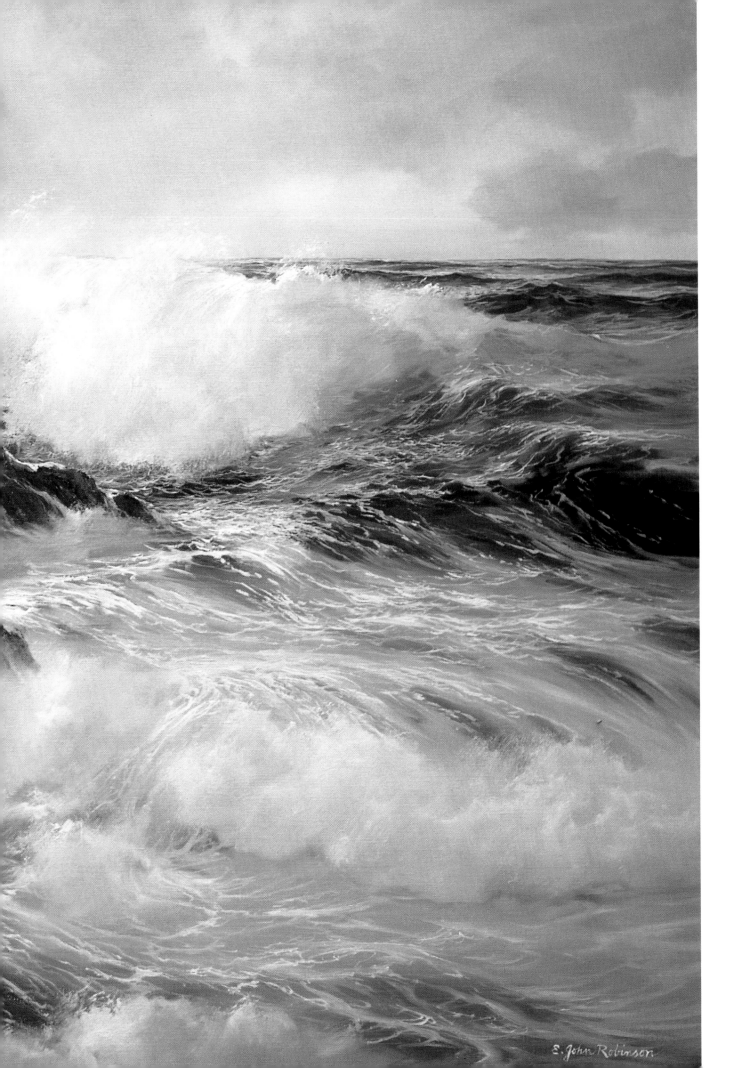

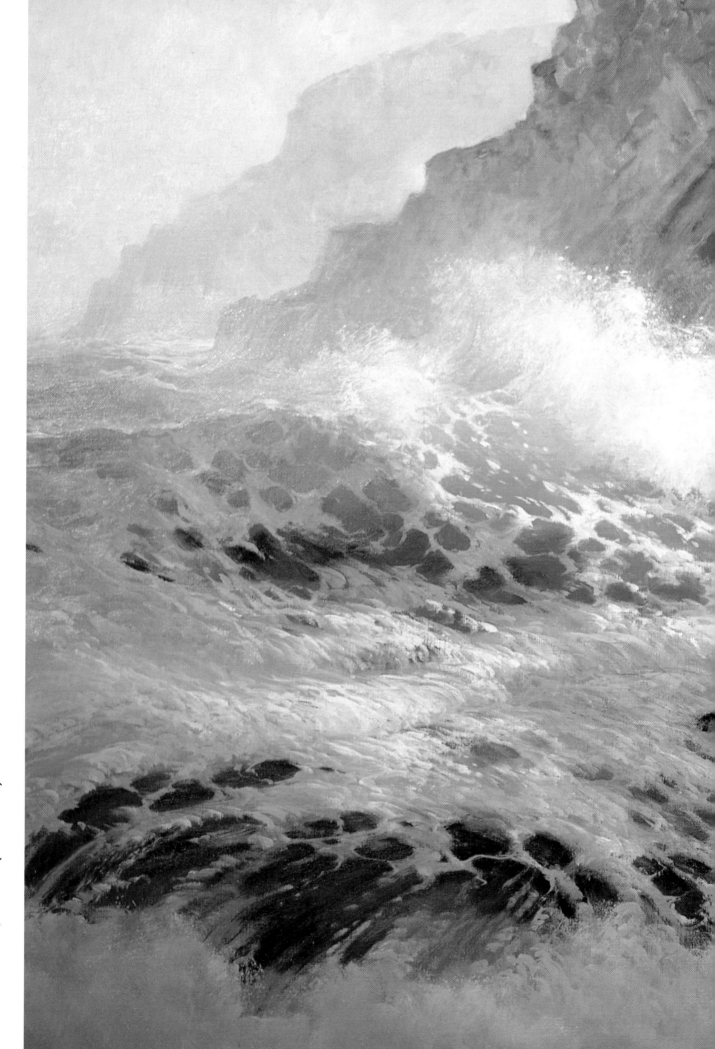

"Shelter Side", 30 x 40'' (76 x 102cm)

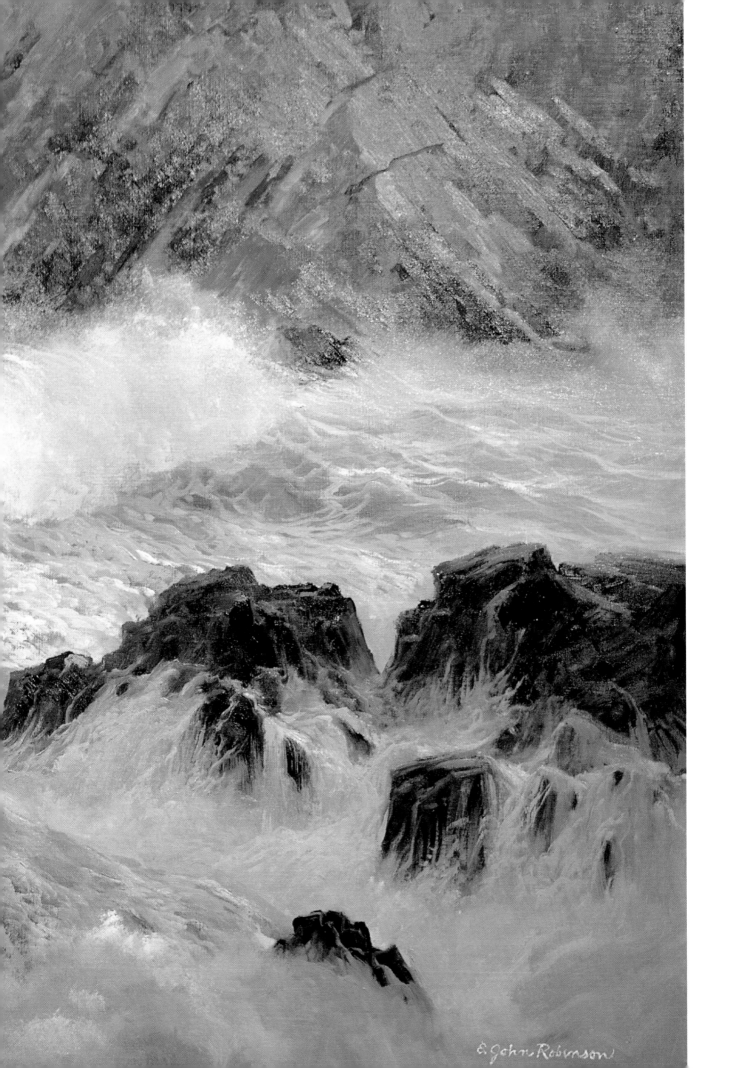

E. John Robinson

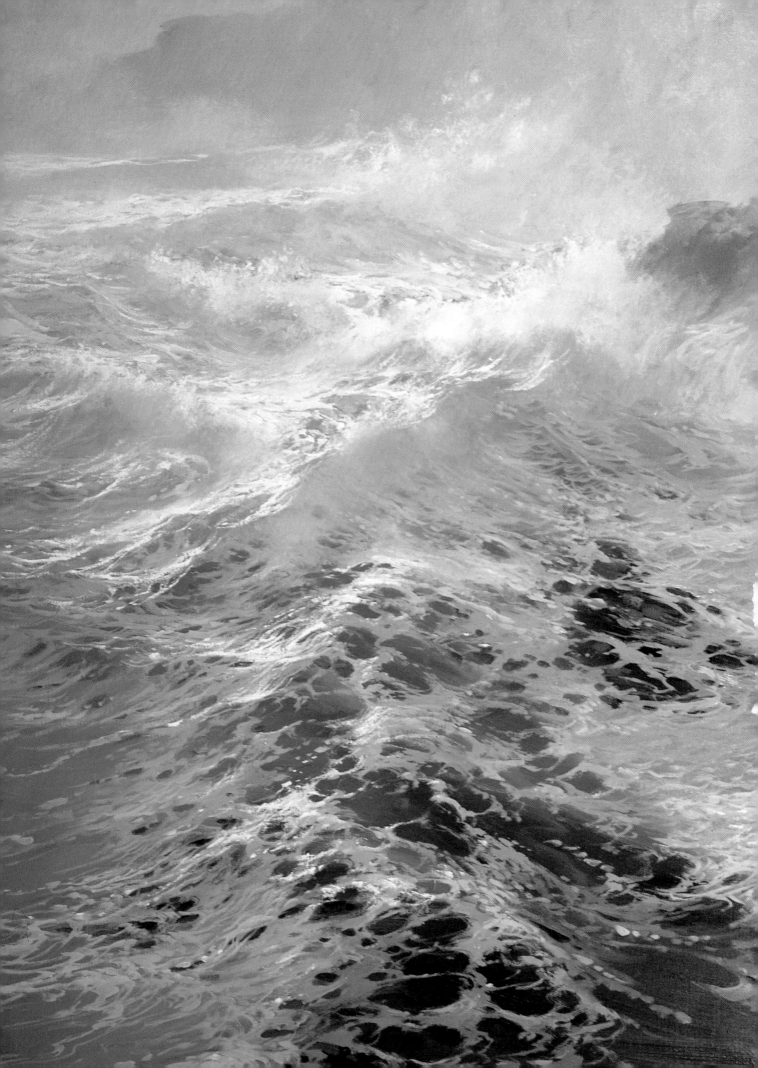

conclusion

There are three stages or levels of creative development:

1 Copying

We all started by copying others. We watched what others were doing and tried to make our attempts look like theirs. Most people started learning in this manner well before they went to school and most people, for one reason or another, never advance beyond this approach

2 Advanced copying

For the few people who do go beyond stage one, the next stage requires some skills. They still copy but rely more on photos or even go outside and copy what they see from nature. The more they practice, the more skilled they become, and some extremely fine art has been created in this way. However, most do not go beyond this stage.

3 Expression

In the third level of creative development the artist goes beyond just making an image and expresses a mood or a message. Stages one and two are still there to a certain extent but now the personal touch is more evident. There has always been a personal touch in that everyone in each stage chose their favorite subject, favorite colors, and ways of expressing unlike others, but now the artist uses the subject as a means to express feelings. It could be a seascape, a landscape, a still life, or an abstraction, but now it conveys to a viewer what the artist felt when he first came upon this moment in time. Now the artist can express joy or sadness, happiness or anger, a feeling of motion or peaceful rest. No matter whether the message is considered good or bad, it is a message to be felt rather than just viewed.

This book has given a few ways to go beyond the first two levels and you must know there are many more. Discovering them will be much easier now that you are aware of another level and as you develop your skills to express yourself, more ways will become apparent. Painting is one of the most exciting things a human can do on this earth and you are fortunate indeed, to have such a gift. Remember though, it takes time and effort to develop the technical skills. It can be frustrating at times but you will advance. Simply try to improve today over what you did yesterday and look forward to tomorrow to improve over today. Never mind what others are doing, these are your skills and your expressions. All it takes is awareness, dedication, and the pleasure of much, much, painting.

E John Robinson

"In the third level of creative development the artist goes beyond just making an image and expresses a mood or a message."

"Sport of the Waves", 36 x 28" (91 x 71cm)

about the artist

E. John Robinson has always been an artist. He started with pencils, crayons, anything he could find, until he was given watercolors at age six. He graduated to oils at age twelve and has been painting ever since. His first award came in high school when he placed among the top ten in the National Scholastic Art Contest. Since then he has avoided such contests considering popular acceptance much more satisfying. He went on to study art in Seattle at the Cornish School of Arts, then to the California College of Arts and Crafts, Oakland, California. He was told no one could ever make a living as an artist so he entered education and taught public school. However, after twelve years he was making more from his paintings than as a teacher so he and his family moved to the village of Mendocino on the rugged north coast of California where he could specialize in painting the sea. From 1960 to 1980, E. John painted only the sea and with a keen reverence for nature that is a hallmark in his paintings. He eventually painted landscapes as well and carried the same love of nature to them. Today, after a long, satisfying career, he can look back on over 4,000 seascapes, most of which are in private collections, four covers for *Reader's Digest*, instructional books, articles, and video tapes, and widespread recognition.

His paintings are in numerous collections of notables as well as corporations both in America and Europe.

E. John and his wife still live in Mendocino and he continues to paint, always looking for that special moment, always reaching out, and always trying to improve.

— Ted Hendershot, gallery owner